SIMPLY JAPANESE

日本の家庭料理

SIMPLY JAPANESE

日本の家庭料理

100 Authentic Recipes for Easy Home Cooking

家庭で出来る百の
オリジナルレシピ
とその作り方

MAORI MUROTA
PHOTOGRAPHY BY AKIKO IDA

An Imprint of HarperCollins Publishers

FOREWORD

This is a book about my everyday cooking. It contains recipes I learned from watching my mother and grandmother cook and by tasting their dishes, my mouth filled with flavors and happiness. It's my pleasure to share here the traditional recipes for the everyday Japanese dishes I grew up with, as well as my own original recipes inspired by foreign cuisines. This blend of tradition and fusion is very typical of modern Japanese cuisine.

When entering a kitchen in Japan, you will often find olive oil, nuoc cham, gochujang (spicy Korean paste), and cheese. We are very interested in foreign foods and often adopt them to add novelty to our cooking. Yet, we also remain attached to the jars of preserves and nukazuke pickles (fermented daily in a rice bran bed called a nukadoko), using the same method as our grandmothers.

It is entirely possible to respect traditional family cooking while at the same time cooking with an open mind and thinking outside the box. This is my version of today's Japanese cuisine.

In recent years, after the birth of my daughter and the Covid-19 lockdowns, my perspective on food has changed a lot. I began to want to use more locally produced food, with less of an environmental impact. My family and I spent the first lockdown on a small island in France. It was, of course, difficult to find Japanese products in the shops, so I started making my own udon noodles and gyoza dough and fermenting tsukemono pickles. I was pleasantly surprised—they were delicious and not as complicated as I had thought they might be.

After an initial period of panic, I realized how much joy there was in cooking from scratch, in creating everything with my own hands, just like my mother and grandmother did. I no longer worry when I can't access the Japanese grocery stores in the heart of Paris—I can do everything myself!

In my quest to find the right ingredients, I was fortunate to meet passionate local producers who make miso, seaweed, Japanese vegetables, and tofu . . . all the things I thought I had to import from Japan. It is now possible to make Japanese dishes in France almost independently.

In this book I introduce my favorite 100 percent homemade recipes for iconic Japanese dishes, such as sushi and ramen, but also recipes to make miso paste, natto, anko, and Japanese curry without using processed curry cubes. Cooking food at home is, of course, healthier, because you know exactly what's in the dish, but it's also much more delicious!

I now follow a mostly vegan diet, but my family eats everything, so I cook meat and fish for them. I provide as many vegan alternatives as possible in this book because you can cook very good, totally plant-based Japanese dishes. I want to share my recipes with everyone, regardless of their religion or diet.

I hope this book inspires your everyday cooking and that you enjoy preparing these dishes. I will be delighted if it helps you find your own version of Japanese cuisine.

FLOUR	粉物	11
RICE	米	55
FERMENTING AND PRESERVING	発酵 保存食	89
VEGETABLES	野菜	119
FISH	魚	161
MEAT	肉	191
TEA AND SWEETS	お茶のお供	219
RESOURCES	付録	253
RECIPE INDEX		258
INDEX		260
ACKNOWLEDGMENTS		264

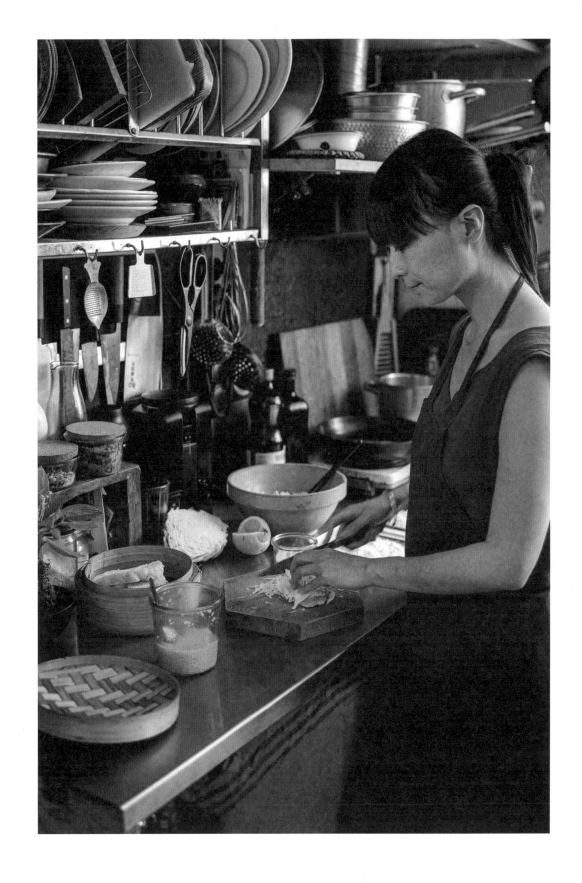

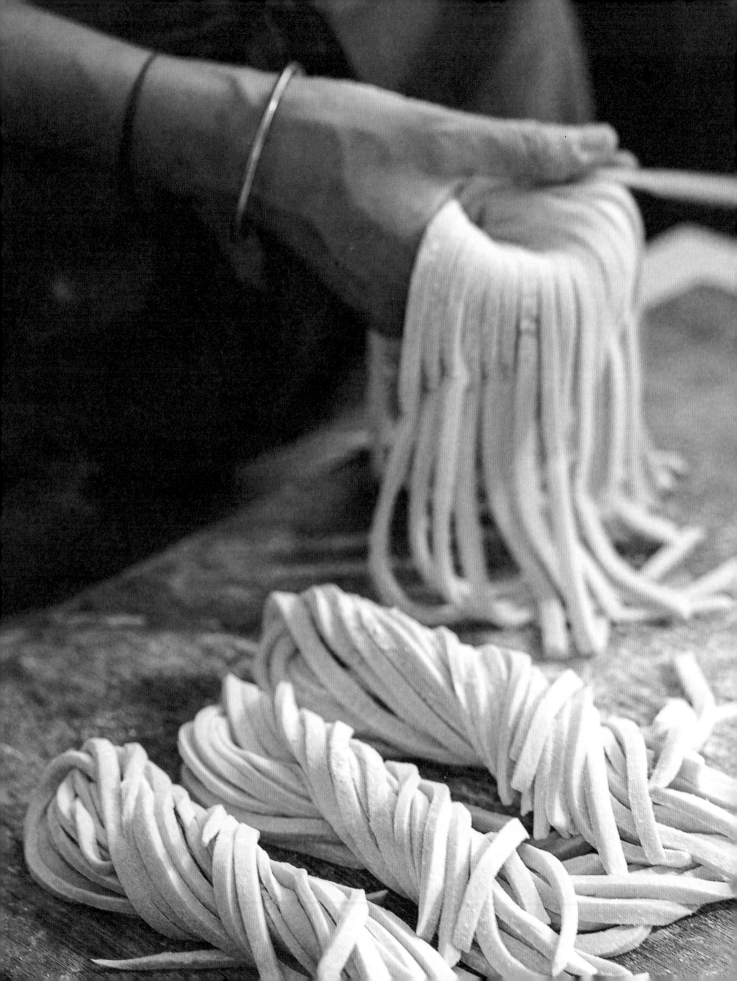

粉物

FLOUR

Udon

手打ちうどん

VEGAN

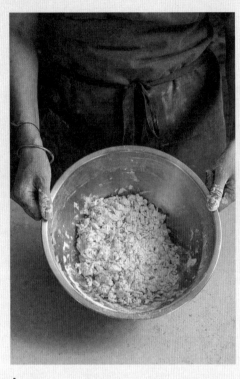

A

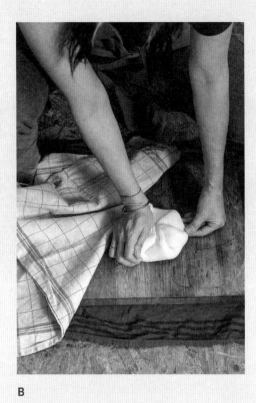

B

Serves 4, or makes 600 g (1 lb 5 oz)
Preparation: 1 hour
Resting: 1½–3½ hours
Cooking: 12 minutes

20 g (4 teaspoons) salt
180 ml (¾ cup) filtered water
350 g (2⅓ cups) all-purpose flour
50 g (1¾ oz) corn flour, arrowroot, or tapioca starch

For working the dough
Potato starch or corn flour

Dissolve the salt in the filtered water. Sift the flour and corn flour into a bowl. Add the salt water gradually, mixing with your fingers until you get a crumbly texture **(A)**. Form a ball of dough by pressing well with your hands. At this point, the dough will not be smooth. Wrap the dough in a tea towel and leave to rest for 15 to 30 minutes at room temperature.

Put a board on the floor, cover it with a tea towel, place the dough on top, and cover it with another tea towel (or place it in a large sturdy ziplock bag). Knead the dough with your feet. Start from the center and take small steps toward each side (about 50 steps).

When the dough is nice and flat, fold it in four. Knead it again with your feet. Repeat the folding and kneading one more time. Once the dough is flat again, fold the edges toward the center to form a ball **(B)**. Work the folds with your fingers to smooth the ball. Turn the dough over with the closed side underneath. Wrap it in a damp tea towel. Leave to rest at room temperature: 1 hour in summer, 2 hours in spring and autumn, 3 hours in winter.

Liberally sprinkle a work surface and the dough with potato starch. Press a rolling pin down on the middle of the ball (closed side underneath), and roll out the dough upward. Start from the

粉物

FLOUR

STEP-BY-STEP

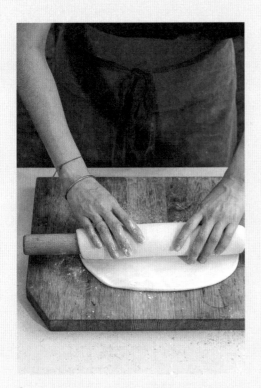

C

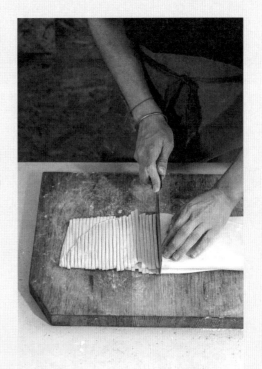

D

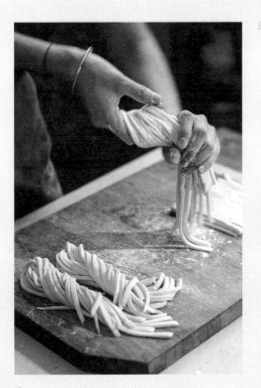

E

center again and roll downward. Turn the dough 90 degrees and repeat the process. Wrap the dough around the rolling pin **(C)**, press down on the rolling pin, using your hands to thin the dough out, and then unroll. Repeat this process until you get a square that is 3 mm (⅛ inch) thick.

Dust a cutting board and both sides of the dough with starch. Fold the dough into thirds and cut into noodles that are 3 mm (⅛ inch) wide **(D)**. Separate them one by one, adding starch if necessary. Place them in piles on another board **(E)**.

Bring a large pot of water to a boil. Shake the noodles a little to remove excess starch and drop them into the water. Stir with chopsticks to separate and prevent them from sticking. Lower the heat and cook for about 12 minutes. To check if the udon are cooked, take a noodle, dip it in cold water and bite it—if the inside is translucent, then it's ready. Drain and rinse with cold water to remove starch.

STORING UNCOOKED NOODLES

Keep noodles for up to 3 days in an airtight container in the refrigerator and 1 month in a ziplock bag in the freezer.

Mentsuyu
(NOODLE SAUCE)

めんつゆ

Classic Mentsuyu

Makes 600 ml (20 fl oz) sauce
Preparation: 5 minutes
Cooking: 5 minutes

200 ml (7 fl oz) soy sauce
100 ml (3½ fl oz) sake
100 ml (3½ fl oz) water
200 ml (7 fl oz) mirin
10 g (¼ oz) dried kombu
10 g (¼ oz) katsuobushi (dried bonito flakes)

Combine all the ingredients in a saucepan. Bring to a boil, then reduce the heat and leave to simmer over a low heat for 5 minutes. Leave to cool.

Remove the kombu and katsuobushi. Squeeze the katsuobushi over the pan to extract as much liquid as possible.

TIPS

The sauce will keep for 10 days in an airtight jar in the refrigerator.

—

Don't throw away the kombu and katsuobushi. You can turn them into delicious condiments (p. 139) for making onigiri (p. 74).

Mentsuyu shojin 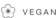 VEGAN

Makes 600 ml (20 fl oz) sauce
Preparation: 5 minutes
Resting: Overnight
Cooking: 5 minutes

200 ml (7 fl oz) soy sauce
100 ml (3½ fl oz) sake
100 ml (3½ fl oz) water
200 ml (7 fl oz) mirin
10 g (¼ oz) dried kombu
10 g (¼ oz) dried shiitake mushrooms

Put all the ingredients into a jar or airtight container and leave to rest overnight in the refrigerator to gently infuse the flavor of the kombu and shiitake.

Pour the mixture into a saucepan, bring to a boil, then reduce the heat and leave to simmer over a low heat for 5 minutes. Leave to cool.

TIP

You can also use the leftover kombu and shiitake in other dishes (see the furikake recipe for using kombu and katsuobushi, p. 167). Shiitake mushrooms rehydrated in the sauce go perfectly with somen noodles (p. 34).

These recipes are very useful if you like noodles. Simply dilute the mixture in a little water to make a sauce or in more hot water for a delicious hot soup broth!

粉物

FLOUR

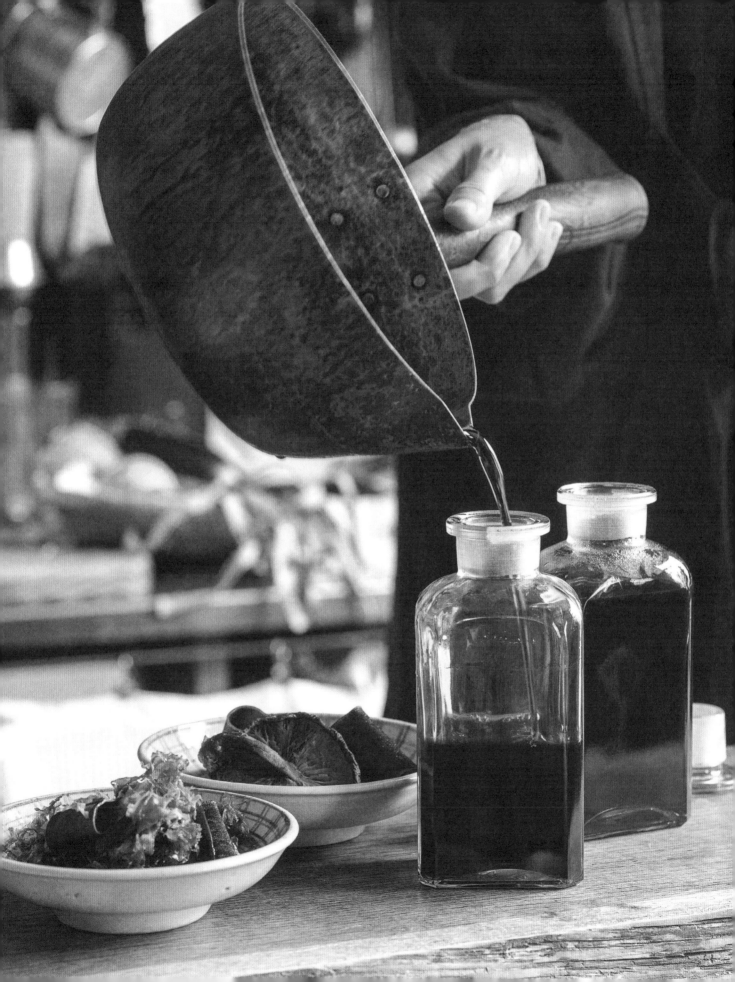

Udon with duck broth

鴨南蛮つけうどん

Serves 4
Preparation: 10 minutes
Cooking: 25 minutes

200 g (7 oz) duck breast fillet
1 leek
1 teaspoon sunflower oil
500 ml (2 cups) water
300 ml (10 fl oz) mentsuyu (p. 14)
400 g (14 oz) dried or 600 g (1 lb 5 oz) fresh udon noodles (p. 12; precooked udon and frozen udon are packaged individually)

Garnish

4 cm (1½ inches) daikon (white radish) or ½ black radish, peeled and grated
10 g (¼ oz) fresh ginger, peeled and grated
1 nori sheet, torn into small pieces
1 scallion, thinly sliced

Cut the duck breast into 1-cm (½ inch) slices and the leek into 3-cm (1¼-inch) sections. Heat the oil in a saucepan over medium heat and cook the duck slices for 1 minute each side. Remove from the pan and set aside. In the same pan, brown the leek for 1 minute over medium heat (without cooking completely). Add the water and mentsuyu and cook for about 5 minutes. Just before serving, return the duck slices to the pan and cook for 1 minute.

In a large pot of boiling water, cook the udon noodles according to the packet instructions (dry noodles) or recipe (homemade udon). Drain and rinse the noodles well under cold water.

Divide the udon noodles onto four plates or woven bamboo baskets (zaru). Pour the hot broth into bowls, dividing the duck and leek evenly, and serve with grated radish and ginger, small pieces of nori, and thinly sliced scallion. Dip or add the udon noodles to the broth and enjoy.

TIP

At the end of the meal, to drink the broth as as soup, you can dilute the broth with boiling water. This broth also goes very well with soba noodles—just dilute the broth with the cooking water.

VEGAN VERSION

Replace the duck with 150 g (5½ oz) roughly chopped mushrooms. I particularly like a mix of oyster and shiitake mushrooms.

粉物

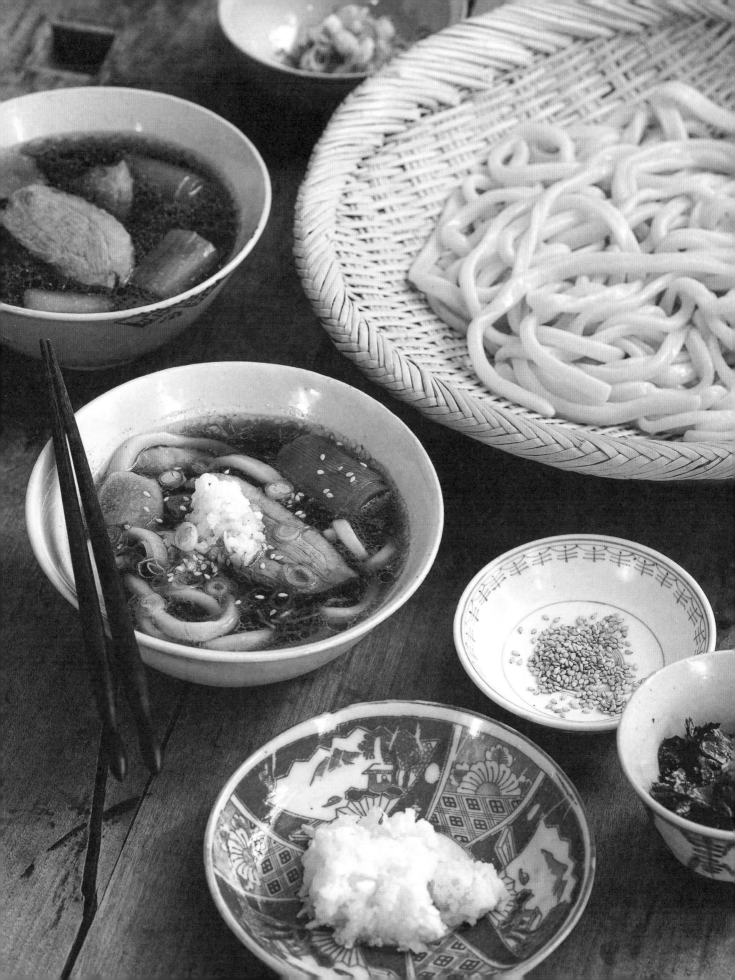

Spinach udon
WITH MINT

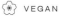 VEGAN

ほうれん草の幅広麺

Serves 4
Preparation: 45 minutes
Resting: 30 minutes–1 hour
Cooking: 4 minutes

125 g (4½ oz) baby spinach leaves
350 g (2⅓ cups) all-purpose flour
50 g (1¾ oz) potato starch or tapioca starch
10 g (2 teaspoons) salt

For working the dough
Potato starch or corn flour

Seasoning
1 garlic clove, chopped
2 pinches raw sugar
1–2 tablespoons chile powder (optional)
4 tablespoons neutral vegetable oil
4 tablespoons tamari (or soy sauce)
2 tablespoons Chinese black vinegar
1 handful mint leaves, roughly chopped
A few baby kale leaves (optional), cut into bite-sized pieces
20 g (¾ oz) walnuts, roughly chopped

Blanch the baby spinach in a pot of boiling water for 1 minute, drain well, and purée with a stick blender. Add enough cold water to make up 200 ml (7 fl oz) of water-spinach mixture.

Mix the flour, starch, and salt in a bowl. Gradually add the water-spinach mixture to the dough, mixing with your fingers to moisten it until you get a crumbly texture, similar to a crumble topping. Knead for 10 minutes until no more dough remains on the sides of the bowl and the dough is smoother. Wrap it in a damp tea towel. Leave to rest for 30 minutes to 1 hour at room temperature.

Roll out the dough following the steps in the udon noodle recipe (p. 12) or using a pasta maker. If using a pasta maker, form a log of dough and cut into four equal pieces. Dust the dough pieces all over with starch. Feed each piece through the rollers on the widest setting. Gradually reduce the thickness of the dough each time you roll it through, until it is 2–3 mm (1/16–1/8 inch) thick (on my machine, I use settings 0, 2, 4, 5). Then cut wide—2-cm (¾-inch)—strips lengthwise using a knife.

Bring a large pot of water to a boil. Drop the noodles into the water and cook for around 3 minutes. Drain and tip the noodles into a bowl or large plate. Put the garlic, sugar, and chile powder, if using, in the middle of the noodles. Heat the oil in a small saucepan until it smokes (make sure you turn off the heat as soon as it starts to smoke). Pour the hot oil over the garlic, sugar, and chile. Add the tamari, vinegar, and half the mint and kale, if using. Mix together immediately.

Place the noodles on individual plates and sprinkle with the walnuts and remaining mint and kale. Serve immediately.

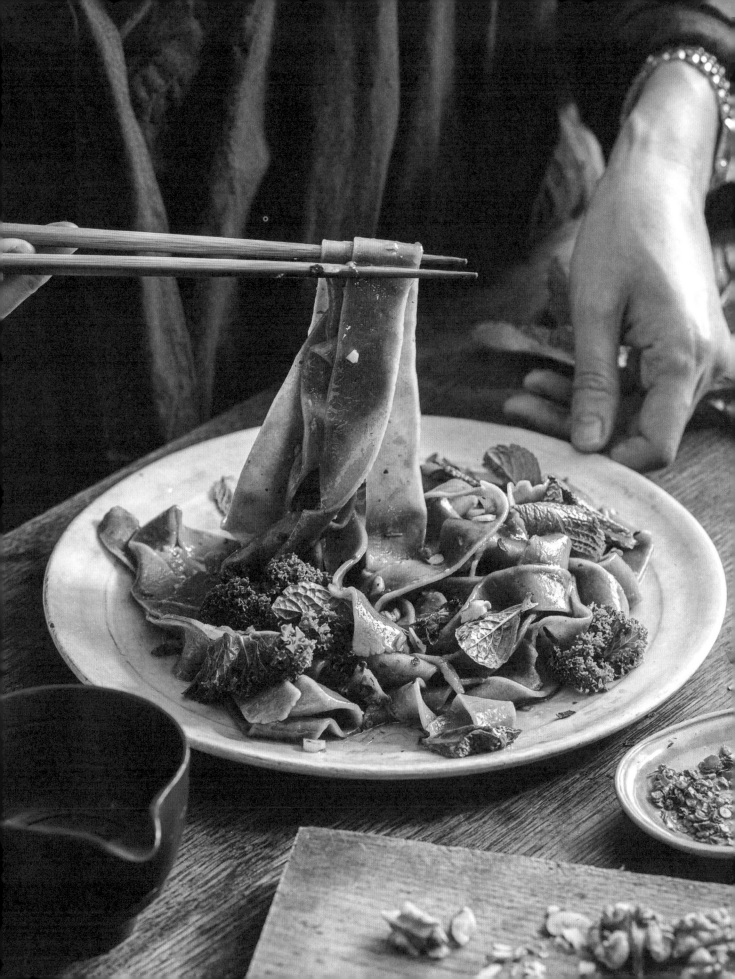

Ramen

手打ち中華麺

VEGAN

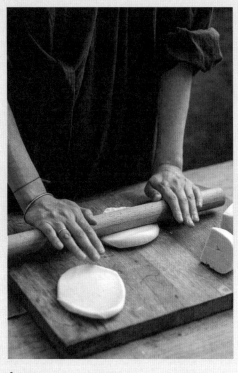

A

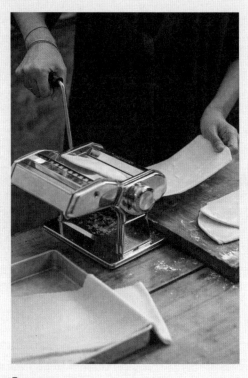

B

Serves 4, or makes 600 g (1 lb 5 oz)
Preparation: 1 hour
Resting: 1½–3½ hours +
1–2 days
Cooking: 1–1½ minutes

4 g (1 teaspoon) salt
175 ml (6 fl oz) filtered water
350 g (2⅓ cups) all-purpose flour
50 g (1¾ oz) corn flour, arrowroot, or tapioca starch
4 g (1 teaspoon) baking soda

For working the dough
Potato starch or corn flour

Dissolve the salt in the filtered water. Sift the flour and corn flour into a bowl. Add the salt water gradually, mixing with your fingers until you get a crumbly texture, similar to a crumble topping. Form a ball by pressing well with your hands. At this point, the dough will not be smooth. Wrap it in a tea towel. Leave to rest for 15 to 30 minutes at room temperature.

Put a board on the floor, cover it with a tea towel, place the dough on top, and cover it with another tea towel (or place it in a large sturdy ziplock bag). Knead the dough with your feet. Start from the center and take small steps toward each side (about 50 steps).

When the dough is nice and flat, fold it in four. Knead it again with your feet. Repeat this process a total of four times. Once the dough is flat, fold the edges toward the center to form a ball. Work the folds with your fingers to smooth the ball. Turn the dough over with the closed side underneath. Wrap it in a damp tea towel. Leave to rest at room temperature: 1 hour in summer, 2 hours in spring and autumn, 3 hours in winter.

Do not flour the work surface or dough at this stage. Cut the dough into four equal pieces. Use a rolling pin to flatten the

STEP-BY-STEP

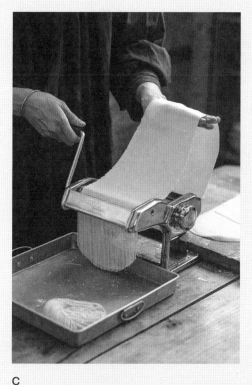

C

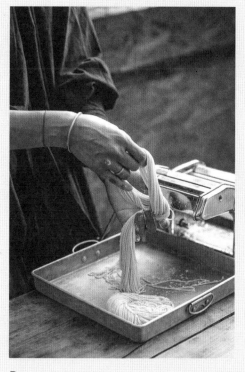

D

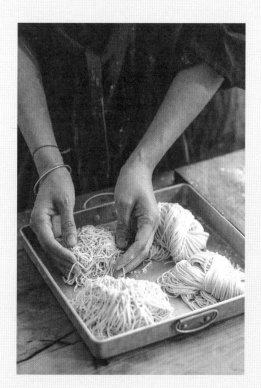

E

pieces until they are 1 cm (½ inch) thick **(A)**. Now feed each piece through the rollers on a pasta maker using the widest setting. Fold each piece in half and feed it through the machine again **(B)**. Repeat this process three times to properly develop the gluten. Generously flour all sides of the dough with starch, then gradually reduce the thickness of the dough each time you roll it through, until it is 2–3 mm (¹⁄₁₆–⅛ inch) thick (on my machine, I use settings 0, 2, 4, 5). Then cut each piece in half lengthwise to get eight pieces of rolled-out dough. Install the thinnest cutter attachment and feed each piece through **(C)**. Make piles of noodles **(D)**. The ramen noodles are ready!

To make curly noodles, place them on the work surface, sprinkle with starch, then squeeze them together by pressing them between your hands. Release and repeat with the other piles of noodles **(E)**.

Put the noodles in an airtight container, cover with parchment paper, close the lid, and leave to rest in the refrigerator for 1 to 2 days before cooking. This will improve the texture and taste.

Cooking

Bring a large pot of water to a boil. Drop the noodles into the water and cook for 1 to 1½ minutes or until cooked through. Drain.

Shoyu ramen
(TOKYO-STYLE RAMEN)

醬油ラーメン

Serves 4
Preparation: 15 minutes
Cooking: 5 minutes

Soup

1.6 liters (6½ cups) meat broth (p. 25)

180 ml (¾ cup) cha-shu marinade (p. 25)

1 tablespoon oyster sauce

2 tablespoons malted or nutritional yeast

Salt

400 g (14 oz) dried or 600 g (1 lb 5 oz) fresh ramen noodles (precooked ramen and frozen ramen are packaged individually)

Toppings

2 handfuls bean sprouts, blanched in boiling water for 1 minute and well drained

4 ajitsuke tamago (p. 25), cut lengthwise

8 slices cha-shu marinated pork (p. 25)

1 scallion, thinly sliced

½ nori sheet, cut into 4 rectangles

Pepper

Ra-yu (p. 139) (optional)

Prepare the soup. Pour the broth, cha-su marinade, oyster sauce, and yeast into a saucepan. Heat over medium heat and season with a little salt to taste.

In a large pot of boiling water, cook the noodles according to the packet instructions (dry noodles) or recipe (homemade ramen). Drain well and divide into four large bowls. Pour the hot soup over the noodles, add the toppings, and serve immediately.

TIP

You can also find plain dried or fresh ramen at Asian grocery stores, or you can use the ramen noodles from a packet and save or discard the soup base. For substitutes, choose thin, slightly yellow noodles, such as egg noodles. However, homemade noodles will always be better!

粉物

FLOUR

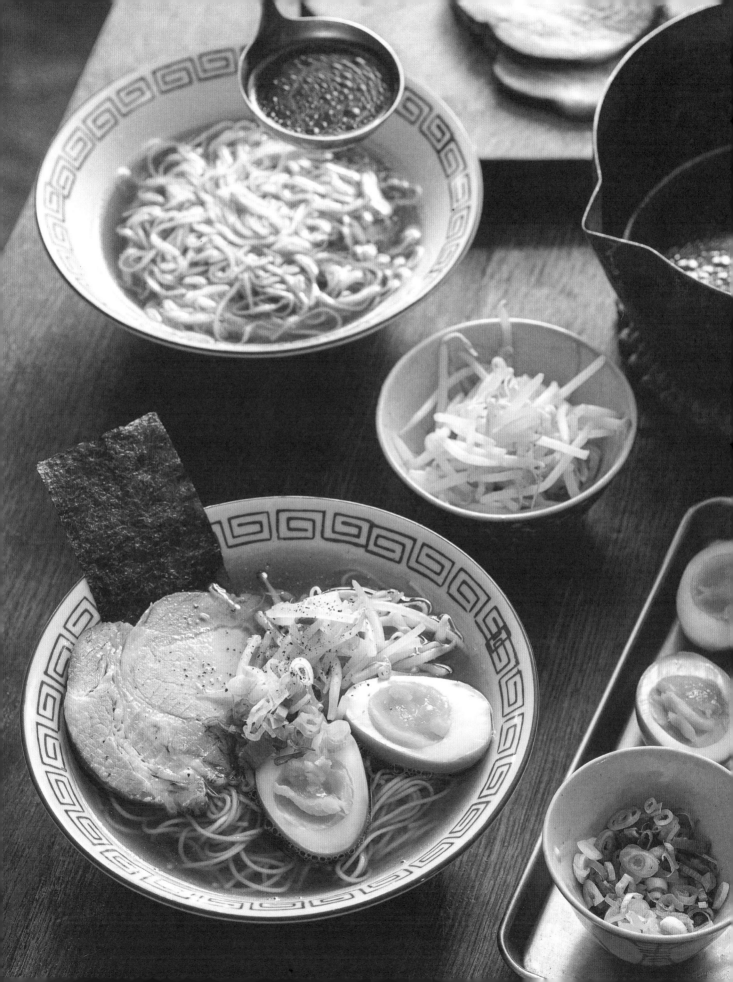

Meat broth

ラーメンスープ

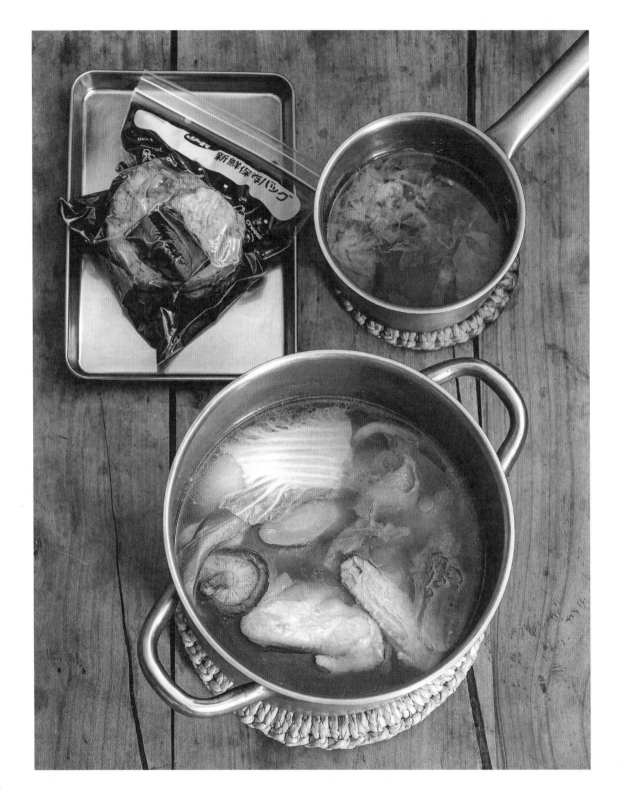

粉物

FLOUR

Serves 4
Preparation: 30 minutes
Resting: 2 hours–overnight
Cooking: 2½ hours

Dashi concentrate

500 ml (2 cups) water

5 g (⅛ oz) dried kombu

10 g (¼ oz) katsuobushi (dried bonito flakes)

Cha-shu marinade

150 ml (5 fl oz) soy sauce

2 tablespoons sake

1 tablespoon mirin

1 tablespoon raw sugar

1 piece dried kombu (5 cm/ 2 inches square)

Ajitsuke tamago (marinated soft-boiled egg)

4 eggs, at room temperature for at least 30 minutes

Broth

4 free-range chicken wings

500 g (1 lb 2 oz) pork shoulder

2 liters (8⅓ cups) water

½ onion, halved

2 napa cabbage leaves

½ carrot, cut into 2-cm thick (¾-inch) rounds

1 dried shiitake mushroom

1 leek (green part)

100 ml (3½ fl oz) sake

2 slices fresh ginger (5 mm/ ¼ inch each), skin on

2 garlic cloves

Prepare the dashi concentrate. Bring the water, kombu, and katsuobushi to a boil in a saucepan, then simmer for 10 minutes. Turn off the heat and allow to cool. Drain and squeeze the katsuobushi to extract the last drop of liquid.

Pour all the cha-shu marinade ingredients into a ziplock bag large enough to hold the pork.

Bring a saucepan of water to a boil, then add the eggs and boil for 6½ minutes. Remove from the heat and immerse them in cold water to stop the cooking. Allow to cool, then peel. Dip the eggs in a bowl filled with water for 1 minute to remove the egg smell. Drain.

Prepare the broth. Blanch the chicken wings and pork for 1 minute in a pot of boiling water. Drain. Pour the water for the broth into a large pot, add the chicken wings, pork, onion, cabbage leaves, carrot, shiitake mushroom, leek, sake, ginger, and garlic. Bring to a boil over medium heat, then reduce the heat to low. Cover, leaving a 5-mm (¼-inch) gap, and simmer for 1 hour and 30 minutes. Remove the chicken wings and pork and allow them to cool. Simmer the broth another 30 minutes. Uncover, add the dashi concentrate, and continue to simmer over low heat, uncovered, for a further 45 minutes. Strain. This makes around 1.6 liters (6½ cups) of broth.

Add the pork and soft-boiled eggs to the cha-shu marinade bag. Press to remove as much air as possible from the bag, close it, and leave to marinate in the refrigerator for at least 2 hours, ideally overnight.

TIPS

It would be a shame to throw away the tender chicken wings! Enjoy them with a little soy sauce, toasted sesame oil, rice vinegar, and some fresh herbs (cilantro or chives). They make a delicious little dish!

—

Never throw away any remaining katsuobushi or kombu! They can be used to prepare furikake seasoning (p. 167).

—

The cha-shu can be used to make chimaki (p. 80). Simply prepare an additional 100 g (3½ oz) pork here (it freezes very well if needed).

Vegan ramen

WITH THREE MUSHROOMS AND INFUSED OIL

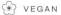 VEGAN

精進ラーメン

Serves 4
Preparation: 20 minutes
Cooking: 20 minutes

Soup
100 g (3½ oz) enoki mushrooms
60 g (2 oz) oyster mushrooms
10 g (¼ oz) dried shiitake mushrooms rehydrated in vegetable broth (p. 28)
2 tablespoons neutral vegetable oil
1 garlic clove, chopped
1 recipe vegetable broth (p. 28)
4 tablespoons soy sauce
3 tablespoons mirin
3 tablespoons malted or nutritional yeast
Salt

Infused oil (negiabura) 葱油
2 scallions, thinly sliced
5 g (⅛ oz) fresh ginger, peeled and finely chopped
1 garlic clove, chopped
1 large red chile, cut into 1-cm (½-inch) thick slices
150–200 ml (5–7 fl oz) sunflower or cold-pressed sesame oil

Ramen
400 g (14 oz) dried or 600 g (1 lb 5 oz) fresh ramen noodles, p. 20 (precooked ramen and frozen ramen are packaged individually)
2 bok choy, quartered lengthwise
Pepper

Prepare the soup. Wash the enoki mushrooms, remove the stems, and roughly separate the strands. Roughly separate the oyster mushroom clusters and remove the stems. Cut the shiitake mushrooms into quarters.

Heat the oil and garlic in a saucepan over medium heat. When the garlic aromas begin to be released, add the mushrooms and sauté for 1 minute, until they are cooked. Pour in the broth, soy sauce, mirin, and yeast, and cover. Once boiling, reduce the heat to low and leave to simmer for 10 minutes. Taste and adjust the seasoning with 1 to 2 teaspoons of salt to your liking.

Prepare the infused oil. Add the sliced scallions, ginger, garlic, and chile to a frying pan or small saucepan. Pour in the oil so that the ingredients are floating but not covered. Heat over medium heat. When the oil starts to bubble, reduce the heat to low and cook for 3 minutes, stirring occasionally. When the scallions are nice and golden, strain the oil. Keep the fried scallions and chile to use as a garnish.

Prepare the ramen. In a large pot of boiling water, cook the noodles according to the packet instructions or recipe on p. 21. Just before the end of the cooking time, add the bok choy to the pot and cook for 1 minute. Drain the bok choy, then the noodles.

Serve the noodles in large individual bowls. Arrange the bok choy on top, drizzle with the mushroom soup and add 1 to 2 teaspoons of negiabura. Season with pepper and serve immediately.

TIP
I love to drizzle tofu with negiabura and soy sauce and sprinkle it with fried scallion and chile! The infused oil also goes very well with pasta.

粉物

FLOUR

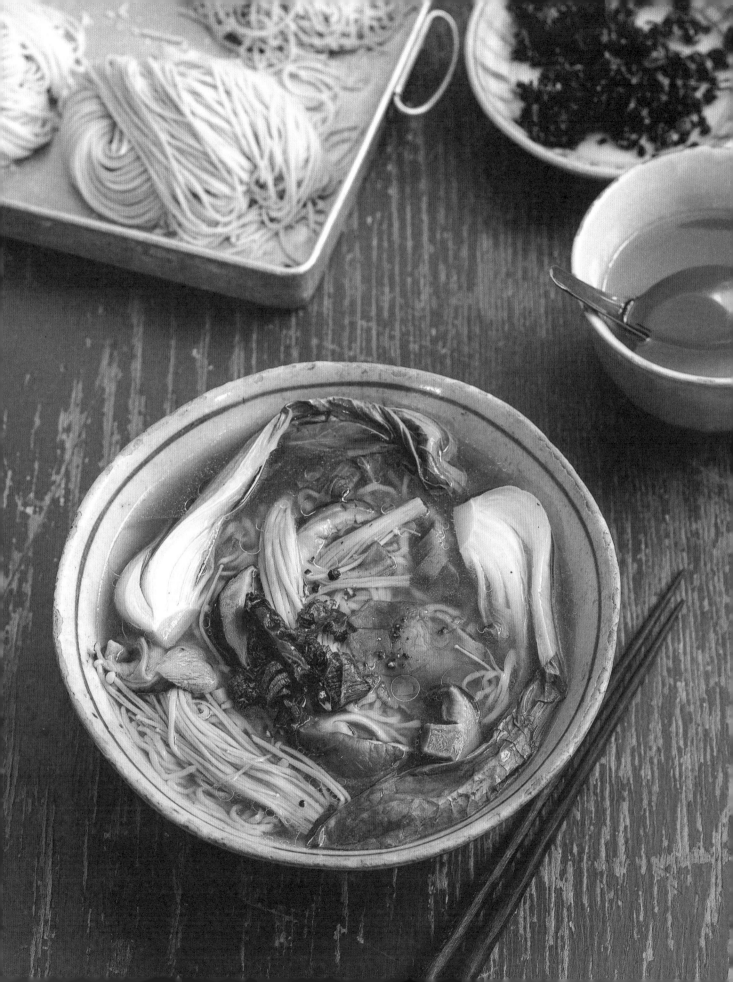

Vegetable broth

VEGAN

Serves 4
Preparation: 10 minutes
Resting: Overnight
Cooking: 45 minutes

10 g (¼ oz) dried kombu

10 g (¼ oz) dried shiitake mushrooms

2.4 liters (10¼ cups) filtered water

160 g (5¾ oz) vegetable scraps (carrot peel, broccoli stems, cabbage core, outer Chinese cabbage leaves, mushroom stems, etc.)

1 small onion, quartered

1 leek (green part)

5 g (⅛ oz) fresh ginger, skin on

2 garlic cloves

Combine the kombu, shiitake mushrooms, and 1 liter (4¼ cups) of the filtered water in a container. Leave to infuse overnight (or 2 hours in boiling water, but it is best infused overnight in cold water).

Pour the infused water with the kombu and shiitake mushrooms into a large saucepan. Add the remaining 1.4 liters (6 cups) filtered water, the vegetable scraps, onion, leek, ginger, and garlic.

Bring to a boil over medium heat, cover, leaving a 5-cm (2-inch) gap, and simmer for 40 minutes over medium-low heat. Strain the broth.

TIP

Keep a ziplock bag in the freezer and add any vegetable scraps to it so you can make this broth at any time.

Hiyashi tantan-men

(CHILLED NOODLES WITH SOY MILK SOUP)

✽ VEGAN

豆乳冷やし坦々麺

粉物

FLOUR

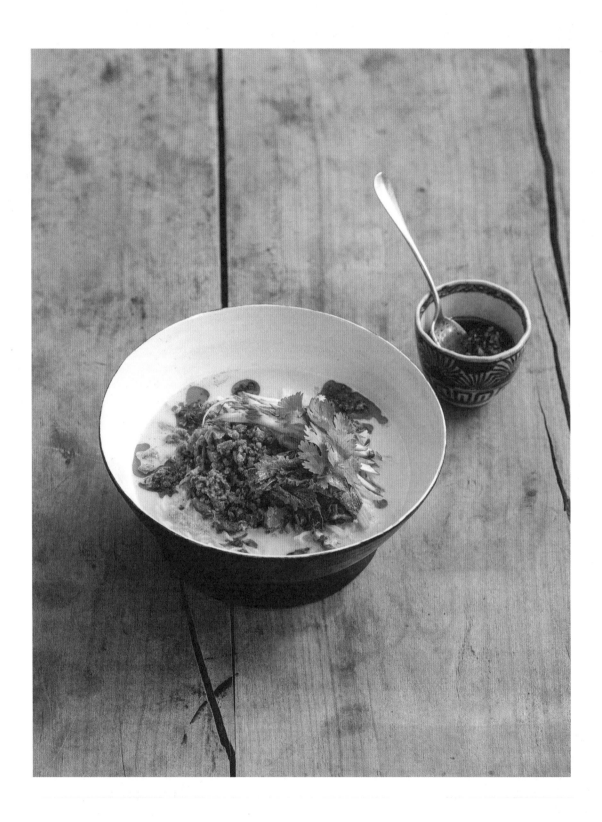

Serves 4
Preparation: 25 minutes
Cooking: 20 minutes

Vegan spicy stew

50 g (1¾ oz) dehydrated soy protein (small pieces) (weight after rehydration)

½ onion

2 cm (¾ inch) fresh ginger

1 garlic clove

10 g dried shiitake mushrooms rehydrated in 1 liter dashi shojin

100 g (3½ oz) mushrooms

2 tablespoons neutral vegetable oil

150 ml (5 fl oz) dashi shojin (p. 122)

1 tablespoon white miso

1–1½ tablespoons soy sauce

1 tablespoon raw sugar

1 tablespoon mirin (or 1 teaspoon sugar or 1 teaspoon sugar + 1 tablespoon sake)

20 g (¾ oz) walnuts, chopped

1 teaspoon sesame oil

2 handfuls spinach leaves

Salt

Soup

2 tablespoons soy sauce

4 tablespoons white miso

4 tablespoons tahini

400 ml (13½ fl oz) dashi shojin (p. 122)

400 ml (13½ fl oz) soy milk

½–1 teaspoon salt

400 g (14 oz) dried or 600 g (1 lb 5 oz) fresh ramen noodles (precooked ramen and frozen ramen are packaged individually)

Garnish

A few cilantro leaves

Sesame seeds

Ra-yu (p. 139)

Vegan spicy stew

Rehydrate the soy protein according to the packet instructions. Peel the onion, ginger, and garlic and chop finely. Remove the stems from the dried shiitake mushrooms. Chop the dried shiitake mushrooms and other mushrooms.

Heat the oil in a frying pan over medium-high heat. Before the oil is hot, add the chopped ginger and garlic. When it starts to smell good, add the onion. Sauté for about 2 minutes. Add the mushrooms and sauté until cooked and tender. Add the soy protein, dashi, miso, soy sauce, sugar, and mirin. Stir constantly to evaporate the liquid. When the liquid is almost evaporated, add the chopped nuts and sesame oil to flavor. Taste and add salt if needed.

Blanch the spinach leaves for 1 minute in a saucepan of lightly salted boiling water. Remove from the water, leave to cool slightly, then squeeze gently to remove excess water. Set aside.

Soup

Mix the soy sauce, miso, and tahini with a few tablespoons of dashi in a large bowl until well combined. Add the soy milk and remaining dashi. Taste and add salt if needed.

Keep the vegan spicy stew warm over low heat.

In a large pot of boiling water, cook the noodles according to the packet instructions or recipe on p. 21. Drain them into a colander and rinse well under cold running water. Squeeze the noodles with your hand to drain completely.

Divide the soup, noodles, spinach, and stew into four large bowls. Top with the cilantro leaves and sesame seeds and drizzle with ra-yu. Serve immediately.

TIPS

This dish can be eaten hot. To do so, add an extra 100 ml (3½ fl oz) soy milk and an extra 50 ml (1¾ fl oz) dashi to the soup mixture, and a little more salt if needed to your taste. Heat the soup over very low heat to avoid boiling, which will alter the texture. After the noodles are cooked, do not rinse them but simply put them into the hot soup immediately.

—

The vegan spicy stew can be kept in the refrigerator for 3 days and is suitable for freezing.

—

I love this stew so much! It can be served with Italian pasta, Japanese rice, or even salad. I prepare it in large quantities and use it all the time.

Cold soba with bottarga

カラスミ蕎麦

Serves 4
Preparation: 5 minutes
Cooking: 5–10 minutes

120 g (4¼ oz) daikon (white radish)
25 g (1 oz) bottarga (karasumi) (or more depending on taste), plus extra for grating
240 ml (8 fl oz) mentsuyu (p. 14)
120 ml (½ cup) water
280 g (10 oz) dried soba noodles
2 tablespoons extra virgin olive oil
½ yuzu or bergamot or lemon, quartered, plus extra for squeezing

Peel and grate the daikon. Cut the bottarga (karasumi) into eight thin slices. Mix the mentsuyu and water for the sauce in a bowl.

Cook the soba noodles according to the packet instructions. Drain into a colander and rinse well by swishing them with your hand under cold running water to remove the starch. Lightly squeeze the noodles with your hand to drain completely. Place in a large bowl.

Add the sauce and olive oil to the soba noodles and mix. Divide into four plates and garnish with the grated radish, bottarga slices, and yuzu wedges. Just before serving, squeeze some yuzu over the top and sprinkle with a little grated bottarga.

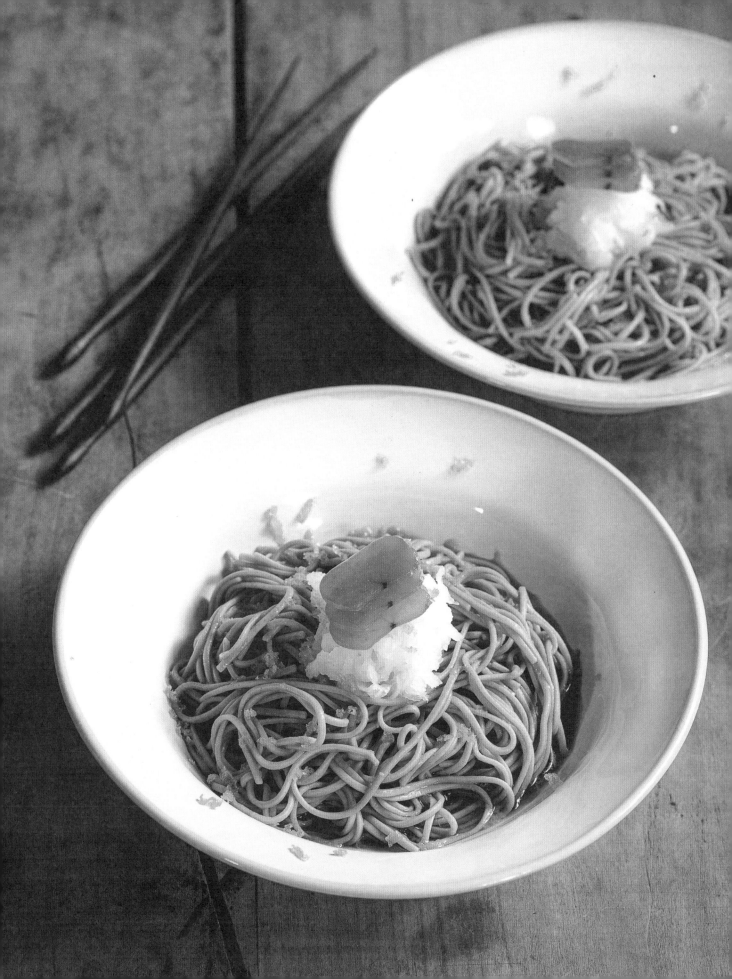

Somen noodles

茄子素麺

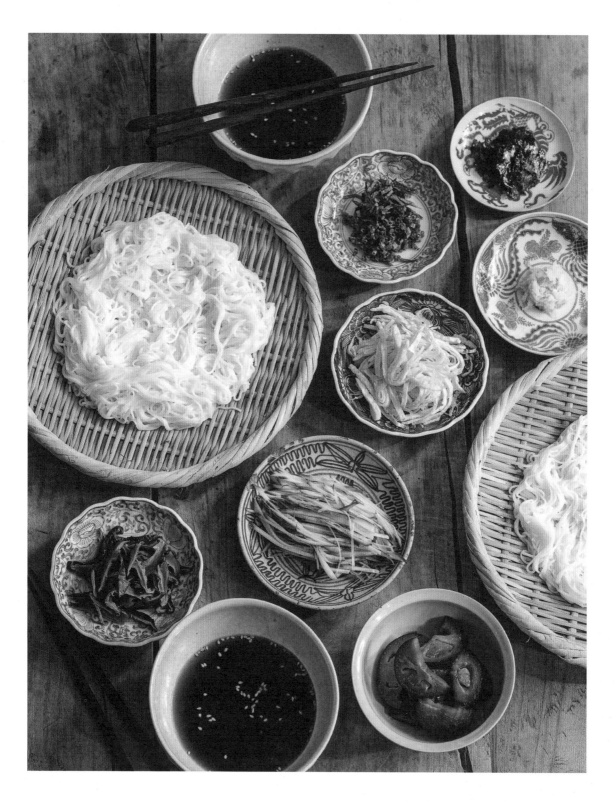

粉物

FLOUR

Serves 4
Preparation: 15 minutes
Cooking: 15 minutes

Topping A
200 g (7 oz) eggplant (aubergine)
2 teaspoons neutral oil
1 tablespoon water
1 teaspoon mentsuyu (p. 14)

Topping B
120 g (4¼ oz) cucumber

Topping C
1 egg
½ teaspoon raw sugar
1 teaspoon oil

Topping D
2 shiitake mushrooms
from mentsuyu shojin (p. 14)
or
2 fresh shiitake mushrooms +
1 teaspoon neutral oil + 1 teaspoon
mirin + 1 teaspoon soy sauce

Topping E
1 scallion, finely chopped

Topping F
20 g (¾ oz) fresh ginger,
peeled and grated

Topping G
5 shiso leaves, minced

Sauce
200 ml (7 fl oz) mentsuyu (p. 14)
200 ml (7 fl oz) water

320 g (11¼ oz) somen noodles

Prepare topping A. Wash the eggplant and slice thinly. Heat the oil in a pan and stir the eggplant slices for one minute over medium heat. Add the water, cover, and cook over medium heat. When the eggplant becomes tender, after 1–2 minutes, add the mentsuyu and sauté for 30 seconds.

Prepare topping B. Wash the cucumber and cut it in half lengthwise. Remove the seeds and cut into thin matchsticks.

Prepare topping C. Beat the egg and sugar together in a bowl with a whisk. Heat the oil in a frying pan and pour in the egg to make a thin omelette, like a crepe. As soon as the surface has dried, turn the omelette over and cook for 10 seconds on the other side. Turn out onto a plate. Cut the omelette into three large strips, layer those, and cut again into very thin strips.

Prepare topping D. Cut the shiitake mushrooms from the mentsuyu shojin into thin strips. Or cut the fresh shiitake mushrooms into thin strips, sauté in the oil for 2 minutes over medium heat, add the mirin and soy sauce, then mix.

Put all the toppings on small separate plates to allow each person to serve themselves as they like. Mix the mentsuyu and water for the sauce and pour into four individual bowls.

Once everything is ready, cook the somen noodles in a large quantity of water following the packet instructions. Drain in a large fine-mesh strainer, rinse thoroughly with cold water to remove the starch that forms a sticky film on the surface of the noodles, and drain well. Place the noodles on a large plate or a zaru (with a plate under it). Enjoy immediately by dipping the noodles in the sauce and accompanying each bite with the different toppings.

TIPS

The cooking time for somen noodles is very short and the noodles must be eaten immediately after cooking to best enjoy their texture. That is why it is preferable to prepare the toppings before cooking the noodles.

—

To drain the somen noodles, avoid traditional Italian pasta strainers because the water containing the starch remains at the bottom (see Utensils, p. 256–57).

VEGAN VERSION

Omit the omelette and use mentsuyu shojin.

Soba salad

WITH PEANUT BUTTER AND CILANTRO

 VEGAN

蕎麦サラダ

Serves 4
Preparation: 10 minutes
Cooking: 5–10 minutes

Sauce

6 tablespoons peanut butter or tahini or other nut butter

4 teaspoons raw sugar

6 tablespoons soy sauce

4 tablespoons extra virgin olive oil

Juice ½ lemon

Toppings

180 g (6¼ oz) Jerusalem artichokes

½ red onion

100 g (3½ oz) button mushrooms

½ cucumber

A few arugula leaves (optional)

A few cilantro leaves

280 g (10 oz) dried soba noodles

Garnish

20 g (¾ oz) chopped mixed walnuts and hazelnuts

1 pinch chile powder

Extra virgin olive oil

Mix all the sauce ingredients in a bowl.

Peel the Jerusalem artichokes and cut into slices that are 3 mm (⅛ inch) thick. Cut the red onion and mushrooms into very thin slices. Remove the seeds from the cucumber and cut into thin matchsticks.

Cook the soba noodles according to the package instructions. Drain into a colander and rinse well by swishing them with your hand under cold running water to remove the starch that forms a sticky film on the surface. Lightly squeeze the noodles with your hand to drain completely.

Divide the noodles, toppings, and sauce into four bowls (reserve some mushrooms, arugula, if using, and cilantro leaves for garnishing). Mix together. Sprinkle with the chopped nuts, chile powder, the reserved mushrooms, arugula, and cilantro. Drizzle with a little olive oil.

粉物

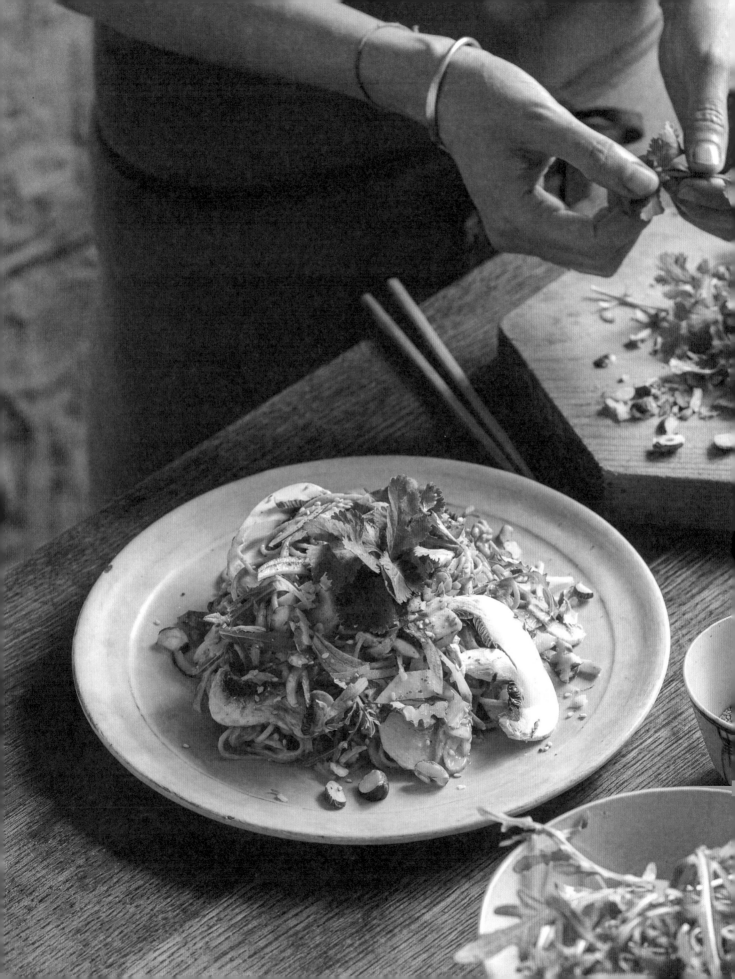

Gyoza dough

手作り餃子の皮

VEGAN

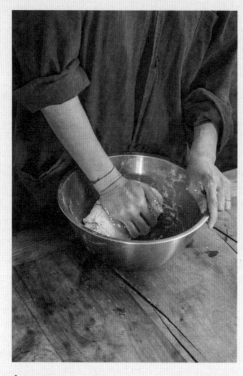

A

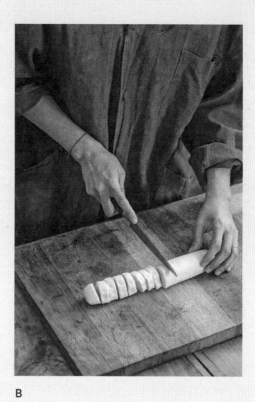

B

Serves 4–6 (40 gyoza)
Preparation: 1 hour
Resting: 30 minutes–1 hour
Cooking: 10 minutes

400 g (2⅔ cups) all-purpose flour
1 teaspoon salt
200 ml (7 fl oz) hot water

Panfried gyoza
Neutral oil
Sesame oil

For working the dough
Potato starch or corn flour

Filling of your choice
to prepare in advance
See p. 40.

Mix the flour and salt in a bowl. Pour in the hot water and mix with chopsticks (or a fork). The dough should have the texture of a crumble topping. Once the dough has cooled slightly, knead by hand until the crumbs can be combined and form a ball **(A)**. Place it on a work surface and knead for 10 minutes, until the dough is completely smooth. Make a ball. Work the folds with your fingers to smooth the ball. Turn the dough upside down with the closed side underneath. Wrap it in a damp tea towel and leave to rest for 30 minutes to 1 hour at room temperature. Divide the ball in half, form each half into a log, then cut each log into 20* small pieces **(B)**. Cover the dough to prevent it from drying.

On a work surface floured with starch, flatten a piece with your hand. Then hold the dough with your left hand and the rolling pin with your right hand. Roll once, turn the dough 90 degrees, roll again, turn the dough 90 degrees again, and so on until you **(C)** form a nice round shape. The center of the round must be thicker (2 mm/1⁄16 inch) than the edges (1 mm/1⁄32 inch). Flour both sides with starch and set aside under a tea towel. Repeat the process with all the pieces of dough.

粉物

FLOUR

STEP-BY-STEP

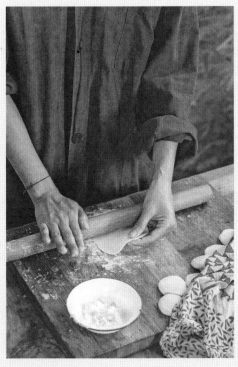

C

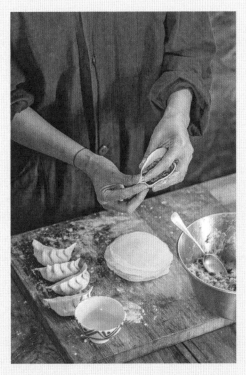

D

Place 1 teaspoon filling in the center of a gyoza wrapper. Wet the edge of the wrapper with your finger. To close the gyoza, fold the wrapper in half over the filling and press the middle of the two edges between your thumb and middle finger. Between the pinched middle and one side, fold to form a pleat **(D)** and continue sealing the dough between your two index fingers, pinching to the corner.

Repeat to seal the other side. You should get five or six pleats. Place the gyoza on a plate and press the gyoza lightly to flatten the bottom. Set aside under a tea towel. Repeat with the remaining wrappers and filling.

Panfried gyoza

Bring 100 ml (3½ fl oz) water to a boil. Using a piece of paper towel, oil a frying pan (with a tight-fitting lid) with 1 tablespoon oil and heat the pan over medium heat. Add the gyoza to the pan, making sure they don't touch (15 gyozas in a 26 cm [10-in] pan and 18 in a 28 cm [11-in] pan), and brown the undersides. Then pour 100 ml (3½ fl oz) boiling water into the pan and cover.

Cook for 7 to 8 minutes over medium-low heat. Bring a medium saucepan of water to a boil and keep simmering. If the water evaporates before the end of cooking, add a little more. Remove the lid and drizzle 1 teaspoon toasted sesame oil over the gyoza and cook for another minute, until the bottom of the gyoza is nicely golden. Repeat with the remaining gyoza.

Boiled gyoza**

Bring a large pot of water to a boil. Drop approximately 20 gyoza into the water. Once the gyoza rise to the surface, leave to cook for 4 to 5 minutes. Drain. Repeat for the remaining 20 gyoza.

Whichever cooking method you choose, serve the gyoza immediately.

** For the photo, I cut the dough into 16 pieces to clearly illustrate the process but the gyoza must be a little smaller.*

*** Make sure the gyoza are tightly sealed, otherwise they will break apart in the water.*

Gyoza fillings

餃子のタネ

Pork filling 豚肉餃子

Makes 40 gyoza.
Preparation: 30 minutes
Soaking: 3 hours

7 g (¼ oz) dried shiitake mushrooms
300 ml (10 fl oz) water
150 g (5¼ oz) pointed cabbage or wombok (Chinese cabbage)
½ teaspoon salt
300 g (10½ oz) minced pork shoulder
1 garlic clove, grated
5 g (⅛ oz) fresh ginger, peeled and finely chopped
½ small onion, finely chopped
1 tablespoon soy sauce
½ tablespoon oyster sauce
1 teaspoon toasted sesame oil
Pepper

Rehydrate the dried shiitake mushrooms by soaking in the water for 3 hours. Drain, remove the stems, and finely chop the mushrooms. Finely chop the cabbage, season with the salt, mix, and leave for 20 minutes to drain, then squeeze with your hands to remove excess water. In a large bowl, mix the pork with the garlic and ginger until it becomes pasty. Mix in the cabbage, shiitake mushrooms, and onion, then add the soy sauce, oyster sauce, and sesame oil. Season with pepper. Mix well and set aside in the refrigerator.

TIPS

If you do not make homemade dough, make sure you buy gyoza wrappers (round and white), not wonton wrappers (square and often yellow).

Ra-yu (p. 139) makes a great dipping sauce for gyoza.

Vegetable filling 野菜餃子 ✺ VEGAN

Makes 40 gyoza.
Preparation: 20 minutes
Soaking: 3 hours
Cooking: 10 minutes

7 g (¼ oz) dried shiitake mushrooms
300 ml (10 fl oz) water
1 large zucchini
1 tablespoon salt
1 carrot
150 g (5¼ oz) white cabbage, curly kale, or napa cabbage
250 g (8¾ oz) firm tofu
1 tablespoon neutral oil
1 shallot, chopped
1 garlic clove, chopped
5 g (⅛ oz) fresh ginger, peeled and finely chopped
1½ tablespoons soy sauce
2 tablespoons malted or nutritional yeast
1 teaspoon raw sugar
1 teaspoon toasted sesame oil
2 teaspoons potato starch or corn flour

Rehydrate the dried shiitake mushrooms by soaking in the water for 3 hours. Drain, remove the stems, and finely chop the mushroom caps. Coarsely grate the zucchini using a box grater, season with the salt, and leave for 15 minutes to drain, then squeeze out the excess water. Squeeze out the excess liquid in the tofu, then mash the tofu roughly with a fork or your hands. Coarsely grate the carrot using a box grater. In a large pot of boiling water, blanch the cabbage leaves for 1 to 2 minutes, remove and squeeze out the excess water, then chop. Heat the neutral oil, shallot, garlic, and ginger in a frying pan over medium-high heat. When the aromas start to release, add the zucchini and carrot. Sauté for 2 to 3 minutes, until the carrot is cooked. Add the cabbage and shiitake mushrooms and sauté for 2 minutes. Add the tofu and sauté for 1 minute. Add the soy sauce, yeast, sugar, sesame oil, and starch. Mix and allow to cool completely.

粉物

FLOUR

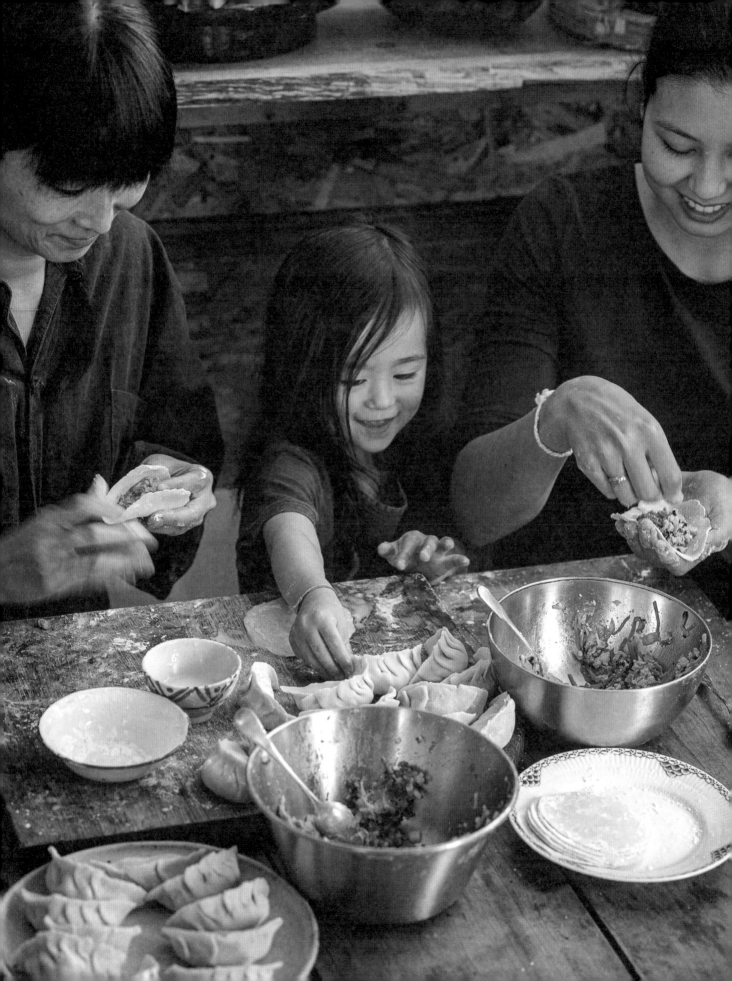

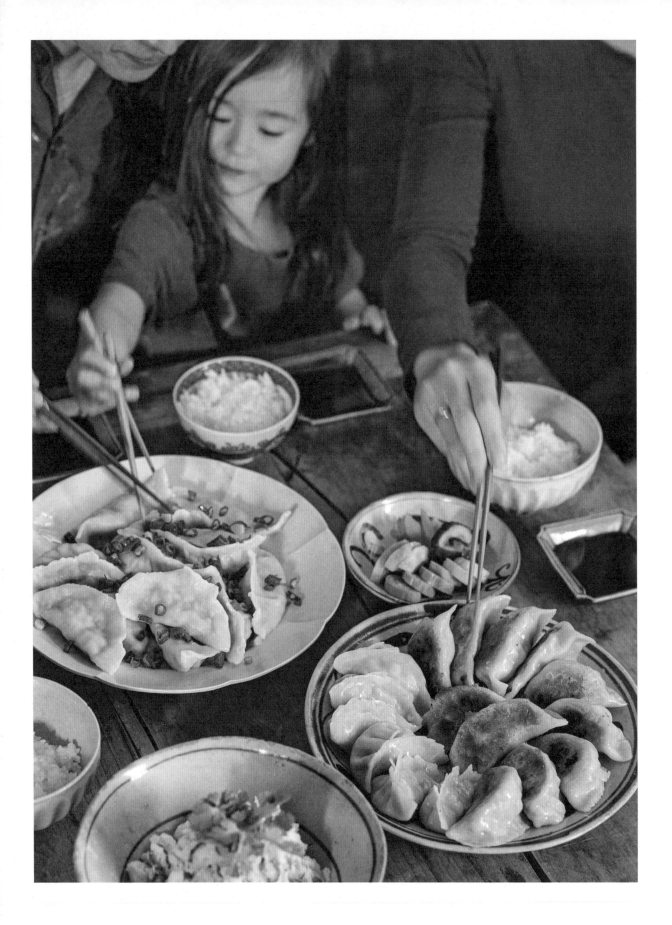

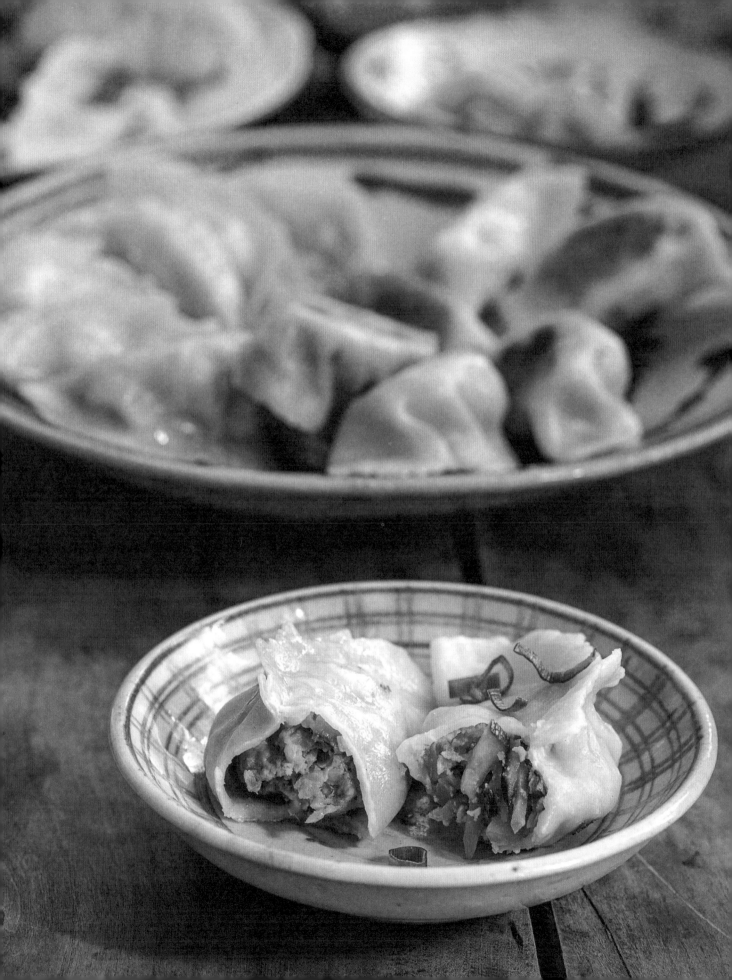

Okonomiyaki

(JAPANESE PANCAKE)

お好み焼き

Serves 4
Preparation: 15 minutes
Cooking: 10 minutes per okonomiyaki

200 g (7 oz) cabbage
2 scallions
100 g (3½ oz) peeled prawns
100 g (3½ oz) yam or potato
16 oysters
200 ml (7 fl oz) water
2 eggs
200 g (1⅓ cups) all-purpose flour
½ teaspoon salt
1 handful katsuobushi (dried bonito flakes)
4 tablespoons sunflower oil

Garnish

Okonomiyaki sauce or tonkatsu sauce*
Mayonnaise or soy mayonnaise (p. 139)
4 generous pinches katsuobushi (dried bonito flakes)
A few dill leaves (optional)

Cut the cabbage into thin strips, scallions into thin rounds, and prawns in half lengthwise. Grate the yam. Open the oysters and remove them from their shells.

In a bowl, mix the grated yam, water, and eggs. Add the flour and salt and mix. Stir in the cabbage, scallions, and katsuobushi (crumbled between your fingers). Add the prawns and oysters, then mix.

Heat a frying pan over medium heat. Pour in 1 tablespoon oil and wipe the excess with a paper towel. Pour a quarter of the batter into the hot frying pan. Cook for about 3 minutes. Turn the okonomiyaki over, cover, and cook for 5 minutes. Flip the okonomiyaki back and cook for another 2 to 3 minutes, uncovered, until the bottom is a light golden brown. Remove from the pan and keep warm. Repeat the process until all the batter is used. This will make 4 okonomiyaki.

Serve the okonomiyaki on individual plates with a generous amount of sauce spread on top and drizzled with the mayonnaise. Sprinkle with some katsuobushi and decorate with a few dill leaves.

* TO REPLACE THE OKONOMIYAKI (OR TONKASTU) SAUCE

In a small saucepan, mix 4 tablespoons Worcestershire sauce, 2 tablespoons ketchup, 1 tablespoon mirin, and ½ teaspoon soy sauce. Heat over low heat, stirring until the sauce thickens.

VEGAN VERSION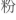

Replace the seafood with 150 g (5½ oz) mushrooms (oyster, shiitake, etc.) sautéed in 1 tablespoon oil and seasoned with ½ teaspoon salt and 1 tablespoon malted or nutritional yeast. Add an additional 100 g (3½ oz) yam (or potato).

Have fun experimenting by addding ingredients of your choice to okonomiyaki. In Japanese, okonomi means "as you like" and yaki means "grilled." Restaurants offer a wide choice of toppings. Feel free to invent your own version of this recipe!

粉物

FLOUR

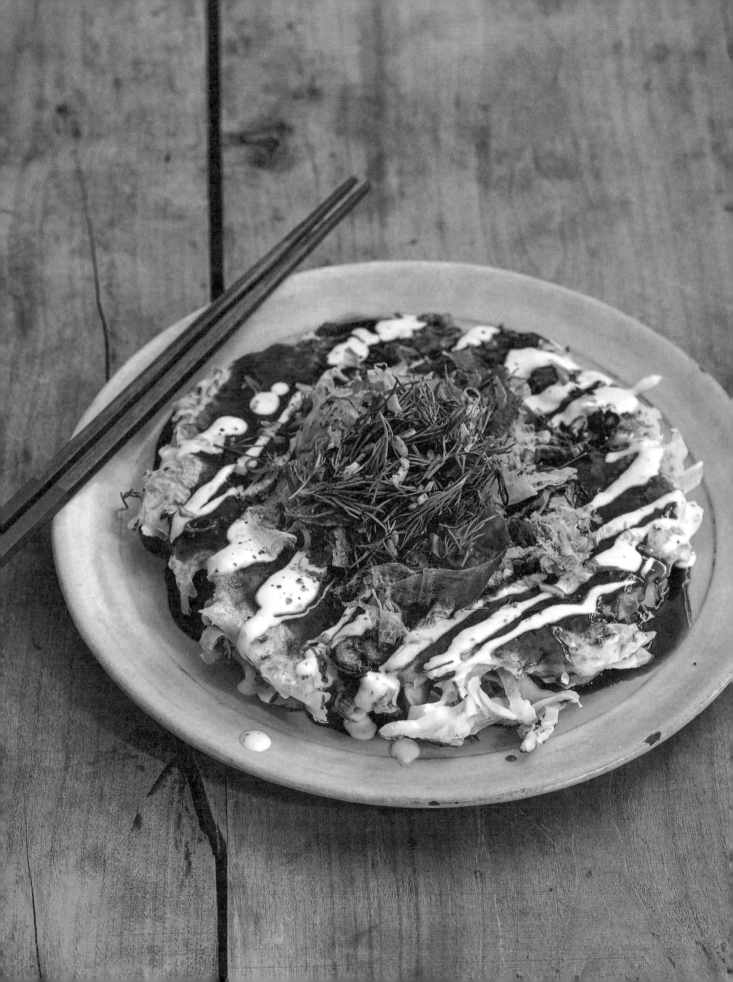

Oyaki
(GRILLED VEGETABLE DUMPLINGS)

おやき

✱ VEGAN

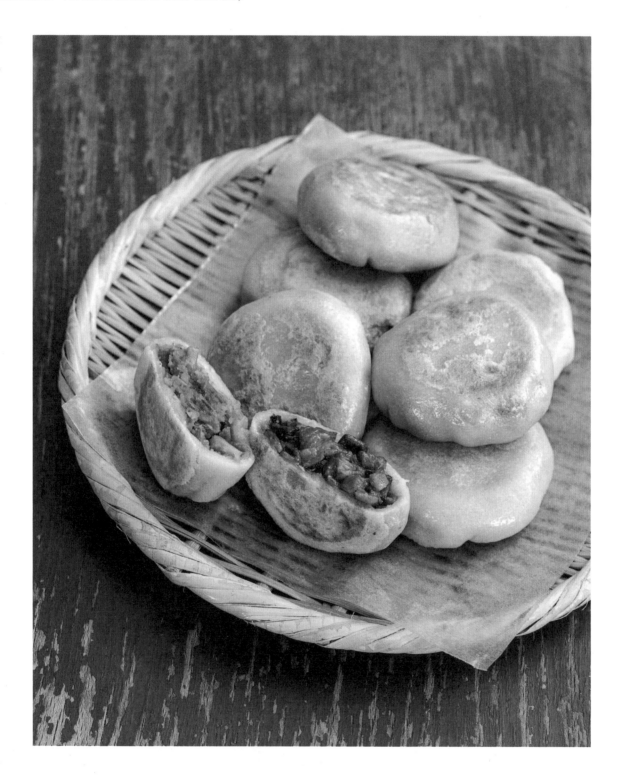

粉物

FLOUR

Makes 8 dumplings
Preparation: 30 minutes
Resting: 1 hour
Cooking: 20 minutes

Dough

190 g (6¾ oz) all-purpose flour

10 g (¼ oz) potato starch

140 ml (4¾ fl oz) boiling water

Pumpkin filling (for 4 dumplings)

200 g (7 oz) kabocha or red kuri squash

1 teaspoon potato starch (for red kuri squash only)

½ tablespoon soy sauce

1½ teaspoons raw sugar

1 pinch salt

15 g (½ oz) walnuts, roughly chopped

Eggplant and miso filling (for 4 dumplings)

1 tablespoon brown miso

1 tablespoon sake

2 teaspoons soy sauce

1 tablespoon mirin

1 teaspoon raw sugar

½ eggplant

2 fresh shiitake mushrooms

1½ tablespoons neutral oil

Shaping and cooking

Potato starch

Neutral oil

100 ml (3½ fl oz) water

Prepare the dough. Combine the flour and starch in a bowl. Pour in the boiling water and mix with a spatula. Once the dough has cooled slightly, knead by hand, first in the bowl and then on a work surface sprinkled with a little potato starch if the dough is too sticky. Once the dough is smooth, form a ball, wrap in a damp tea towel, and leave to rest for 1 hour at room temperature.

Prepare the pumpkin filling. Peel the squash and chop into large pieces. Steam until tender. Drain and place in a bowl. Using a masher, mash the squash. If you used red kuri squash, mash it together with the potato starch. Add the soy sauce, sugar, and salt and mix. Stir in the walnuts. Form four balls of filling and set aside in the refrigerator.

Prepare the eggplant and miso filling. Make the seasoning by mixing the miso, sake, soy sauce, mirin, and sugar in a bowl. Wash the eggplant. Cut the eggplant and shiitake into 1-cm (½-inch) cubes. Heat the oil in a frying pan and sauté the eggplant and shiitake over medium heat. When the eggplant is tender, add the seasoning and sauté for 4 to 5 minutes until the liquid has evaporated. Leave to cool.

Make the oyaki. Lightly flour your work surface with starch. Form the dough into a log and cut it into eight equal portions. Using a rolling pin, roll out each portion to form a round that is 10 cm (4 inches) in diameter, making sure that the edges are thinner than the center. Put 1 tablespoon eggplant filling or 1 tablespoon pumpkin filling in the center of each round and close by pinching the dough at the top to form a ball. Place each oyaki closed side underneath and flatten slightly.

Heat two teaspoons of oil in a frying pan over medium heat and wipe the excess with a paper towel. Brown the oyaki on both sides, then pour in the water and cover. Cook for 8 minutes over medium-low heat. If the water evaporates before the end of cooking, add a little more. Serve hot.

TIPS

Cooked oyaki freeze very well. To serve from frozen, reheat for 5 to 6 minutes in a steamer basket or 5 to 6 minutes covered with 50 ml (1¾ fl oz) water in a lightly oiled frying pan.

—

Kabocha is a Japanese variety of pumpkin, which is sweeter and contains less water than red kuri squash.

Nikuman and yasaiman
(PORK BUNS AND VEGETABLE BUNS)

 VEGAN

肉まん / 野菜まん

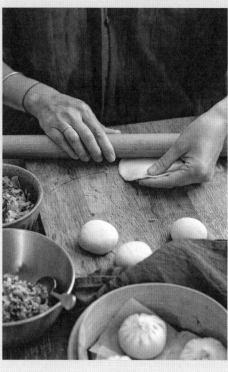

A

B

Makes 8 buns
Preparation: 30 minutes
Resting: 1½–2½ hours
Cooking: 17 minutes

Dough

200 g (1⅓ cups) all-purpose flour

1 pinch salt

2.5 g (1/16 oz) baking powder

65 ml (¼ cup) water at 25–40°C (77–104°F)

50 ml (1¾ fl oz) soy milk

45 g (1½ oz) light brown sugar

5 g (⅛ oz) dry yeast

1 tablespoon neutral oil, plus extra for greasing

Potato starch or corn starch

Filling of your choice to prepare in advance
See p. 50.

Prepare the dough. Put the flour, salt, and baking powder in a bowl. In another bowl, combine the water and soy milk, sugar, dry yeast, and oil. Gradually add the liquid mixture to the dry mixture, mixing well, first with chopsticks then using your hand. Knead for 10 minutes on a work surface until you get a smooth dough. Form a ball, place it in a bowl, and lightly oil the surface of the dough. Cover with a damp tea towel. Leave to rest for 1 to 2 hours in a warm spot (25–30°C/77–86°F), until the dough has doubled in volume.

Shape the buns. Cut the dough into eight equal parts. Shape each piece of dough into eight round balls. Cover with a damp tea towel and let stand for 15 minutes at room temperature. Then flatten each ball with your hand. Lightly flour the work surface with starch. Using a rolling pin, roll out each ball to form a round that is 10 cm (4 inches) in diameter, making sure that the edges are thinner than the middle **(A)**. Fill each round with about 1 heaped tablespoon of filling **(B)**.

粉物

FLOUR

STEP-BY-STEP

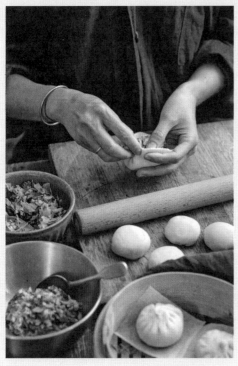

C

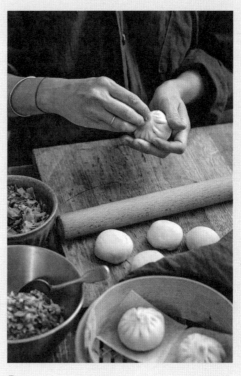

D

To close the bun, pinch 2 cm (¾ inch) of the edge of the dough between your fingers **(C)**, then the next 2 cm (¾ inch) against the first to form pleats. Continue until the dough is completely closed over the filling. Once the bun is closed, pinch the remaining dough at the top and twist into a spiral shape **(D)**.

Place the buns on a piece of parchment paper in a steamer basket. Cover and leave to rest for 15 minutes. Steam for 17 minutes over medium-high heat. Serve hot with Japanese mustard and a soy sauce and rice vinegar dipping sauce (3 tablespoons soy sauce, 1 tablespoon rice vinegar).

These buns are originally from China. My father used to prepare them on the weekend and the smell of steamed buns coming from the kitchen always made my mouth water. Unlike many men of his generation, who never set foot in a kitchen, my father loved cooking, especially exotic dishes. He introduced me to many foreign flavors when I was young.

These buns became popular as a hot winter snack in Japan with the rise of konbini (24-hour convenience stores). But there's nothing like homemade buns!

Bun fillings

肉まん / 野菜まん

Pork filling

Makes 8 buns
Preparation: 10 minutes
Soaking: 3 hours

5 g (⅛ oz) dried shiitake mushrooms
200 ml (7 fl oz) water
200 g (7 oz) minced pork belly
1 leek, finely sliced
5 g (⅛ oz) fresh ginger, peeled and finely chopped
½ garlic clove, chopped
2 tablespoons soy sauce
1 teaspoon raw sugar
1 teaspoon soy sauce
1 teaspoon toasted sesame oil
Pepper

Rehydrate the dried shiitake mushrooms by soaking in the water for 3 hours. Drain and chop finely.

Place the mushrooms in a bowl and add the remaining ingredients. Mix thoroughly by hand until you get a nice sticky texture. Set aside in the refrigerator.

Vegetable filling VEGAN

Makes 8 buns
Preparation: 20 minutes
Soaking: 3 hours
Cooking: 5 minutes

10 g (¼ oz) dried shiitake mushrooms
100 ml (3½ fl oz) water
50 g (1¾ oz) bean vermicelli noodles
1 tablespoon neutral vegetable oil
1 cm (½ inch) fresh ginger, peeled and finely chopped
1 shallot, finely chopped
2 fresh shiitake mushrooms, chopped
50 g (1¾ oz) spinach leaves, minced
2–3 leaves of pointed cabbage (100 g/3½ oz), chopped
1 tablespoon malted or nutritional yeast
1 teaspoon soy sauce
1 pinch salt
2 pinches sugar
1 teaspoon toasted sesame oil
2 teaspoons potato starch or corn flour

Rehydrate the dried shiitake mushrooms by soaking in 100 ml (3½ fl oz) water for 3 hours. Drain (but keep the soaking liquid) and finely chop. Cook the bean vermicelli according to the packet instructions, drain, and roughly chop.

In a frying pan, heat the oil, ginger, and shallot over medium heat. Add the shiitake mushrooms, fresh and rehydrated, and stir for 1 minute. Add the spinach leaves and cabbage. Sauté for 2 to 3 minutes, until the vegetables are tender. Add the vermicelli, yeast, soy sauce, salt, sugar, and sesame oil. Allow the liquid to evaporate while stirring. In a bowl, dissolve the starch into the shiitake soaking liquid and pour into the pan. Stir for 30 seconds and remove from the heat. Allow to cool completely and set aside in the refrigerator.

粉物

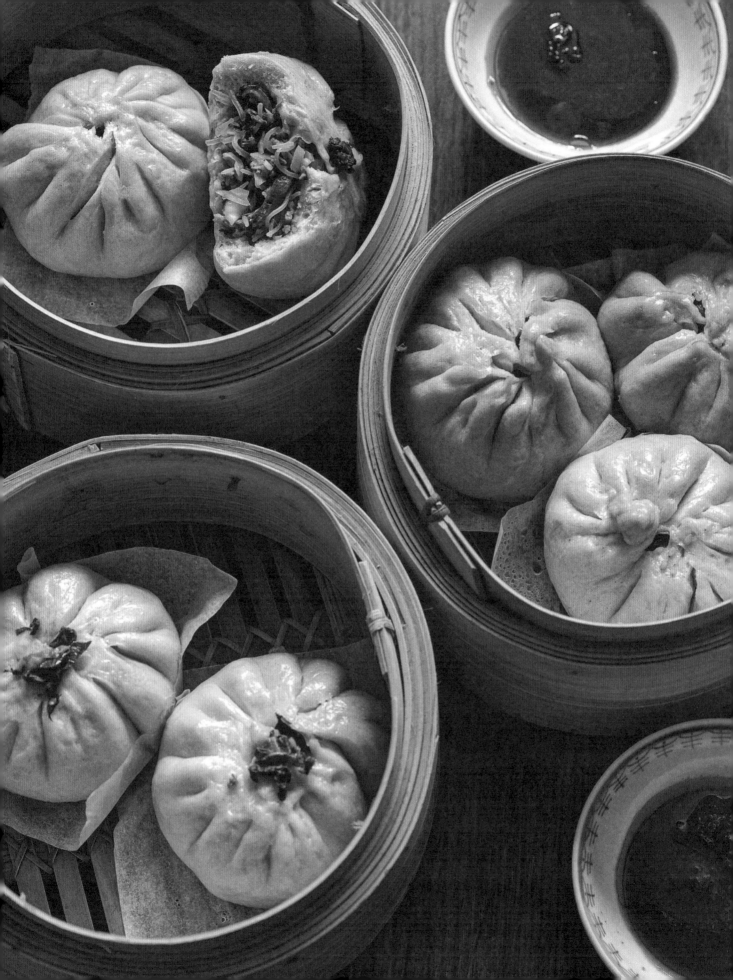

釜浅 商店
KAMA-ASA
DEPUIS 1908

KAMA-ASA

釜浅商店

FEATURE

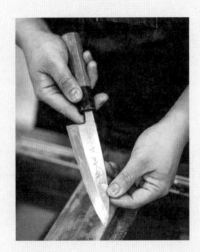

To write my previous book, *Tokyo Cult Recipes*, I went to Japan. While I was there, I visited the famous Tsukiji market and decided to walk to Kappabashi, the cooking and utensils district.

The streets are full of shops related to the world of cooking: packaging, food replicas, utensils, crockery . . . I could wander around there all day!

Walking into one shop, I was amazed by the beauty, elegance, and quality of the utensils, as well as by the expertise of the shop assistants. They were true professionals, who knew their products inside out.

This shop was called KAMA-ASA. A few years later, I found out that a KAMA-ASA shop had opened in Paris. The Parisian boutique is tiny, but it is a treasure box. You are in safe hands with the two shop assistants, who are passionate about the quality of their products. Hand-hammered pans, Nambu cast-iron dishes, a beautiful kama (Japanese cauldron), knives of all shapes and materials, suitable for every use imaginable. This is the place of my dreams! When you buy a product here, your KAMA-ASA story is just beginning. The professionals will explain how to use the utensils properly and how to maintain them for many years. Their mission is to ensure you enjoy the best cooking experience using real Japanese utensils made with great precision and care. The boutique stocks a child's knife called "My First Knife." It is a knife that will take on a nice knife shape after several years of sharpening, once the child becomes an adult. This knife symbolizes KAMA-ASA's vision of the relationship between their utensils and their customers. I am delighted to be able to experience the true spirit of Japanese craftsmanship in Paris.

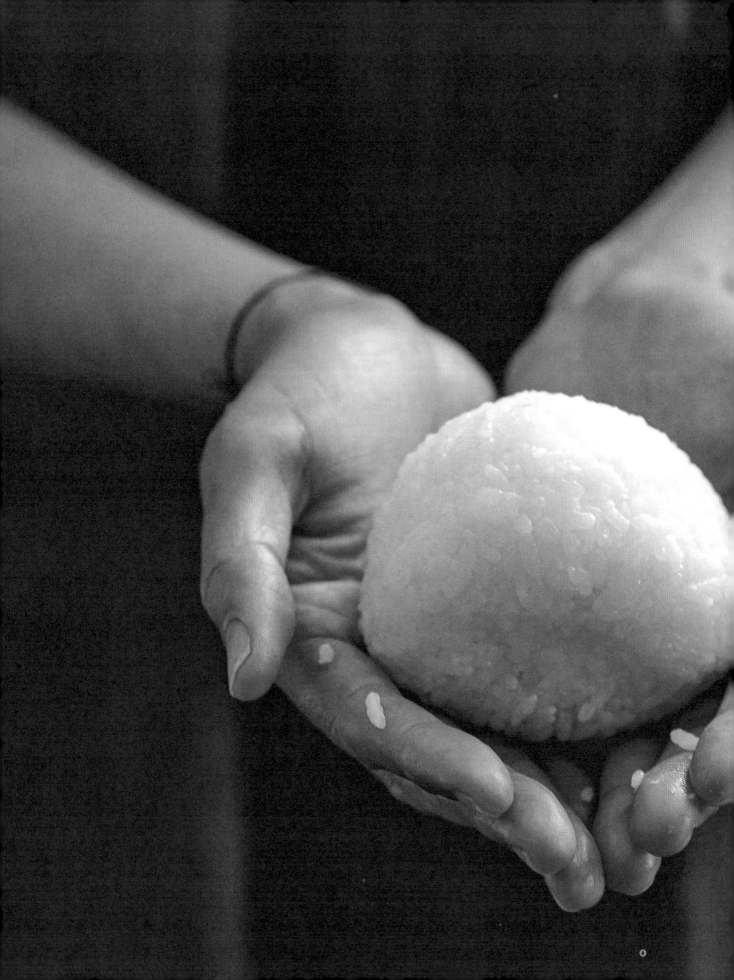

米

RICE

Cooking rice

 VEGAN

White rice in a saucepan 白米の炊き方

Serves 4
Preparation: 5 minutes
Resting: 40 minutes
Cooking: 13 minutes

400 ml (13½ fl oz)* short-grain white rice
480 ml (16 fl oz) filtered water

Based on the graduations of your measuring cup.

Put the rice in a large bowl. Pour a large quantity of tap water into the bowl and mix using your hand. Drain immediately with a colander and discard the water. Return the rice to the bowl. Cup your hand into a ladle shape, like holding a tennis ball. Dip your fingers in the rice grains and move your hand in a wide circular motion about 20 times. Pour water into the bowl; it will turn white. Discard immediately and repeat the movement with your hand 20 times. Repeat this process 4 times in total, until the water is more or less clear. Drain well.

Pour the rice and filtered water into a heavy saucepan. Cover and soak for 30 minutes, then heat over medium heat until boiling. Reduce the heat to the lowest setting and cook for 12 to 13 minutes. Remove from the heat and let stand for 10 minutes. Fluff the rice quickly with a spatula and cover again until it is ready to be used.

TIPS

To cook using a rice cooker, use the measuring cup supplied with the cooker (usually 180 ml/ ¾ cup) and follow the level indicated for the quantity of water.

—

Soaking the rice in filtered water for 30 minutes before cooking is not essential, but allows the grains to absorb water and they taste better.

Brown rice in a pressure cooker 玄米の炊き方

Serves 4
Preparation: 5 minutes
Resting: 2¼–12 hours
Cooking: 35 minutes

400 ml (13½ fl oz)* short-grain brown rice
1 liter (4¼ cups) filtered water (soaking)
480 ml (16 fl oz) filtered water (cooking)
½ teaspoon salt

Based on the graduations of your measuring cup.

Put the rice in a large bowl. Pour in a large quantity of tap water and mix using your hand. Drain immediately using a colander and discard the water. Return the rice to the bowl. Dip your hands in the bowl and rub the rice grains between your hands, taking care not to break the grains. Pour water into the bowl, mix, drain, and return the rice to the bowl. Repeat this process a total of 3 times. This will slightly break down the outer layer of the rice so that the grains absorb the water well. Cover the rice with twice its volume of filtered water and leave to soak for at least 2 hours (12 hours ideally). Drain well.

Pour the 480 ml (16 fl oz) filtered water, rice, and salt into a pressure cooker. Heat over medium heat. When it starts to whistle, cover, and cook over low heat for 25 minutes. Remove from the heat and let stand for 15 minutes. Fluff the rice quickly with a spatula and cover until it is ready to be used.

TIPS

When cooking in a saucepan, pour in the rice, salt, and 540 ml (18½ fl oz) filtered water. Bring to a boil, then reduce the heat and cook over a low heat for 35 minutes. Remove from the heat and let stand for 15 minutes.

—

The salt helps remove the bitterness from the brown rice.

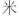

TECHNIQUE

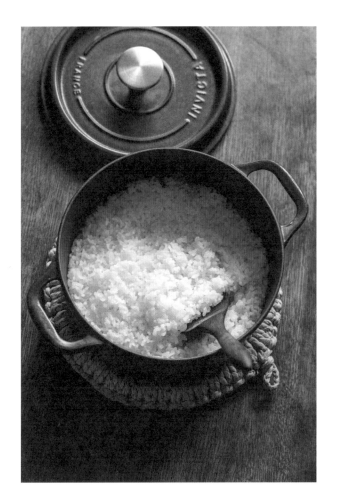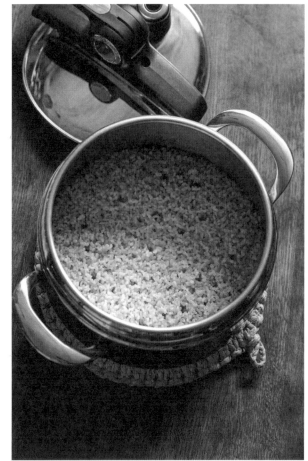

Sushi rice

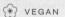 VEGAN

お米の炊き方

Serves 4
Preparation: 5 minutes
Resting: 40 minutes
Cooking: 13 minutes

400 ml (13½ fl oz)* short-grain white rice
410 ml (14 fl oz) filtered water
1 tablespoon sake
5 g (⅛ oz) dried kombu

Sushi vinegar
120 ml (½ cup) rice vinegar
1 tablespoon granulated sugar
2 teaspoons salt

*Based on the graduations of your measuring cup.

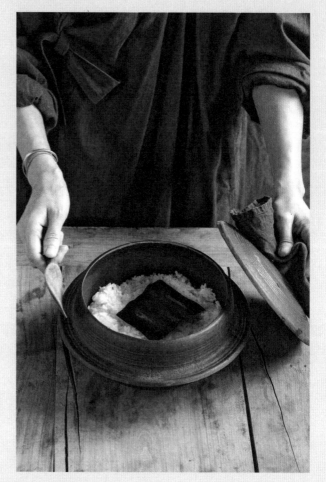

A

Wash the rice and cook (see cooking rice p. 56), adding the sake to the water and placing the slice of kombu on top **(A)**.

In a small bowl, mix the sushi vinegar ingredients together well to dissolve the salt and sugar completely.

米

RICE

STEP-BY-STEP

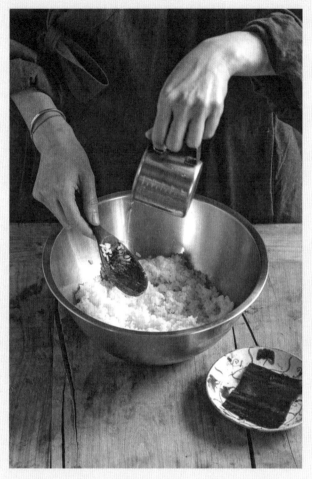

B

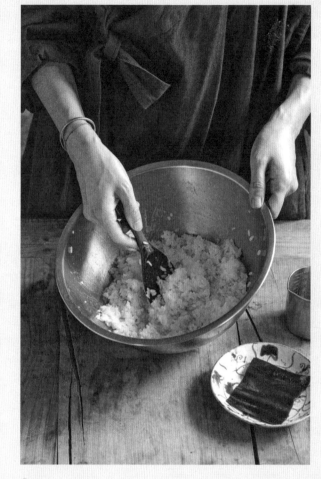

C

After the rice is cooked and has stood for 10 minutes, immediately place it in a large bowl. Sprinkle the vinegar over it in three pours, so that the vinegar covers the whole surface of the rice **(B)**.

With each pour, use a spatula to "cut" the rice on an angle **(C)**, cooling the rice with a fan at the same time. Be careful not to crush the grains of rice. Cover with a damp tea towel. Set aside at room temperature.

TIP

Never put sushi rice in the refrigerator as this completely changes its texture.

Temari-zushi

手まり寿司

Serves 4
(28 pieces, choice of toppings)

1 recipe sushi rice (p. 58)

Purple radish (makes 4 pieces) VEGAN

12 very thin slices purple radish
½ teaspoon salt
½ teaspoon sugar
1 umeboshi, pitted and quartered (optional)
1 pinch peeled fresh ginger, cut into thin matchsticks

Sprinkle the radish slices with the salt and sugar and leave to drain for 15 minutes. Squeeze between your hands to remove excess water. To assemble (see opposite), overlap three slices in the middle of the cloth. Place 1 piece of umeboshi, if using, then 1 ball of rice on top, and form the temari-zushi. Sprinkle with a little ginger.

Sautéed shiitake (makes 4 pieces) VEGAN

1 tablespoon neutral oil
4 fresh shiitake mushrooms, halved
2 tablespoons sake or dashi water
½ teaspoon soy sauce
Juice ⅛ lemon
Sesame seeds

Heat the oil in a frying pan and cook the shiitake mushrooms for 1 to 2 minutes over medium-low heat, turning regularly. Add the sake, cover, and cook over low heat. After the liquid has evaporated, sprinkle with the soy sauce and turn off the heat. Sprinkle with the lemon juice and allow to cool. To assemble (see opposite), overlap 2 pieces of shiitake mushroom in the middle of the cloth. Place 1 ball of rice on top and form the temari-zushi. Sprinkle with sesame seeds.

Amani shiitake (makes 4 pieces) VEGAN

4 dried shiitake mushrooms
250 ml (1 cup) water
1 tablespoon soy sauce
1 tablespoon mirin
½ tablespoon sugar
Yuzu zest or other citrus fruit, cut into thin strips

In a small saucepan, rehydrate the dried shiitake mushrooms by soaking in the water for 3 hours. Squeeze them over the saucepan to retain the soaking liquid. Remove the stems and return the caps to the saucepan. Add the soy sauce, mirin, and sugar, cover, and leave to simmer for 15 minutes over medium heat. Remove the lid and allow the liquid to evaporate until it just covers the bottom of the pan. Turn off the heat and let cool. Squeeze the shiitake mushrooms over the pan (the liquid is excellent for sprinkling over cooked rice). To assemble (see opposite), place 1 shiitake mushroom in the middle of the cloth. Place 1 ball of rice on top and form the temari-zushi. Top with a little zest.

Sardine (makes 4 pieces)

2 sardines, cut into 4 fillets (step-by-step p. 178, or by a fishmonger)
1 pinch salt
½ teaspoon grated fresh ginger

Sprinkle the sardines with salt and leave to rest for 15 minutes in the refrigerator. Pat the surface gently with a paper towel. Cut each fillet in half. To assemble (see opposite), place 2 pieces of sardine, back down and slightly overlapping, in the middle of the cloth. Place 1 ball of rice on top and form the temari-zushi. Top with a little ginger.

RICE

Sea bream (makes 4 pieces)

80 g (2¾ oz) wild sea bream fillet, boneless

1 pinch salt

1 sprig chives, finely chopped

Wasabi (optional)

Cut the sea bream into 8 slices, sprinkle with salt, and leave to rest for 10 minutes in the refrigerator. Pat the surface gently with a paper towel. To assemble (see below), place 2 pieces of sea bream slightly overlapping in the middle of the cloth. Place 1 ball of rice on top and form the temari-zushi. Sprinkle with a little chopped chives.

Marinated bell pepper (makes 8 pieces) VEGAN

1 small yellow bell pepper

2 teaspoons soy sauce

1 tablespoon rice vinegar

1 teaspoon raw sugar

1 pinch salt

1 tablespoon olive oil

1 sprig chives, chopped, or a little cucumber skin in thin strips

In an oven preheated to 250°C (500°F), place the bell pepper on a baking tray and cook for 15 to 20 minutes on each side, until the skin is blackened. Put it in a covered bowl or bag for 5 minutes. Remove the skin and seeds. Mix the soy sauce, rice vinegar, sugar, salt, and olive oil in a container. Add the pepper and marinate for 30 minutes in the refrigerator. Then cut each piece in half lengthwise. To assemble (see opposite), place 2 pieces of pepper, slightly overlapping, in the middle of the cloth. Place 1 ball of rice on top and form the temari-zushi. Sprinkle with a little chopped chives.

Kale (makes 4 pieces) VEGAN

4 baby kale leaves

Salt

½ teaspoon soy sauce

1 umeboshi, pitted and quartered (optional)

A few dill leaves

Blanch the kale leaves in a pan of boiling salted water for 1 minute. Drain by squeezing between your hands. Sprinkle with the soy sauce. To assemble (see below), spread 1 kale leaf in the middle of the cloth. Place 1 piece of umeboshi, if using, in the middle, then 1 ball of rice on top and form the temari-zushi. Sprinkle with a little dill.

Kinpira burdock (makes 4 pieces) VEGAN

¼ recipe Burdock and shiitake mushroom kinpira (p. 127)

Chile powder

To assemble (see below), put a quarter of the kinpira in the middle of the cloth. Place 1 ball of rice on top and form the temari-zushi. Sprinkle with a little chile powder.

Assembly

Wet your hands thoroughly under running water and pat on a clean tea towel. Your hands need to be quite moist but not dripping wet. Shape the sushi rice into 28 equal-sized balls. Take 1 heaping tablespoon of rice and form a ball the size of a Ping-Pong ball, taking care not to squash the rice too much. At this stage, the balls do not need to be perfectly round.

Wet a square of muslin or fine cloth and wring out well. Place 1 portion of the topping on the cloth, then 1 ball of rice. Close the cloth by twisting it into a tightly closed ball. Rinse and wring out the cloth after every two or three temari-zushis.

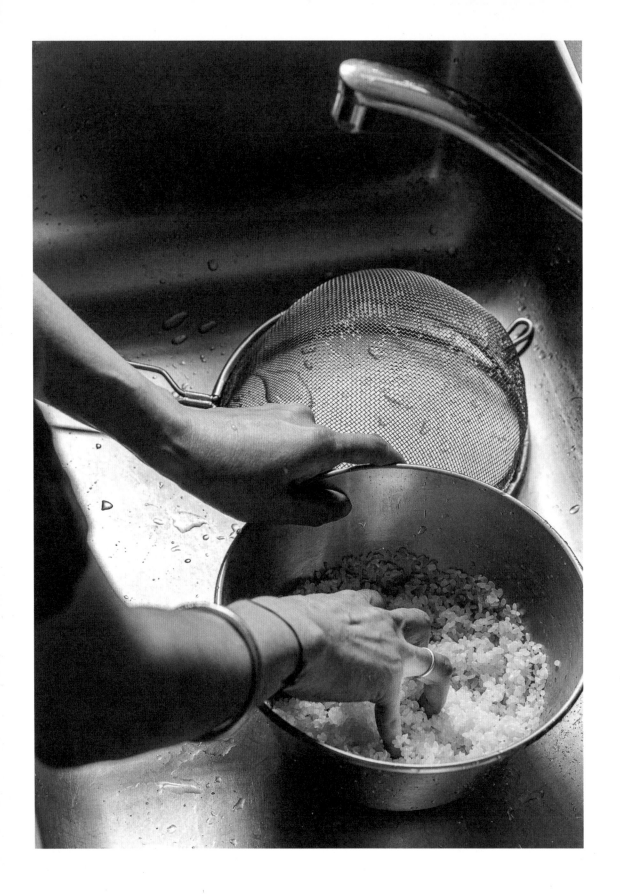

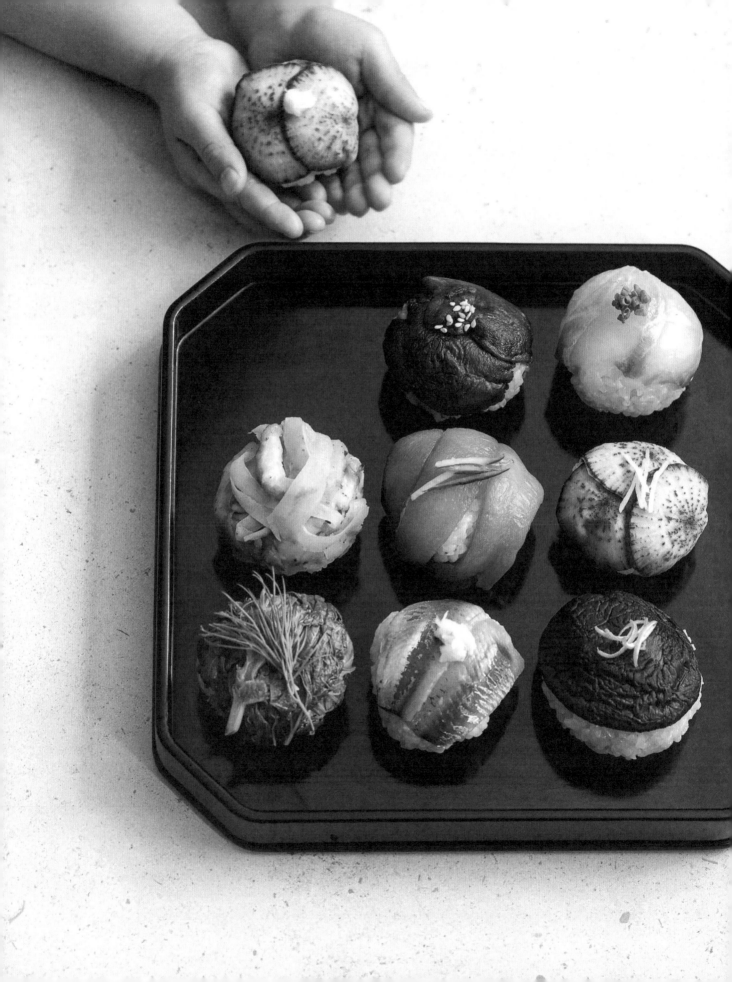

Chirashi-zushi

ちらし寿司

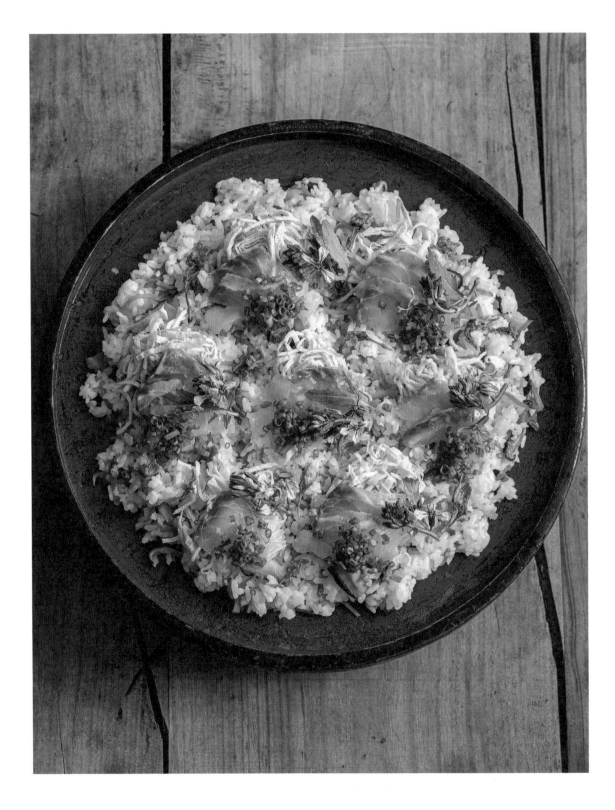

米
RICE

Serves 4
Preparation: 45 minutes
Soaking: 2 hours
Resting time: 30 minutes–1 hour
Cooking: 10 minutes

Amani shiitake

10 g (¼ oz) dried shiitake mushrooms

200 ml (7 fl oz) water

1 small carrot

1 teaspoon sunflower oil

1 tablespoon soy sauce

1 tablespoon mirin

1 tablespoon raw sugar

1 teaspoon rice vinegar

Thin omelette

2 eggs

1 teaspoon raw sugar

1 pinch salt

1 teaspoon neutral oil

Sea bream

300 g (10½ oz) wild sea bream fillets, skinless and boneless

2 pinches salt

Cooked sushi rice for 4 people (p. 58)

Garnish

150 g (5¼ oz) salmon roe from a jar (optional)

A few chives, finely chopped

A few rocket leaves and flowers

A few cherry blossoms (p. 116), washed and gently dried

Soy sauce

Amani shiitake

Rehydrate the shiitake mushrooms by soaking in the water for at least 2 hours. Drain, keeping the soaking liquid. Measure out 100 ml (3½ fl oz) of the liquid and reserve. Save any remaining liquid for another use (see Tip, below). Peel the carrot, cut into 2-cm (¾-inch) sections, then into matchsticks. Remove the hard part of the shiitake stems and slice the caps into 3-mm (⅛-inch) strips. Heat the oil in a saucepan and sauté the carrot and shiitake for 1 minute. Add the reserved soaking liquid, soy sauce, mirin, sugar, and rice vinegar. Leave to simmer uncovered over medium heat, stirring occasionally, until the liquid has almost completely evaporated (a small amount of liquid should be left in the bottom of the pan). Remove from the heat and allow to cool.

Thin omelette

Break the eggs into a bowl and add the sugar and salt. Oil a frying pan using a piece of paper towel. When the pan is hot, pour in a thin layer of egg, as for a crepe, and cook over medium heat. Be careful not to overcook the omelette, it will cook quickly and it should remain yellow. Once cooked, turn the omelette over and cook the other side for 1 second. Place on a plate immediately.

Repeat the process until all the eggs are used. This makes two to three thin omelettes. Stack the omelettes and cut them into three wide strips and then into very thin strips.

Sea bream

Sprinkle each side of the sea bream fillets with salt. Leave to rest for 30 minutes to 1 hour in the refrigerator. Wipe the surface with paper towels. Cut the fillets in half lengthwise, then into sashimi slices. Wrap in plastic wrap and set aside in the refrigerator.

Assembly

Prepare the sushi rice. Before it has completely cooled, gently fold in the amani shiitake filling with a spatula, being careful not to crush the grains. Place the rice in a large dish and sprinkle with the omelettes, sea bream, and garnishes. Serve this as a shared dish with a little soy sauce.

TIPS

If you use a wooden spatula to mix the rice, wet it first to prevent the grains from sticking to the spatula.

—

Keep the remaining soaking liquid from the shiitake mushrooms for another dish (e.g., broth). It is rich in umami!

Futomaki

VEGAN

太巻き（鯛／精進）

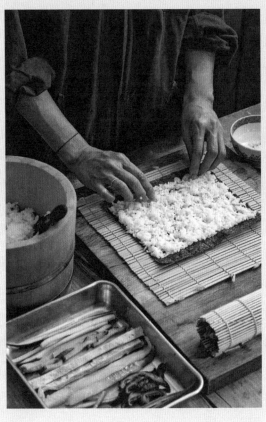

A

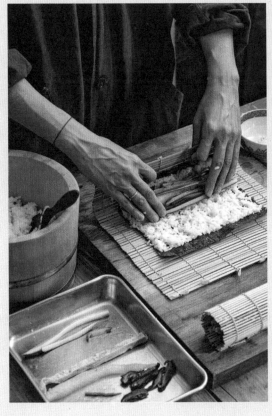

B

Serves 4
Preparation: 20 minutes

Rice vinegar
4 nori sheets
Cooked sushi rice for 4 people
(p. 58)

Filling of your choice to prepare in advance
See p. 68.

Prepare a bowl of water with a little rice vinegar added. Place a nori sheet on the makisu (bamboo sushi mat) with the rough side facing up and the long side parallel to the edge of the work surface. Moisten your hands in the bowl of vinegared water. Take a handful of sushi rice and spread it over the entire surface of the nori, leaving 1 cm (½ inch) uncovered on the lower edge (where you will start rolling up) and 2 cm (¾ inch) uncovered on the top edge (furthest from you) **(A)**. Be careful not to use too much rice, to prevent it from spilling out when you roll it up. You should be able to see the nori slightly through the spread-out rice grains.

STEP-BY-STEP

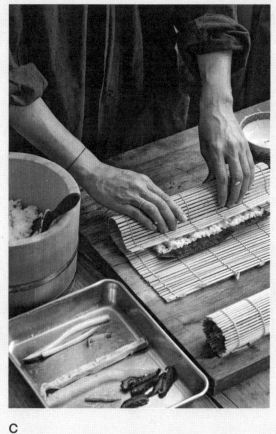

C

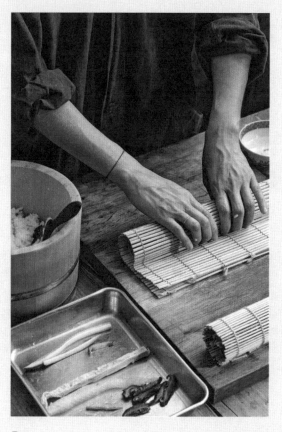

D

Align the filling ingredients (p. 68), parallel to the long edge on the lower part of the nori, overlapping them so that they are not stacked more than three or four ingredients high.

Fold down the bottom part of the makisu to start rolling while holding the fillings with your fingers to keep them in place **(B)**. Roll to close in the toppings, carefully press the maki without crushing the rice and toppings **(C)**, then continue to wrap the makisu around the nori. After the roll is formed, press again. Keep the makisu around the maki for 1 minute **(D)**. Remove and carefully place the maki on a cutting board, with the joined side facing down.

Repeat these steps for the remaining three rolls.

Cut each roll in half, and then cut each half into four pieces, making sure to wipe the knife blade with a damp cloth between each cut, to prevent the grains from sticking on the blade.

Futomaki fillings

太巻き（鯛／精進）

Sea bream maki filling 鯛
Makes 32 pieces

150 g (5¼ oz) wild sea bream fillet, skinless and boneless

1 pinch salt

1 cucumber

12 chives, trimmed

6 slices sweet-savory radish with shiokōji (p. 96), cut into thin strips (optional)

Tamago
2 eggs

1 teaspoon raw sugar

½ teaspoon soy sauce

2 chives, finely chopped

1 teaspoon neutral oil

Shiitake and amani burdock
10 g (¼ oz) dried shiitake mushrooms

200 ml (7 fl oz) water

1 burdock root or salsify

1 tablespoon sunflower oil

1 tablespoon soy sauce

1 tablespoon mirin

1 tablespoon raw sugar

1 teaspoon rice vinegar

Sprinkle the sea bream with the salt and leave to rest for 30 minutes in the refrigerator, then wipe the surface with a paper towel and cut into eight long strips.

Cut the cucumber in half lengthwise, remove the seeds, and cut into sections the same width as the nori sheets, then into 16 matchsticks.

Prepare the tamago using the instructions for tamagoyaki on p. 175, but with 2 eggs, to obtain an omelette the same width as the nori sheets. Then cut into four long strips.

Prepare the shiitake and amani burdock. Rehydrate the dried shiitake mushrooms by soaking in the water for 3 hours. Drain, keeping the soaking liquid. Measure out 100 ml (3½ fl oz) of the liquid and reserve. Save any remaining liquid for another use. (See Tip, p. 65.) Move the stems and slice the caps into 5-mm (¼-inch) strips. Peel the burdock and cut it into 5-cm (2-inch) sections, then into matchsticks. Heat the oil in a saucepan over medium heat and sauté the shiitake mushrooms and burdock for 1 minute. Add the reserved soaking liquid, the soy sauce, mirin, sugar, and rice vinegar. Simmer for 7 minutes over medium heat, stirring until the cooking liquid is almost completely evaporated. Leave to cool.

Maki shojin filling 精進 VEGAN
Makes 32 pieces

1 small avocado

1 squeeze lemon juice

1 handful baby spinach

1 teaspoon salt

6 slices sweet-savory radish with shiokōji (p. 96), cut into thin strips (optional)

1 recipe shiitake and amani burdock (see opposite)

Carrot kinpira (p. 127)
½ carrot (45 g/1½ oz)

1 teaspoon toasted sesame oil

1½ tablespoons mirin

½ teaspoon soy sauce

1 small pinch salt

Cut the avocado in half, remove the pit, then cut each half into six slices lengthwise. Sprinkle with lemon juice to prevent oxidation. Wash the spinach and blanch for 1 minute in a pot of salted boiling water, drain, then squeeze out the water. Prepare the shiitake and amani burdock. Prepare the carrot kinpira using the instructions on p. 127 but with the quantities shown here.

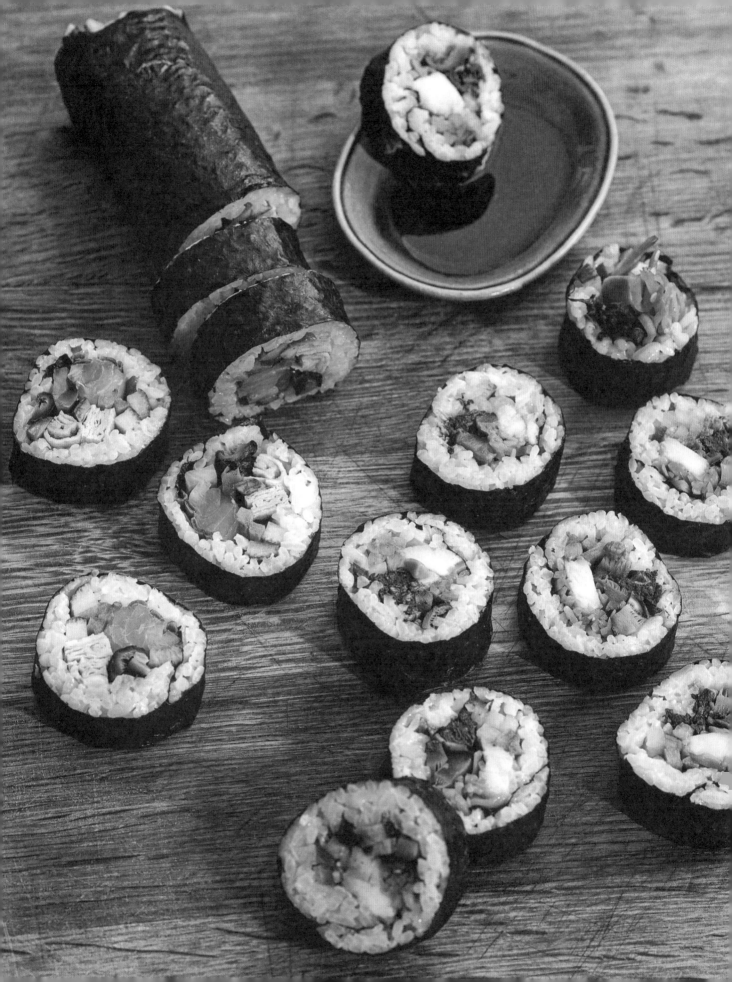

Tegone-zushi

(MARINATED TUNA AND HERB SUSHI)

てごね寿司

Serves 4–6
Preparation: 10 minutes
Marinating: 40 minutes

Marinade

6 tablespoons soy sauce

4 tablespoons mirin

4 teaspoons toasted sesame oil

10 g (¼ oz) fresh ginger, peeled, grated and pressed to extract juice

Tuna

600 g (1 lb 5 oz) bluefin tuna or extra fresh bonito!

1 teaspoon salt

1 pinch raw sugar

1 recipe sushi rice (p. 58)

10 chives, finely chopped

6 sprigs cilantro, finely chopped

10 shiso leaves, cut into thin strips

2 tablespoons toasted sesame seeds

7 g (¼ oz) fresh ginger, peeled and finely chopped

2 nori sheets, torn into small pieces

Yuzu, bergamot, or lemon (optional)

Mix all the marinade ingredients together in a bowl.

Cut the tuna into pieces that are 5 mm (¼ inch) thick. Spread the pieces on a large flat plate and sprinkle with the salt and sugar. Leave to rest for 10 minutes in the refrigerator. Add the tuna pieces to the marinade, then leave to marinate for 30 minutes in the refrigerator.

Place the rice in a large bowl and add half the chives, cilantro, and shiso, and all the sesame and ginger. Fold through with a spatula, taking care not to crush the grains. Add the bluefin tuna pieces (without the marinade) and mix quickly. Just before serving, sprinkle with the remaining herbs and torn nori sheets. Squeeze over the citrus juice, if using, and sprinkle with the remaining marinade to your taste.

HISTORY

Tegone means to "mix with the hand." Originally, this recipe was a dish prepared by fishermen while they were out fishing on their boats. The sashimi slices are therefore not delicately arranged on the rice but coarsely mixed together by hand. Today, we use a spatula for hygiene reasons, but the "raw" sushi spirit is there. I love to make this recipe with lots of different herbs!

RICE

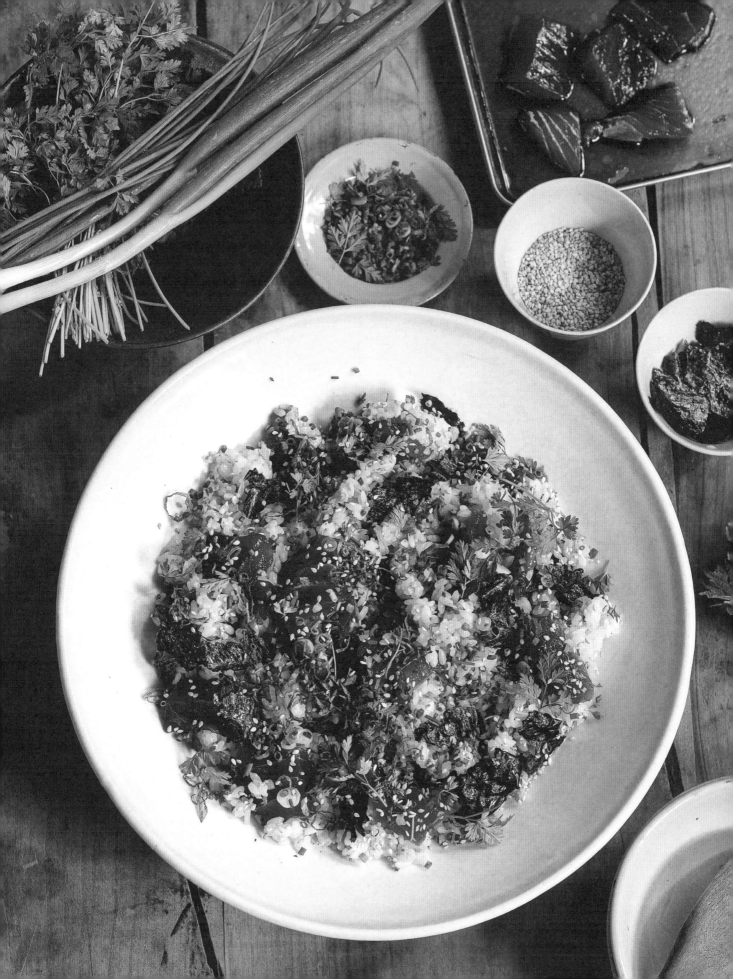

Onigiri

おにぎりの握り方

✽ VEGAN

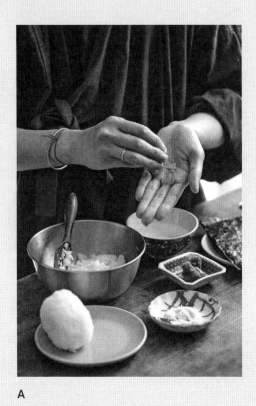

A

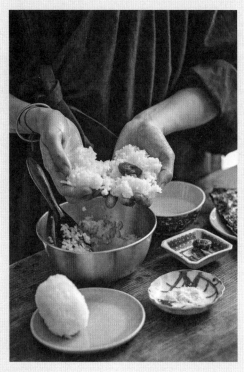

B

Serves 4 (makes 4 large or 8 small onigiri)
Preparation: 10 minutes

Hot cooked white rice for 4 people (p. 56)
Salt
Filling (see p. 74)
1 nori sheet, cut into 4 or 8 strips (optional)

Spread the rice out in a bowl so that it becomes cool enough to touch. Slightly and carefully fluff the grains using a spatula. Prepare a small bowl with water and a small plate with salt. Wash your hands well with nonperfumed soap. Thoroughly wet your hands under the tap, then shake to remove excess water. Your hands should be moist, but not dripping wet.

Take 1 pinch of salt between the thumb, index finger, and middle finger (for the correct amount) and put it in the palm of the other hand **(A)**. Rub your hands to spread the salt over the entire surface. Take a quarter of the rice (or an eighth for small hands or to make small onigiri), poke a small hole in the middle, and slide the filling of your choice **(B)** into it. Form a ball using your other hand by pressing the filling into the ball. Add a little more rice to cover the filling, if needed. Use your bottom hand to make

STEP-BY-STEP

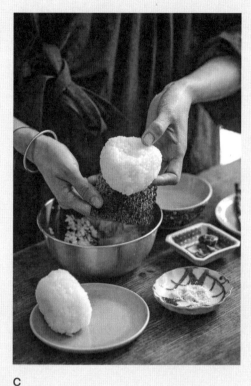

C

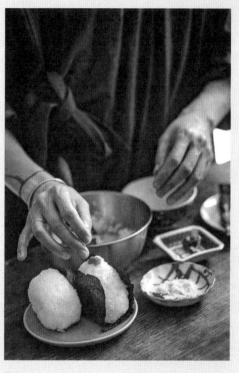

D

a spoon shape to form the base of the triangle and make a pointed mountain-shape with your top hand to create the top of the triangle. Squeeze both hands to form a triangle. Then turn the onigiri and press again to neatly shape **(C)** each corner. Turn and press gently several times. Only use a little force the first two times. If you press too much afterward, you will crush the grains and the onigiri will become pasty. Wrap the onigiri with a strip of nori, if using **(D)**.

Wash your hands and repeat until all the rice and filling is used.

TIP

The starch in short-grain white rice makes it easy to form triangles. If the rice is not hot enough, it hardens and you will need to exert unnecessary pressure and crush the grains to form the shape. This means your onigiri will be pasty. The grains will no longer separate in your mouth as they should. To use cold or even lukewarm rice, heat it in a steamer or in the microwave. Ideally, prepare the onigiri just after the rice has been cooked (and rested for 10 minutes).

Mixed onigiri

おにぎり

Serves 4 (makes 4 large or 8 small onigiri)
For the quantity of rice and shaping the onigiri, see pp. 72–73.

Katsuo-kombu 鰹こんぶ

4 tablespoons + 4 pinches furikake seasoning (p. 167)

Mix the 4 tablespoons furikake seasoning with the hot cooked rice. Shape the onigiri, then sprinkle with the remaining 4 pinches furikake.

Tuna-mayo ツナマヨ

100 g (3½ oz) tuna in sunflower oil

1 tablespoon mayonnaise or soy mayonnaise (p. 139)

2 teaspoons soy sauce

A little lemon or bergamot zest, cut into thin strips

Chile powder

Drain the tuna well, break up the flesh with a fork, and place in a bowl. Mix in the mayonnaise and soy sauce. Put a little of this mixture inside the onigiri, continue shaping, and then put some tuna mixture, zest, and chile powder on top of the onigiri.

Nameshi (green leaf) 菜飯 VEGAN

70 g (2½ oz) green leaves and stalks (turnip, radish, or kale)

1⅓ teaspoons salt

1 tablespoon toasted sesame seeds

Wash the leaves thoroughly, keeping them whole. Bring water to a boil in a saucepan with 1 teaspoon of the salt. Immerse the leaves in the water, starting with the stem, and cook for 1 to 2 minutes. Drain and leave to cool. Squeeze the leaves thoroughly with your hands and chop finely. Mix the remaining ⅓ teaspoon salt and the leaves in a large bowl. Add the hot rice and the sesame seeds, mix to combine, then shape the onigiri.

Umé (salted Japanese plum) 梅 VEGAN

5 umeboshi

1 nori sheet

Pit the umeboshi by making a small slit in the umeboshi and pushing the pit through it. Cut 1 into quarters for decoration. Cut the nori sheet into four strips. Shape the onigiri by putting an umeboshi inside each. Wrap each onigiri with a strip of nori and place a piece of umeboshi on top.

Ikura いくら

50 g (1¾ oz) fish roe (salmon, trout, etc.) from a jar

4 shiso leaves

Shape the onigiri by putting a small spoonful of fish roe inside each. Add some fish roe on top of each onigiri and wrap with a shiso leaf.

米

RICE

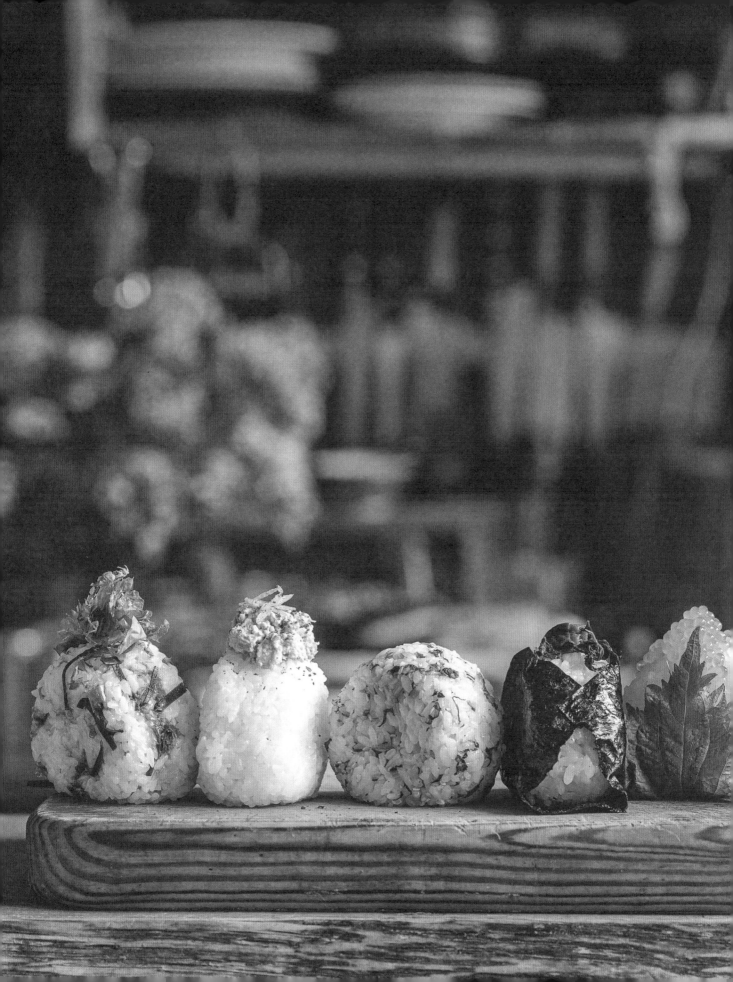

Chestnut and ginger rice

VEGAN

栗ご飯

Serves 4
Preparation: 15–45 minutes
Resting: 40 minutes–1 hour
40 minutes
Cooking: 13 minutes

500 g (1 lb 2 oz) raw chestnuts or 250 g (8¾ oz) cooked and peeled chestnuts

400 ml (13½ fl oz)* short-grain white rice

5 g (⅛ oz) fresh ginger, peeled and sliced into thin strips

1 teaspoon salt

20 ml (4 teaspoons) sake

460 ml (16 fl oz) filtered water

Gomashio (toasted sesame seed and sea salt seasoning) (optional)

*Based on the graduations of your measuring cup.

To peel the raw chestnuts, put them in a saucepan, cover with water, bring to a boil, and cook for 5 minutes. Drain the chestnuts, put them in a bowl, cover them with boiling water, and let stand for 1 hour. Drain. Cut the rough part (which I call the "buttocks" of the chestnut) a bit with a knife and pull back the bark (aptly named "devil's skin") toward the point. Then remove the thin skin with the knife.

Wash the rice following the rice cooking steps on page 56. Put the rice, chestnuts, ginger, and salt into a heavy saucepan (or rice cooker). Pour in the sake and water and follow the remaining instructions on page 56. Sprinkle gomashio on top before serving, if desired.

TIPS

If you decide to use fresh chestnuts, bravo! It's a lot of work, but it's worth it! There are other tips for peeling them (for example, using the oven), but they tend to dry out and harden. Every year, as soon as we find chestnuts at the market, we try to make time to cook this rice, even though it takes a while to prepare. When I came home from school as a child, I was always excited when I found my mother peeling chestnuts, and my stomach started grumbling immediately! For me, this is a festive and special dish that announces the arrival of autumn. But if you can't find fresh chestnuts (like me, writing this book in spring), you can make it with precooked chestnuts; it's tasty as well!

—

For rice cooker cooking, use the measuring cup supplied with the rice cooker and measure out 2 cups. Put the rice, sake, and salt in first, then add water using the correct quantity for 2 cups of rice. Then add the ginger and chestnuts. It is important to follow the water-to-rice ratio for the particular rice cooker you are using.

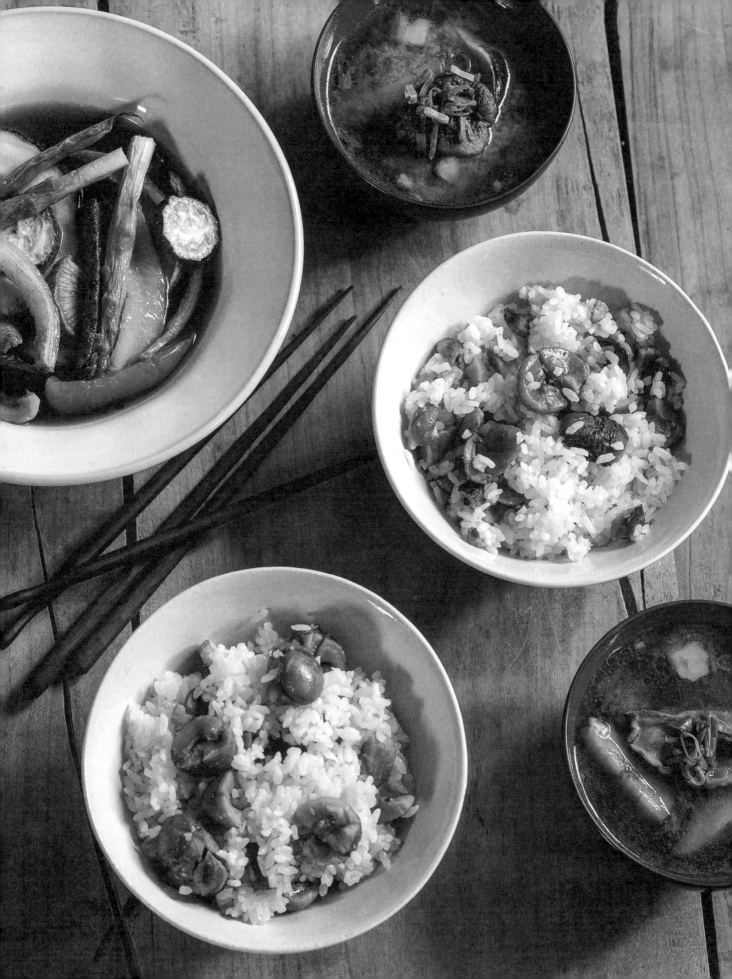

Rice with peas

 VEGAN

豆ご飯

Serves 4
Preparation: 15 minutes
Resting: 40 minutes
Cooking: 13 minutes

500 g (1 lb 2 oz) fresh peas in their pods (200 g/7 oz shelled)
400 ml (13½ fl oz)* short-grain white rice
3 g (¹⁄₁₀ oz) dried kombu
2 pinches salt
20 ml (4 teaspoons) sake
460 ml (16 fl oz) filtered water
1 teaspoon neutral oil

*Based on the graduations of your measuring cup.

Shell the peas. Wash the rice following the rice cooking steps on page 56 for white rice. Put the rice, peas, kombu, and salt into a heavy saucepan (or rice cooker). Pour in the sake, water, and oil and follow the remaining instructions on page 58.

TIP

For rice cooker cooking, use the measuring cup supplied with the rice cooker and measure out 2 cups. Put the rice in first, then the sake and salt, and pour in the water using the correct quantity for 2 cups of rice. Then add the kombu and peas. It is important to follow the water-to-rice ratio for the particular rice cooker you are using.

This is my favorite rice. It's super easy to make and I love the flavor of the fresh peas. It can also be made with broad beans.

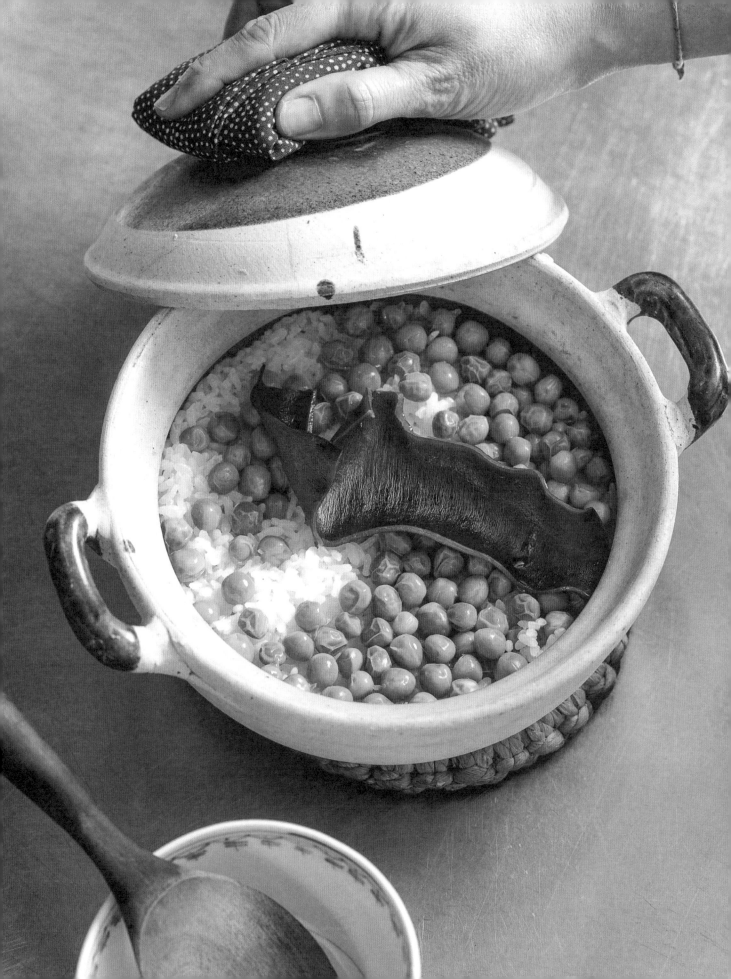

Chimaki
(STEAMED STICKY RICE)

中華ちまき

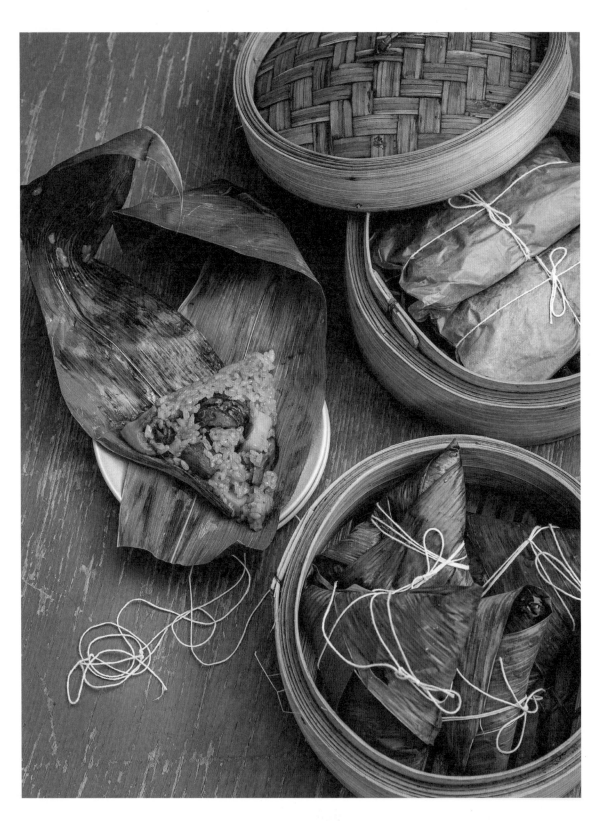

米

RICE

Serves 4 / Makes 8 chimaki
Preparation: 40 minutes
Resting: 2 hours
Cooking: 1¼ hours

Filling

3 large dried shiitake mushrooms

400 ml (13½ fl oz) water

50 g (1¾ oz) carrot

100 g (3½ oz) Jerusalem artichoke

100 g (3½ oz) pork belly (rind removed) or cha-shu (p. 25)

1 tablespoon toasted sesame oil

Filling seasoning

2 tablespoons sake

1½ tablespoons soy sauce

½ tablespoon raw sugar

1 tablespoon oyster sauce

Rice

360 ml (12 fl oz)* glutinous rice

1 tablespoon neutral oil

1 shallot, peeled and finely chopped

10 g (¼ oz) fresh ginger, peeled and finely chopped

Assembly

16–20 bamboo leaves (from Asian supermarkets), fully soaked in a large bowl of water for 15 minutes and wiped dry with a tea towel

8 chestnuts, preboiled (optional)

8 sheets of 30 x 24-cm (12 x 9½-inch) parchment paper (optional, or bamboo leaves substitute)

Kitchen string

*Based on the graduations of your measuring cup.

Rehydrate the dried shiitake mushrooms by soaking in the water for 2 hours. Drain (but keep the soaking liquid), remove the stems, and quarter the mushrooms. Peel the carrot and Jerusalem artichoke and cut into thin matchsticks that are 2 cm (¾ inch) long. Cut the pork into 1.5-cm (⅝-inch) cubes. Heat the sesame oil in a saucepan over medium heat. Add the rehydrated shiitake mushrooms, carrot, artichoke, and pork. Sauté for 1 minute. Add the mushroom soaking liquid and all the seasoning ingredients. Simmer, uncovered, until the liquid has reduced by half. Remove from the heat and set aside.

To prepare the rice, wash it quickly by mixing it with water in a bowl, drain, then refill the bowl with water and let the rice soak for 2 hours. Drain well. Heat the oil in a large frying pan over medium heat with the shallot and ginger. Add the rice and cook for 3 minutes, until the rice grains become semi transparent. Add the simmered filling and liquid. Cook for about 7 minutes, stirring the bottom of the pan occasionally with a spatula without crushing the grains, until the rice has absorbed the liquid. Remove from the heat and allow to cool. Divide the mixture into eight equal portions.

To shape the chimaki, overlap 2 bamboo leaves (if they are large and thick, 1 leaf is enough) and place them with the long side parallel to the edge of a work surface. Fold the bottom part of the leaves to form an ice-cream-cone shape. Fill the cone with a portion of the mixture and press a chestnut, if using, into it. Fold down the top of the leaves to enclose the chimaki, then wrap the leaves around, following the shape of the cone. To finish, slide the end of the leaves into the opening as you would to close an envelope and tie the chinaki tightly with string like a present.

If bamboo leaves are unavailable, use parchment paper to wrap the chimaki.

Prepare a steamer basket (or steamer), place the chimaki in the basket, and cook for 40 minutes.

TIP

Chimaki can be frozen after cooking. To eat from frozen, simply place them still frozen in a steamer basket and heat for about 15 minutes.

Donburi kakiage

WITH PRAWNS AND BROAD BEANS

海老のかき揚げ丼

Serves 4
Preparation: 30 minutes
Cooking: 4 minutes

70 g (2½ oz) carrot
60 g (2 oz) zucchini
70 g (2½ oz) red onion
12 raw prawns, peeled and cleaned
16 broad beans
2 tablespoons all-purpose flour
Oil, for frying
540 ml (18½ fl oz)* uncooked short-grain white rice, cooked in 650 ml (22 fl oz) water (see cooking rice, p. 56)
6 tablespoons mentsuyu (p. 14)
10 g (¼ oz) fresh ginger, peeled and grated
7 tablespoons cold water
5 tablespoons all-purpose flour
1 tablespoon potato starch

*Based on the graduations of your measuring cup.

Peel the carrot. Cut the carrot and zucchini into matchsticks that are 5 cm (2 inch) long and 3 mm (⅛ inch) thick. Peel and halve the onion, then cut into slices that are 3 mm (⅛ inch) thick. Combine the prawns, carrot, zucchini, onion, and beans in a bowl. Sprinkle with the flour and mix.

Prepare the batter. Put the cold water, flour, and starch in a small bowl. Mix quickly and roughly to prevent gluten from developing too much. Add the batter to the vegetables and prawns. Mix together.

In a large deep frying pan, heat 2 cm (¾ inch) of oil to 170°C (340°F). Using a tablespoon, divide the vegetable and prawn mixture into eight portions. Drop them in the oil, spreading them out lightly with chopsticks and making sure the portions don't touch. Cook in two batches if needed. Cook for 30 seconds and turn over. Then, using a chopstick, make two or three holes in each kakiage to ensure even cooking. Cook for about 2 minutes, until the kakiage is crisp and browned. If necessary, turn and cook for another minute. Drain on paper towels.

Divide the rice into four large donburi bowls (larger than a rice bowl). Drizzle each bowl of rice with ½ tablespoon of mentsuyu, place 2 kakiage in each bowl, then drizzle each with 1 tablespoon of mentsuyu and sprinkle with the grated ginger.

VEGAN VERSION ✽

Replace the prawns with 100 g (3½ oz) roughly chopped mushrooms or 100 g (3½ oz) pumpkin or sweet potato cut into matchsticks. You can also try it with Jerusalem artichoke, burdock root, salsify, or bell pepper. Make kakiage with your favorite vegetables!

米

RICE

Donburi

WITH MARINATED FISH AND RAW EGG YOLK

漬け丼

Serves 4
Preparation: 10 minutes
Marinating: 15 minutes

½ small red onion

480 g (1 lb 1 oz) sashimi-quality fish fillets, skinless and boneless*

540 ml (18½ fl oz)** uncooked short-grain white rice, cooked in 650 ml (22 fl oz) water (see cooking rice, p. 56)

4 egg yolks, extremely fresh

Marinade

60 ml (¼ cup) soy sauce

3 tablespoons mirin

1 tablespoon toasted sesame seeds

Check with your fishmonger that the fish is fresh enough to be eaten raw.

**Based on the graduations of your measuring cup.*

Prepare the marinade. Mix the soy sauce, mirin, and sesame seeds in a large bowl. Cut the fish into thin slices. Add the fish to the marinade and marinate in the refrigerator for 15 minutes. Peel the onion and slice it into thin rings. Marinate the fish in this mixture for 15 minutes.

Divide the rice into four large donburi bowls (larger than a rice bowl). Place the marinated fish slices and onion on top of the rice. Place an egg yolk on top in the middle. Sprinkle with 1 tablespoon of marinade and serve.

TIP

I love to make this recipe with wild sea bream, but any sashimi-quality fish, such as salmon, tuna, sardines, horse mackerel, or even bonito, will work well (if using sardines, see p. 178 on how to fillet). The most important thing is to use extremely fresh fish. You'll see how good it is!

米

RICE

Miso Zosui

(JAPANESE RISOTTO WITH MISO PASTE)

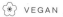 VEGAN

味噌雑炊

Serves 4
Preparation: 10 minutes
Cooking: 10 minutes

50 g (1¾ oz) daikon (white radish)
½ onion
4 fresh shiitake mushrooms
100 g (3½ oz) enoki mushrooms
½ carrot
1 Chinese cabbage leaf (napa cabbage)
4 g (⅛ oz) fresh ginger
A few green leaves (turnip, radish, spinach, rocket, kale, etc.)
1 sheet aburaage (fried tofu) (optional)
1 teaspoon toasted sesame oil
800 ml (3⅓ cups) dashi (p. 166 or p. 122 for vegan dashi shojin)
1 tablespoon soy sauce
1 tablespoon mirin
2–3 small bowls cooked rice (p. 56)
2 tablespoons miso (I used 1 tablespoon white miso and 1 tablespoon brown miso)
Salt
Chile powder (optional)

Peel the radish and onion and cut into bite-sized pieces. Remove the mushroom stems, finely chop the shiitake mushrooms, and cut the enoki mushrooms into thirds. Peel the carrot, cut it in half lengthwise, then into 1-cm (½-inch) slices. Cut the cabbage leaf into bite-sized pieces. Peel and finely chop the ginger. Roughly chop the green leaves. Cut the aburaage in half lengthwise, if using, then into strips that are 2 cm (¾ inch) wide.

Heat the oil in a large saucepan or Dutch oven and brown the radish, onion, mushrooms, carrot, cabbage, ginger, and aburaage, if using, for 1 minute over medium heat. Pour in the dashi, soy sauce, and mirin. Cover and cook for 7 minutes over medium heat, until the vegetables are tender. Add the cooked rice and leave to simmer for 1 minute. Dissolve in the miso, then turn off the heat. Taste and adjust the seasoning with salt. Add the green leaves and cover.

Place the saucepan or Dutch oven on the table to serve. Serve the miso zosui in bowls, sprinkled with chile powder, if desired. This dish partners perfectly with Chinese cabbage shiozuke (p. 94).

TIP

Please note that the rice swells quite a lot, which is why the quantity used is a little less than the usual amount (also why this dish is popular with people on a diet).

This is an ideal recipe to "revamp" cooked rice. I have used a lot of vegetables in this version, but it can be prepared with one or two types of vegetables depending on what you feel like. It is a very easy and quick dish to prepare, in addition to being very nutritious and easy to digest. This was the traditional dish I ate as a child when I was sick. I always keep cooked rice in an airtight container in the refrigerator and I often prepare this dish for my breakfast.

米

RICE

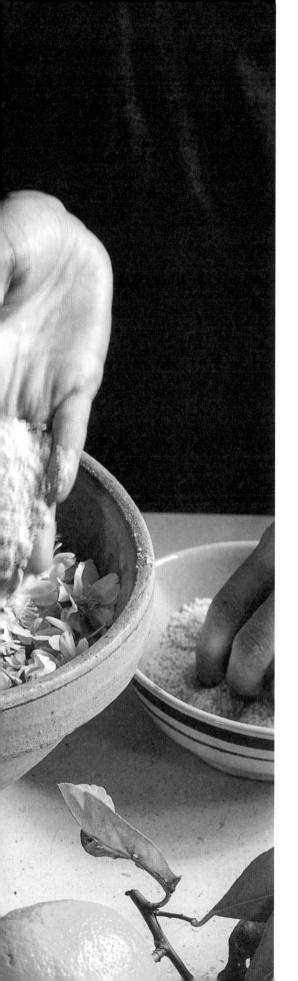

発酵 保存食

FERMENTING
AND PRESERVING

Fermenting and preserving

発酵 / 保存食

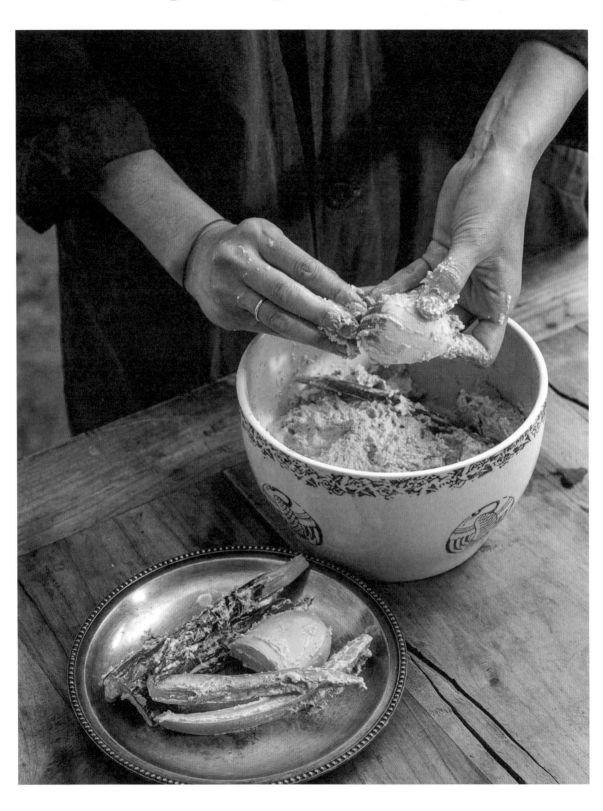

発酵保存食

When it comes to Japanese cuisine, fermented foods are essential. It starts in the morning with miso soup, made with katsuobushi broth, tsukemono, natto, and soy sauce seasoning . . . already five fermented foods on the table!

Fermentation is said to be the secret of longevity in Japan. The health benefits of fermented products are remarkable, but the culture of fermentation developed long before all these benefits were known. They are truly part of our long culinary history because fermented foods create complex and deep flavors. In Japan, the desire to enjoy a little of every season all year round led us to develop different fermentation and preservation techniques. Our lives are enriched by the ability to keep a taste of each season for several months or even years.

1. Fermentation by microorganisms

(Examples: miso paste, soy sauce, shochu, mirin, katsuobushi, etc.)

In other words, this is fermentation by mold. There are many types of molds and they are chosen according to the food you want to ferment. This type of fermentation creates enzymes that transform or decompose the substances in the ingredients to bring out a complex taste, such as umami, a slight acidity, or a certain sweetness. So it is as much a natural flavor enhancer as it is a preservative.

Kōji, an essential ingredient in Japan for making miso paste, soy sauce, and sake, is a ferment obtained by sprinkling spores of a mold called *Aspergillus oryzae* onto cereals (rice, barley, etc.).

Katsuobushi, bonito that is dried and fermented using a mold called *Aspergillus glaucus*, is the ingredient used to prepare dashi broth, one of the staples of Japanese cuisine that adds a rich umami flavor.

2. Lactic and alcoholic fermentation

(Example: tsukemono)

Tsukemono generally refers to vegetables or fish fermented by lactobacilli (lactic fermentation) and yeasts (alcoholic fermentation). Over 1,000 types of tsukemono are found throughout Japan. Each region has its speciality, depending on its environment and climate.

Nukazuke (p. 92) is the most common and most well-known. Vegetables are prepared in a fermented mixture of salt, rice bran, and water, called the nukadoko. Fermentation takes only one day, allowing a variety of fermented seasonal vegetables to be enjoyed.

Shiozuke (p. 94) allows for the long-term preservation of various vegetables and their enjoyment out of season. This was a very important source of vitamins during the winter.

Sokuseki-zuke (p. 96) is a quick tsukemono method that allows you to eat vegetables immediately, without waiting for fermentation.

3. Fermentation by other bacteria

(Example: natto, p. 100)

The Japanese either love natto or hate it! This soybean, fermented after seeding with the *Bacillus subtilis* bacterium, is often served as an accompaniment to rice at breakfast. Its extremely glutinous appearance and its very strong fermentation odor make it hard to stomach for the uninitiated. But once you get used to it, it's hard to go without it.

4. Preservation by salting

This method allows food to be preserved for a long time using salt, without fermentation. Cherry blossoms (p. 116), symbolic of springtime in Japan, have an extremely short flowering period; wild mountain herbs (sansai), harvested in spring and early summer; and wild autumn mushrooms can all be kept year-round using this method. The salting helps to capture the taste of the season.

Nukazuke

(RICE BRAN PICKLES)

糠漬け

- 500 g (1 lb 2oz) rice bran or oat bran
- 80 g (2¾ oz) salt
- 500 ml (2 cups) nonchlorinated water (boiled then cooled)*
- 2 tablespoons plain soy yogurt
- 5 g (⅛ oz) dried kombu, cut into 2–3 pieces
- 1 large mild chile
- 2 dried shiitake mushrooms (optional)
- Vegetables for sutezuke (broccoli stem, carrot skin or wilted carrot, outer cabbage leaves)
- Vegetables for nukazuke (see Making nukazuke, opposite)
- Salt

*It is important to use nonchlorinated water because chlorine prevents fermentation.

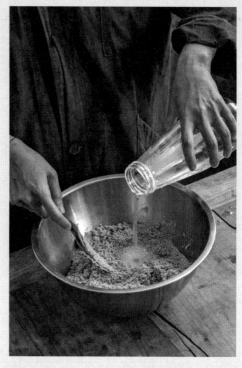

A

The nukadoko, the nukazuke base (*nuka* = "rice bran"; *doko* = "bed")

Mix the bran and salt in a bowl. Pour in the water and mix with your (very clean) hand **(A)**. Mix in the yogurt—its lactic bacteria speeds up the fermentation. Pour the nukadoko into a container with a lid that has been sterilized beforehand. Press the kombu pieces, chile, and dried shiitake mushrooms, if using, into the mixture (kombu and shiitake mushrooms create umami; chile has antiseptic and antioxidant properties and prevents the growth of bad bacteria). Keep the container tightly closed at room temperature and out of direct sunlight.

Sutezuke, nukadoko fermentation (*sute* = "throw")

It takes 7 to 10 days for nukadoko to be ready for nukazuke. Mix the nukadoko every day, using a very clean hand. Lift the lower part of the mixture to the top and push the top part toward the bottom of the container so that the lactic bacteria and yeasts develop evenly.

During this period, sutezuke should be made with vegetable scraps or wilted, well-washed vegetables (e.g., 1 cabbage leaf and 2 [around 5-cm/2-inch] broccoli stem pieces). Put them in the nukadoko, leave to rest for 2 days, then remove them and replace them with new vegetables **(B)**. Repeat this process during this 7-to-10-day period, also remembering to mix the nukadoko every day.

発酵保存食

FERMENTING AND PRESERVING

STEP-BY-STEP

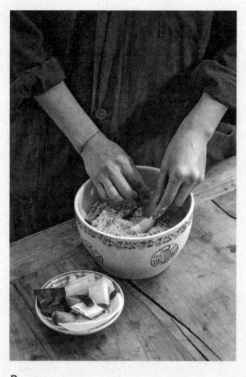

B

C

Making nukazuke

You can now put almost any vegetable in the nukadoko, avoiding those that are too bitter or too watery (you can use half a cucumber cut lengthwise, but make sure the seeds are removed; see photograph on page 90). Peel the vegetables, rub with a pinch of salt, and push into the nukadoko. In winter, leave them to ferment for 24 hours; in summer, a few hours is sufficient. Then remove the vegetables from the nukadoko, wash, and cut them into bite-sized pieces **(C)**. Replace vegetables in the nukadoko.

Nukadoko maintenance

After a few weeks, if the nukadoko has become too watery, make one or two holes in it, poke in a piece of paper towel, and leave overnight to absorb the liquid. Then add 2 to 3 tablespoons of bran.

If the nukazuke is not salty enough, add 1 to 2 teaspoons salt to the nukadoko and mix. Replace the kombu and chile every month or so.

If you are going away for more than a week, there are several options. You can take the nukadoko with you (this is not a joke—I take mine with me every summer holiday!); you can ask a trustworthy person to mix it daily; or cover the surface with salt and store it in the refrigerator (then remove the salt and the layer in contact with the salt before using it).

In Japan, many households have their own nukadoko, often maintained by the wife or whoever runs the kitchen. Traditionally, when a woman married and left her home to establish her own family, her mother would give her a part of her nukadoko so that the taste of her home went with her.

NUKAZUKE WITH OAT BRAN

For the photos in this book, I have used oat bran because rice bran is difficult to find. Oat bran is very easily found in health food shops; it is cheap, and works perfectly, even if the texture is quite different. With rice bran, nukadoko has the texture of wet sand. With oat bran, it is much stickier, and bad bacteria tend to grow because it contains more water. I recommend keeping it in the refrigerator if the summer is hot where you live.

Chinese cabbage shiozuke

(JAPANESE SALTING)

VEGAN

白菜の塩漬け

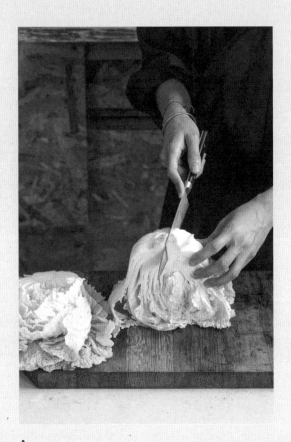

A

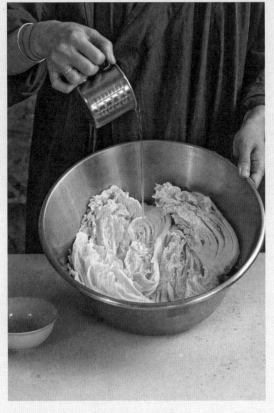

B

1 Chinese cabbage (napa) (1 kg/2 lb 3 oz minimum)

Salt (3% of cabbage weight: for 1 kg cabbage, 30 g/1 oz salt)

200 ml (7 fl oz) water

7 g (¼ oz) dried kombu, cut into 3–4 pieces

1 yuzu or bergamot, thinly sliced

2 mild chiles

Cut into the cabbage core with a knife to around 5 cm (2 inches) deep, then split the cabbage into halves **(A)**. Repeat this process on each half to separate each into three pieces. Dry the cabbage pieces for 3 hours in the sun. Dehydration enhances the taste of the cabbage.

発酵保存食

FERMENTING AND PRESERVING

STEP-BY-STEP

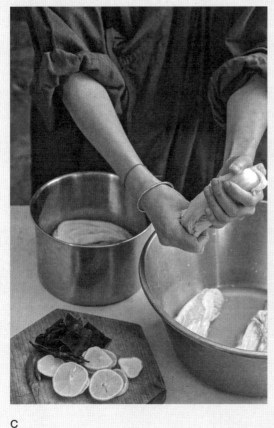

C

D

Prepare a salad bowl or bowl that is narrow enough to ensure that the pieces of cabbage fit tightly. Put the salt between the cabbage leaves, at the base, on the core side. Tightly pack the pieces in the bowl, pour over the water, and turn the cabbage to wet it thoroughly **(B)**. Cover the bowl with a sheet of parchment paper and then place a plate on top that is smaller in diameter than the bowl on top, so that it touches the paper. Place a weight on top that is 1½ times heavier than the cabbage (1.5 kg/3 lb 5 oz). Let stand for 24 hours at room temperature, turning the cabbage once after 12 hours. The cabbage will release a lot of water. Discard it and lightly squeeze the cabbage between your hands **(C)**.

Pack the pieces of cabbage tightly into a smaller container (they may overlap) so that there is no air between the leaves. Insert the kombu pieces and citrus slices between the pieces. Place the chiles on top **(D)**. Cover with a sheet of parchment paper and a weight the same as that of the cabbage (1 kg/2 lb 4 oz). Allow the lactic bacteria to develop by leaving to rest for 2 days in a cool place before eating. Then transfer to an airtight container and store in the refrigerator. The longer you leave it, the more the mixture will ferment.

Sokuseki-zuke

(QUICK PICKLES)

VEGAN

即席漬け

Asparagus with shiokōji and olive oil

Makes 200 g (7 oz) pickles

200 g (7 oz) thin asparagus
2 tablespoons shiokōji (p. 98)
1 tablespoon extra virgin olive oil

Clean the asparagus and remove the woody ends. Combine all the ingredients in an airtight container and marinate for at least 30 minutes in the refrigerator before eating.

Carrots with kombu and garlic

Makes 200 g (7 oz) pickles

200 g (7 oz) multicolored carrots (or orange)
1 tablespoon soy sauce
1 tablespoon mirin
1 tablespoon rice vinegar
3 g (⅛ oz) dried kombu
1 garlic clove, crushed

Peel the carrots and cut into sticks. Mix them with the remaining ingredients in an airtight container. Marinate for at least 30 minutes in the refrigerator before eating.

Sweet-savory radish with shiokōji

Makes 150 g (5½ oz) pickles

150 g (5¼ oz) purple, white, red-fleshed, or blue-fleshed radish or turnip
½ teaspoon salt
1 tablespoon shiokōji (p. 98)
½ teaspoon raw sugar

Peel the radishes. Cut in half lengthwise and then into 7-mm (¼-inch) slices. Put in a bowl, sprinkle with the salt, and mix. Let sit for 30 minutes and drain well. Mix the vegetable slices with the shiokōji and sugar in an airtight container. Marinate for 15 minutes in the refrigerator before eating.

Turnip with kombu and citrus

Makes 200 g (7 oz) pickles

200 g (7 oz) turnip (or raw beet)
4 g (⅛ oz) dried kombu, cut into small rectangles
¼ citrus fruit (bergamot, yuzu, lemon, etc.)
2 teaspoons juice from selected citrus fruit
½ teaspoon raw sugar
1 teaspoon salt

Peel the turnip and cut it as thinly as possible using a mandoline. Mix all the ingredients in an airtight container and marinate for at least 1 hour in the refrigerator before eating.

Cucumber with ginger

Makes 150 g (5¼ oz) pickles

½ cucumber
2 pinches salt
½ garlic clove, grated
3 g (⅒ oz) fresh ginger, peeled and sliced into thin matchsticks
½ teaspoon salt
1 teaspoon rice vinegar
1 teaspoon toasted sesame oil

Wash the cucumber, cut in half lengthwise, and remove the seeds. Hit the cucumber with a rolling pin, and then tear it into bite-sized pieces. Mix the cucumber with the salt in a bowl and let sit for 30 minutes. Drain. Mix the cucumber with the remaining ingredients in an airtight container. Marinate for at least 30 minutes in the refrigerator before eating.

TIP

All pickles will keep for 3 days in the refrigerator.

発酵保存食

FERMENTING AND PRESERVING

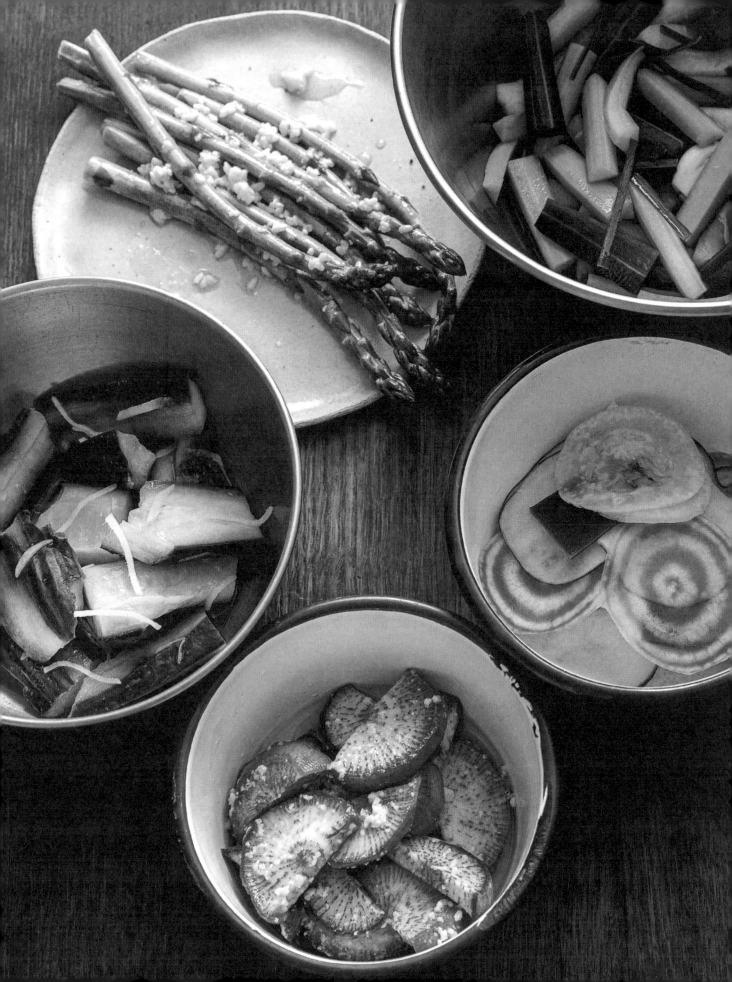

Shiokōji

(FERMENTED CONDIMENT)

VEGAN

塩麹

Makes 500 ml (2 cups) shiokōji
Preparation: 5 minutes

170 g (6 oz) dried kōji
60 g (2 oz) salt
230 ml (8 fl oz) filtered water

Sterilize a jar with boiling water for 1 minute. Put all the ingredients into the jar, mix, and seal tightly. Keep the jar at room temperature for 7 days (in summer) or 10 days (in winter), stirring once a day with a clean spoon. The shiokōji can be stored in the refrigerator for up to 6 months.

TIP

You can use this wonderful umami condiment for everything! To marinate vegetables, fish, meat, or tofu; to mix with a salad dressing; to add to soups; or to prepare sokuseki-zuke (p. 96).

発酵保存食

Natto

(FERMENTED SOYBEANS)

✳ VEGAN

手作り納豆

発酵保存食

Natto is a dish fermented by the Bacillus subtilis bacterium. It is famous and very particular. Its super-sticky texture and taste are unforgettable. So unforgettable that either you hate it or you fall completely in love with it.

FERMENTING AND PRESERVING

200 g (7 oz) whole yellow soybeans

Method A

2 tablespoons natto (store bought or homemade beforehand)

50 ml (1¾ fl oz) boiling water

Method B

2 good handfuls organic herbs or edible leaves (rosemary, mint, parsley, cilantro, nettle, bamboo leaves, vine, fig, etc.), which naturally have *Bacillus subtilis* on them.

Utensils

1 small bowl (Method A)

1 enamel container 15 × 18 × 5 cm (6 × 7 × 2 inches)

Rubber bands

1 thermometer

Wash the soybeans in a bowl filled with water. Change the water two to three times, until it is clear. Then soak the soybeans in three times their volume of water for 20 hours in winter / 15 hours in spring and autumn / 12 hours in summer. To check if a bean is properly soaked, break it in half. If the inside is flat, it is ready; if the inside is sunken, let them soak for 1 to 2 more hours. Preferably start soaking in the evening so that you can check the start of fermentation the following day.

Drain the soybeans and steam them.

Pressure cooker: Put the steamer basket in the pressure cooker, add 2 cups of water and the soybeans. Heat over medium-high heat; from the whistle, cook for 30 minutes over low heat, then remove from the heat and let the pressure drop naturally before opening the lid. The beans should be broken very easily between two fingers.

Steamer basket: Cook for 1½ to 2 hours over medium-low heat. To check if the beans are cooked, crush a bean between your fingers. If it crushes easily, it is cooked. If not, continue cooking until the beans are nice and tender (the beans harden when you make the natto, so it is better for them to be a bit more tender than usual). Drain.

While the beans are cooking, sterilize the small bowl (if using Method A), the enamel container, and a teaspoon by boiling them in a saucepan of water for 2 minutes. Allow to dry.

Method A

In the small, sterilized bowl with the sterilized teaspoon, dissolve the natto in the boiling water. While the cooked soybeans are still hot (heat kills unwanted bacteria but preserves *Bacillus subtilis*), place in the sterilized container. Add the dissolved natto. Cover the container with a paper towel and secure with a rubber band. Leave to ferment (see below). Mix.

Method B

Put the herbs or leaves in a bowl and cover with boiling water to disinfect them, then drain rapidly. Do not wash them to avoid washing away the *Bacillus subtilis* on them. Put half in the base of the sterilized container and add the cooked soybeans while still hot. Cover with the remaining herbs or leaves. Cover the container with a paper towel and secure with a rubber band. Leave to ferment (see below). Mix.

Fermentation

Store the natto in a warm spot heated to 40–45°C (105–115°F) for 18 to 24 hours.* Once fermented, the grains become covered with a white film and you will see sticky strings between the grains when mixed. Then let the natto mature for 2 days in the refrigerator before eating. Make sure you remove the herbs or leaves before you refrigerate (Method B).

Store 2 tablespoons of natto (with the white film) in the freezer for next time.

TIPS

*A yogurt maker is perfect. If you don't have one, then you can do what I do. Place the container of natto on a hot-water bottle filled with 60°C (140°F) water and packed in a towel. Put it all, with a thermometer, in a large, closed insulated bag. In the spring and summer, I place it near a window exposed to the sun; in the winter, near a heater, and cover the bag with a large towel. Check the temperature in the bag from time to time and change the water in the hot water bottle if it falls below 40°C (105°F). You need to be very attentive to the fermentation temperature during the first few hours. I check it often during the day, then I change the water in the hot water bottle before going to bed so I can sleep easy!

—

Serve with finely chopped leek (white part) and soy sauce or mentsuyu (p. 14).

—

If you cannot find any soybeans, you can replace them with chickpeas (note that the cooking time is much shorter than for soybeans).

Miso

味噌

What is it?
Soybean paste fermented with a fungus called kōji. Miso existed before soy sauce and is essential to our life in Japan.

Benefits
As the saying goes, "*Miso ha isha irazu*": "Miso keeps the doctor away." Miso is good for gut flora. It contains many essential amino acids that nourish the body with quality proteins.

How do I choose it?
Choose miso prepared with salt and made following the proper fermentation steps, with (non-GMO) soybeans. The only ingredients it should contain are soybeans, kōji (or *Aspergillus oryzae*), salt, and wheat or barley. Check on the package that it does not contain any flavor enhancers, colors, or preservatives.

There are several types of kōji, which determine the different types of miso. Rice kōji (kome-miso), wheat kōji (mugi miso) or soybean kōji (mame miso).

Miso can also be made by blending different types of miso (awase miso). The taste of miso varies according to the proportion of kōji and the duration of fermentation. The higher the proportion of kōji and the shorter the fermentation, the milder the taste of the miso. The lighter the miso is in color, the more sweet and fruity its taste will be. Darker-colored miso means that it has been fermented for longer, will have a stronger taste, and often will have a higher salt content, because the salt allows for long fermentation.

Types of miso pastes
Black miso (1) (haccho miso or mame miso) is pure soybean miso with very long fermentation. Its taste is special and very strong, but its salt content is not very high.

Red miso (2) (aka miso) has a more pronounced taste and is more salty than white miso.

Brown or light miso (tanshoku miso) has a rather neutral taste and is the easiest to use in the kitchen. (In the photo there is rice miso (3) and chickpea miso (4). I have never seen chickpea miso in Japan, but it is very tasty!)

White or yellow miso (5) (shiro miso) is the mildest and fruitiest.

Where to buy it?
Nowadays, you can find producers of quality miso outside of Japan. You'll also find quality Japanese miso in supermarkets, health food shops, Japanese grocery stores, and online.

Most people buy their miso, but more and more people are enjoying the benefits of making it themselves. It's quite simple, only requires a few ingredients (see p. 108) and there's nothing better than homemade miso!

発酵保存食

Various miso soups

味噌汁

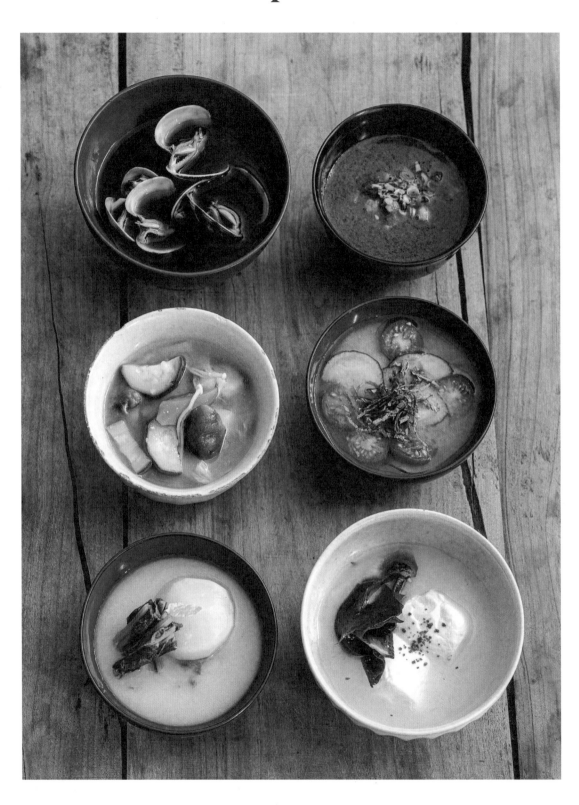

発酵保存食

FERMENTING AND PRESERVING

RED MISO OR MAME MISO
Serves 4

Clams

200 g (7 oz) clams

200 ml (7 fl oz) water

1 teaspoon salt

700 ml (23½ fl oz) dashi (p. 166)

2½ tablespoons red miso or mame miso

Remove the sand from the clams by soaking them in the water and salt for 2 to 3 hours. Wash them. Put them in a saucepan with the dashi, heat over low heat, and bring to a boil. Skim the foam if necessary. Once the clams are open (discard the ones that don't open), turn off the heat and mix in the miso.

Natto 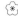 VEGAN

700 ml (23½ fl oz) dashi (p. 166 or p. 122)

4 tablespoons natto (p. 100)

3 tablespoons red miso or mame miso

1 scallion, thinly sliced

Bring the dashi to a boil in a saucepan over medium heat. Turn off the heat, add the natto, and mix in the miso. Add the scallion. You can also add cubes of firm tofu or some mushrooms. The strong smell and the stickiness of the natto disappear in the miso soup. It is therefore much easier to eat natto like this. And, of course, it is delicious!

For nonvegan dashi, see p. 166.
For vegan dashi, see p. 122.

BROWN MISO
Serves 4

Sautéed vegetables 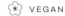 VEGAN

80 g (2¾ oz) radish (white or black)

⅓ carrot

¼ onion

½ small zucchini

60 g (2¼ oz) Jerusalem artichoke or potato

60 g (2 oz) mushrooms

1 tablespoon vegetable oil

3 g (⅒ oz) fresh ginger, peeled and sliced

700 ml (23½ fl oz) dashi (p. 166 or p. 122)

3 tablespoons brown miso

Peel the vegetables and cut them into bite-sized pieces. Heat the oil and ginger in a saucepan over medium heat. Add the vegetables and brown for 1 minute. Pour in the dashi and simmer for 5 minutes, until the vegetables are tender. Remove from the heat and mix in the miso.

Chilled miso soup 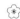 VEGAN

1 pinch salt

¼ cucumber very finely sliced

8 cherry tomatoes, halved

3 tablespoons brown miso paste

700 ml (23½ fl oz) dashi (p. 166 or p. 122), chilled

2 shiso leaves, finely chopped (optional)

Sprinkle the salt over the cucumber, let sit for 15 minutes, then drain by squeezing between your hands. Divide the cucumber and tomatoes into four bowls. Dissolve the miso in the dashi. Pour into the bowls. Sprinkle with the shiso, if using.

WHITE MISO
Serves 4

Turnip VEGAN

4 very fresh whole small turnips and their leaves

750 ml (3¼ cups) dashi (p. 166 or p. 122)

½ teaspoon soy sauce

3 tablespoons white miso

4 small pieces yuzu or bergamot zest

Peel the turnips and wash the leaves. Blanch the leaves for 1 minute in boiling water and drain them by squeezing with your hands. Cut them into 3-cm (1¼-inch) pieces. Bring the dashi, turnips, and soy sauce to a boil in a saucepan, and simmer until the turnips are tender. Turn off the heat and mix in the miso. Divide the turnips and leaves into four bowls. Pour the soup on top and decorate with the citrus zest.

Silken tofu 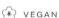 VEGAN

60 g (2 oz) wakame, rehydrated according to the packet instructions

700 ml (23½ fl oz) dashi (p. 166 or p. 122)

3 tablespoons white miso

150 g (5¼ oz) silken tofu

Chile powder or shichimi (Japanese 7-spice seasoning)

Cut the wakame into bite-sized pieces. Bring the dashi to a boil in a saucepan. Add the wakame. Turn off the heat and mix in the miso. Divide the silken tofu into four bowls using a spoon. Gently pour in the hot soup and sprinkle with chile or shichimi.

Sanga

さんが

FEATURE

I had heard the Sanga name on many people's lips: professional cooks, Japanese food lovers, and Japanese friends. "Have you ever tasted the miso from Sanga? You'll love it!" But no... I had never tasted it because I was bringing my miso back from Japan.

After the birth of my daughter, my way of preparing meals changed a lot. Previously, I used to cook what I felt like eating. Spicy, greasy, or even mono diet, I ate anything and everything! But with my little one, I had to make healthy meals every day. So, each morning I started to prepare miso soup with plenty of vegetables. This soup is a perfectly balanced dish, with all the nutritious properties of miso: enzymes, lactic bacteria, quality proteins.... In addition (and this is very important to me), it is quite simply very tasty! But the small amount of miso I was bringing back from Japan was no longer enough. That's how I ended up trying Sanga's miso. I immediately regretted all the years that had passed without having tried them. Their misos are superb and they are made locally in France.

Sanga's miso is very fruity. It is so fresh and "alive" that you can really taste the quality of the ingredients (organic, of course) and all the care taken to respect the fermentation stages, including through the cultivation of their own kōji.

Now, I always get their miso in France. For me and my family, a good miso is like a medicine that promotes our health and happiness every day.

After this experience, I started to look for more local producers offering Japanese products. Before that, I had naively thought that the quality of Japanese products made in Japan was unbeatable. But no! Some products made here in France are even better!

Miso

手作り味噌

A

B

Makes 1.8–2 kg (4 lbs–4 lb 6 oz) miso

500 g (1 lb 2 oz) whole yellow soybeans

500 g (1 lb 2 oz) dried rice kōji*

200 g (7 oz) salt

540 g (1 lb 3 oz) salt in a bag (use 30% of the weight of the miso paste to calculate salt weight, i.e., 1,800 g (4 lb) × 30% = 540 g)

Kōji is a "noble" mold culture called Aspergillus oryzae, which grows on cereals (such as rice, barley, soy, etc.) and allows the fermentation of foods such as miso, shoyu, sake, and mirin. It is essential in Japanese cuisine, and you can now purchase it online.

Use rubbing alcohol to disinfect a 3.5-liter (120-fl-oz) container with a lid, in which to ferment the miso (ceramic, metal, glass, or plastic).

Wash the soybeans in a bowl filled with water, rubbing them between your hands. Change the water two to three times, until it is clean and clear. Then soak the beans in 3 times their volume of water for 20 hours in winter / 15 hours in spring and autumn / 12 hours in summer. To check if a bean is properly soaked, break it in half. If the inside is flat, it is ready; if the inside is sunken, let soak for 1 to 2 more hours. Drain and pour the beans into a pressure cooker or saucepan and cover with water to 1 cm (½ inch) above the level of the beans.

Pressure cooking: Make sure the maximum filling level is not exceeded and cook in batches if needed.

Heat over medium-high heat. When it starts to whistle, cook for 20 to 25 minutes over low heat. Remove from the heat and allow the pressure to drop naturally before opening the lid.

発酵保存食

STEP-BY-STEP

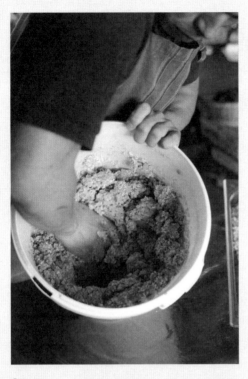

C

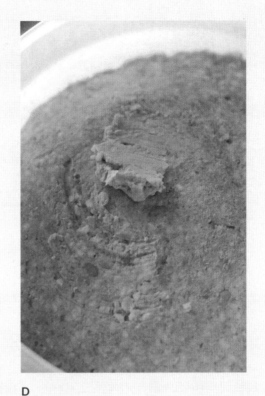

D

Pan cooking: Cook for 1½ to 2 hours over medium heat. Add water during cooking if the water no longer covers the beans.

To check if the beans are cooked, crush a bean between your fingers. If it crushes easily, then it is cooked **(A)**. If not, continue cooking the beans until they are tender. Drain, keeping a little cooking liquid in a bowl, and leave to cool slightly.

Blend the beans in a blender until you get a smooth paste **(B)** or put them in a bag and crush using a wine bottle or your feet.

In a mixing bowl, mix the kōji and salt, add the blended soybeans, and mix with clean hands until you get a nice smooth mixture **(C)**. If the paste is dry or breaks into small pieces, add a little cooking water. You need to get the consistency as smooth as an "earlobe."

Form a large, compact ball (the size of a tennis ball) with a generous handful of dough. Throw the ball firmly into the base of the container and then punch with your fist to release air bubbles, which could allow mold to form. Repeat the process until all the paste is used up.

Smooth out and cover with plastic wrap touching the surface. Place the weight (salt bag) on top and close with the lid. Keep at room temperature in a spot that is not too humid, not too hot, and not too cool, and is protected from light.

Once a month, check that mold is not forming on the miso. If it is, remove the layer of mold, sprinkle this spot with salt, and cover again. After 3 months, turn the miso over (the top layer goes to the bottom) with clean hands. Cover again with the weight and the lid. Leave to ferment for an additional 6 months before eating **(D)**.

TIP

If you cannot find soybeans, you can replace them with chickpeas (note that the cooking time is much shorter than for soybeans); it still tastes great!

Mackerel

SIMMERED IN MISO

鯖の味噌煮

Serves 4
Preparation: 10 minutes
Cooking: 20 minutes

½ large yellow bell pepper
1 leek
500 g (1 lb 2 oz) large mackerel fillets
50 ml (1¾ fl oz) sake
350 ml (12 fl oz) water
1 tablespoon soy sauce
2 tablespoons mirin
1½ tablespoons raw sugar
2 thin slices fresh ginger
3 tablespoons miso (brown or red)

Garnish
3 cm (1¼ inches) leek (white part)
1 pinch chile powder (optional)

To prepare the garnish, cut the leek white into very thin matchsticks, soak in a bowl of water for 15 minutes, and drain well.

Clean the vegetables. Cut the pepper into eighths and remove the seeds. Cut the leek into 3-cm (1¼-inch) pieces. Cut the mackerel fillets in half widthwise and make a slight cross-shaped incision on their skin to ensure even cooking. Put the sake, water, soy sauce, mirin, sugar, and ginger slices into a frying pan or saucepan large enough to fit the mackerel without overlapping. Bring to a boil.

Place the mackerel in the pan without overlapping, skin-side facing up, then the leek and the pepper. Cover and simmer for 10 minutes over medium heat. Place a few spoonfuls of cooking liquid into a bowl, then dissolve the miso in the liquid. Pour the paste and water mixture into the frying pan and cook, covered, for another 5 minutes. Remove the lid and cook for 2 to 4 minutes, allowing the liquid to evaporate.

Serve garnished with the leek matchsticks and chile powder, if desired.

発酵保存食

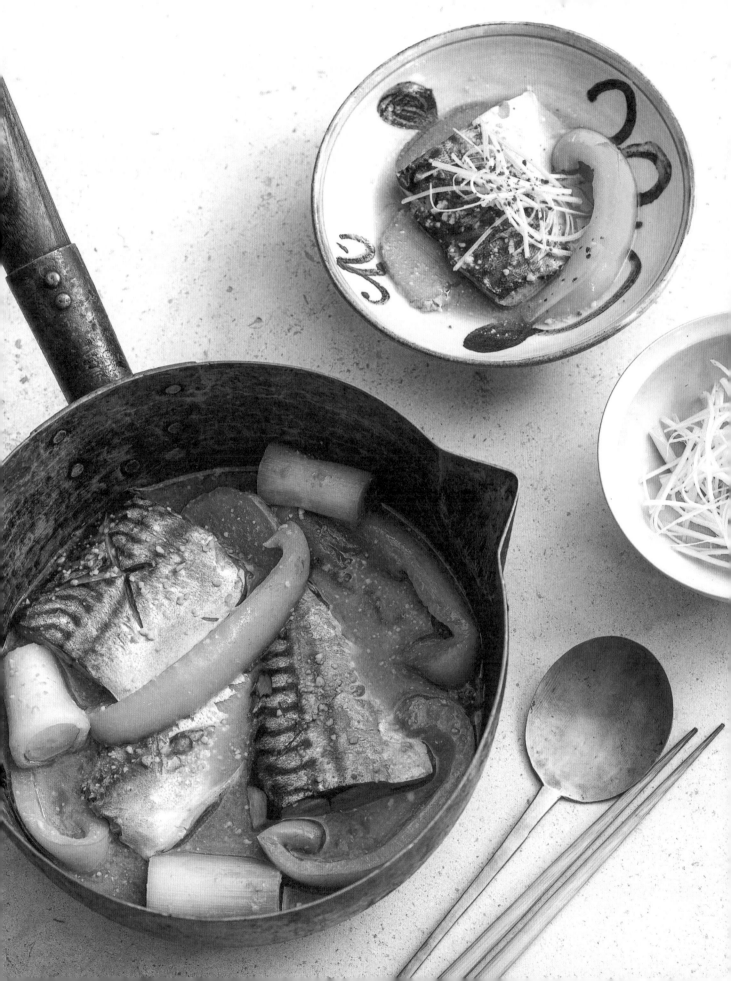

Dengaku

(VEGETABLE SKEWERS WITH MISO SAUCE)

 VEGAN

田楽

Serves 4
Preparation: 25 minutes
Cooking: 1 hour

Dengaku sauce
3 tablespoons red or brown miso
2½ tablespoons raw sugar
3 tablespoons mirin
2 tablespoons water
5 g (2 teaspoons) chopped walnuts

2 large Jerusalem artichokes
2 small carrots
160 g (5¾ oz) daikon (white radish) or a mixture of white and purple radishes
4 small turnips (approx. 200 g/7 oz)
1 teaspoon uncooked short-grain white rice

Broth
5 g (⅛ oz) dried kombu
2 pinches salt

Toppings
5 g (2 teaspoons) chopped walnuts
Zest ¼ yuzu or bergamot, finely chopped
4 chives, finely chopped

To prepare the dengaku sauce, combine the miso, sugar, mirin, and water in a small saucepan. Bring to a boil, stirring constantly, until the mixture thickens. Turn off the heat and stir in the walnuts.

Peel all the vegetables. Cut the carrots in half lengthwise. Cut the daikon into around 3.5-cm (1½-inch) slices, then in 4 or 6 pieces lengthwise. Cut the Jerusalem artichokes in half. Slightly trim the edges of the Jerusalem artichokes, carrots, and daikon to round them so as to prevent them from breaking during cooking.

Put the turnips, daikon, and rice into a pot of water. Bring to a boil and cook for 15 minutes. Drain and discard the rice. The rice is used to remove the bitterness from the turnip and daikon, and also helps make them more tender.

Thread the vegetable pieces onto skewers.

To prepare the broth, put the kombu and salt into a large pot and pour in enough water to submerge the skewers. Immerse the skewers and simmer, covered, for 30 minutes.

Serve the sauce in a small bowl. Place the toppings on small plates. Serve from the pot in the middle of the table.

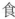

Spaghetti

WITH EGGPLANT, PEPPER, AND MISO SAUCE

 VEGAN

茄子味噌スパゲッティ

Serves 4
Preparation: 10 minutes
Cooking: 20 minutes

1 onion
1 eggplant
1 green bell pepper
2 tablespoons extra virgin olive oil
1 garlic clove, chopped
5 g (⅛ oz) fresh ginger, peeled and finely chopped
Salt
360 g (12¾ oz) spaghetti
120 g (4¼ oz) natto (p. 100) (optional)
Pepper

Sauce
4–5 tablespoons red miso
5 tablespoons mirin
2 teaspoons raw sugar
1 tablespoon soy sauce

Garnish
A few cilantro leaves
1 red chile, sliced into thin rounds

Cut the onion into large slices that are 2.5 cm (1 inch) thick. Cut the eggplant in quarters lengthwise and then into slices 7 mm (¼ inch) thick. Cut the bell pepper in half, remove the seeds, cut into slices that are 2.5 cm (1 inch) wide, then cut the slices in half lengthwise.

Mix all the sauce ingredients together in a bowl.

Heat the olive oil in a frying pan, add the chopped garlic and ginger, then add the eggplant, green bell pepper, and onion. Season with pepper and sauté until the vegetables are cooked but still slightly crunchy. Set aside.

In a large pan of salted boiling water (4 liters/16 cups water + 1 tablespoon of salt), cook the spaghetti al dente. Drain the pasta and add to the sautéed vegetable pan. Heat, add the sauce, and mix well. Taste, and add salt if needed.

Turn off the heat and add the natto, if using. Divide onto four plates. Season with pepper. Sprinkle with the cilantro leaves and chile slices.

I loved this recipe as a child and my mother often made this dish: a fusion between miso and olive oil. In the early days, the only Italian pasta recipes found in Japan were with Bolognese or napoletana sauce (spaghetti sautéed with ketchup). But at the end of the 1980s, there was an Italian cuisine (iitameshi) boom. Italian ingredients appeared in our everyday cooking and we started to make lots of pasta fusion recipes. I don't know where my mother learned this recipe, but it's one of my favorite pasta recipes. If you like natto (p. 100), feel free to add some. It is surprisingly tasty!

発酵保存食

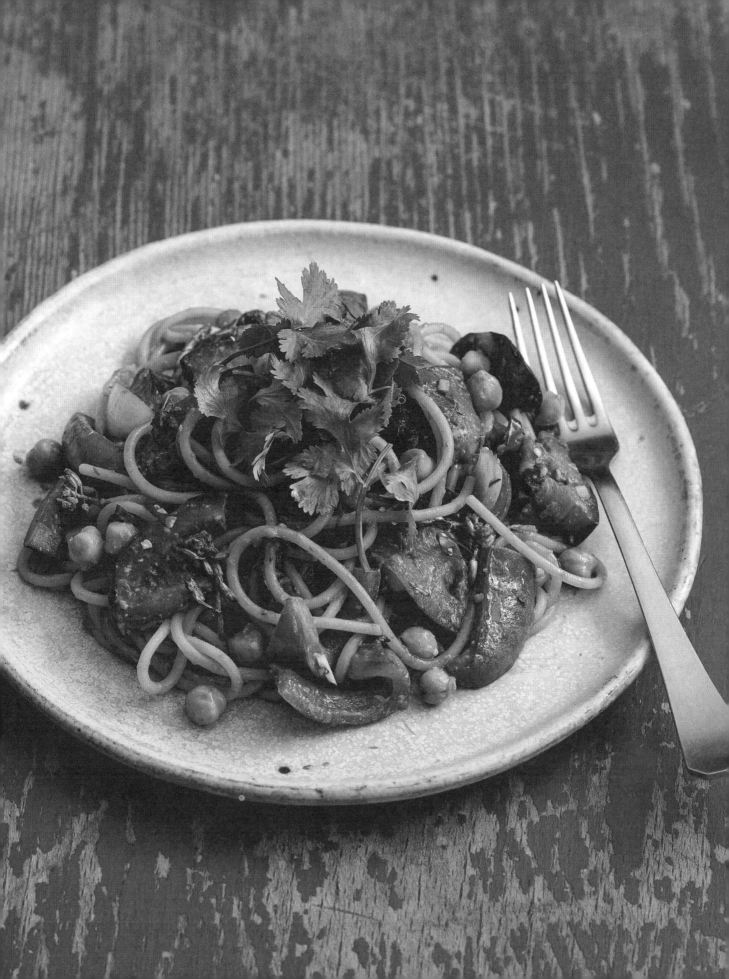

Salted cherry blossoms

 VEGAN

桜の塩漬け

Makes one 250 ml (8½ fl oz) jar
Preparation: 40 minutes
Resting time: 5–6 days

150 g (5½ oz) cherry blossom flowers
45 g (1½ oz) fine salt (or 30% of flower weight)
3–4 tablespoons lemon juice
A good amount of salt for preserving

Gently wash the cherry blossoms in a bowl of water. Pat dry gently between two clean tea towels. Line the base of a container with some of the flowers. Sprinkle with salt and some lemon juice. Make a new layer of flowers, then add salt, and lemon juice. Repeat this process until the flowers, salt, and lemon juice are used, ending with a layer of salt. Cover with parchment paper or plastic wrap touching the top layer. On top of that, place a lid that is smaller than the size of the container, so that the lid presses directly on the paper. Place a weight of approximately 100 g (3½ oz) (a jar filled with water, for example) on the lid. Leave to rest for 3 to 4 days in the refrigerator.

Spread flowers, without overlapping, on zaru baskets or on paper towels. Leave to dry in a cool, dark place for 2 days. The flowers should remain a little damp. Save the liquid at the bottom of the container—it is like cherry blossom vinegar.

Line the base of a container with dried flowers, cover with a layer of salt, and alternate until the flowers are used up. Finish with a generous layer of salt. The flowers will keep for a year at room temperature in the closed container, until the next cherry blossom season!

Only use flowers that are 70 to 80% open. To eat, wash the flowers in a bowl of water to remove the salt and gently pat dry. (To remove the salt thoroughly, soak in water for 2 to 3 minutes.)

Use cherry blossoms as a garnish (chirashi, p. 64, or meat bento, p. 196), in drinks (p. 216), or in desserts (kohakutou, p. 246), and enjoy the smell of spring throughout the year.

発酵保存食

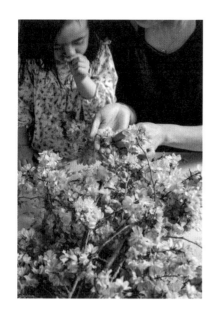
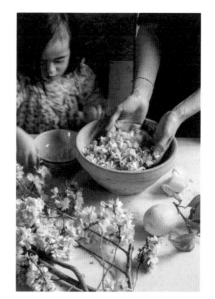

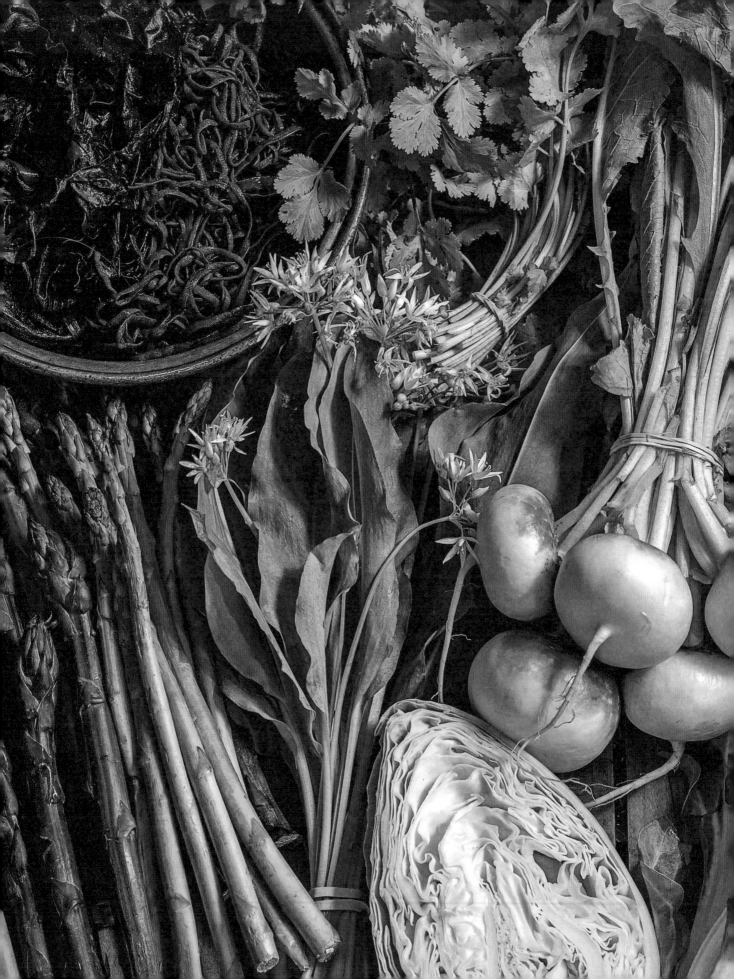

野菜

VEGETABLES

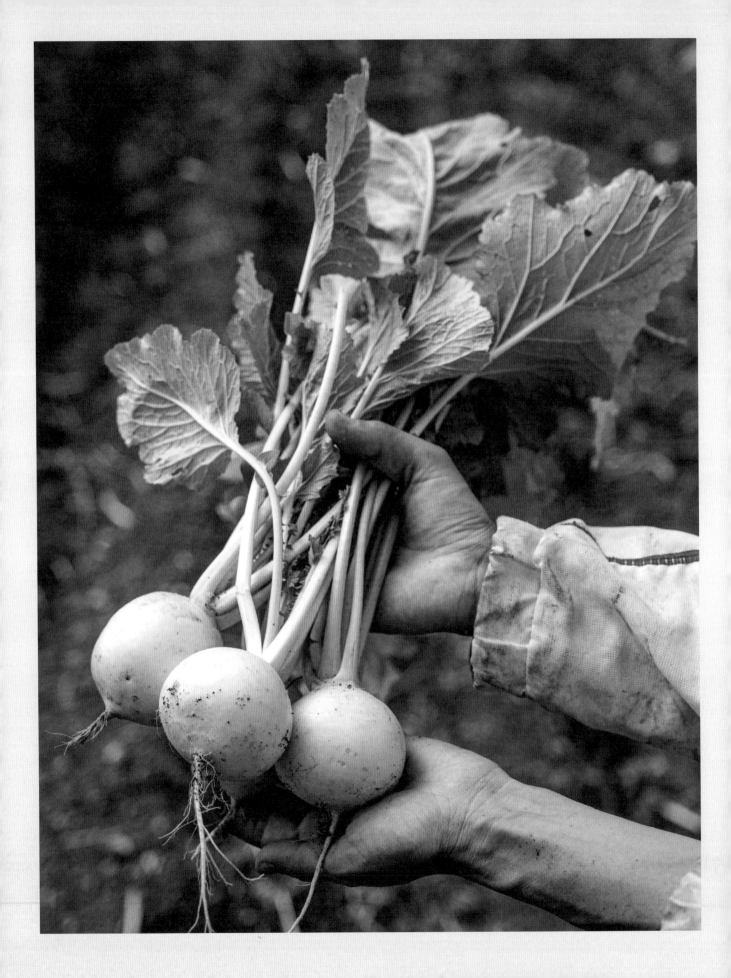

Yasai
やさい

FEATURE

I had been dreaming for quite a while of visiting the Yasai Japanese organic vegetable farm in the Touraine region of France, and meeting producer, Anna Shoji. Photos of magnificent vegetables and their daughter playing with chickens and goats kept popping up on their Instagram account notifications and I immediately thought of her when I started working on this book.

I visited them on a lovely summer's day. Under a blue sky scattered with summer clouds, just like in Japan, Anna showed us around the farm. Then we enjoyed fresh somen noodles (p. 34) with plenty of vegetables she had deftly and gracefully harvested as we toured the farm.

The Japanese turnips were extremely juicy and sweet, while the Japanese cucumbers were very crunchy, and the edamame, which are always small at the beginning of the season, were so tasty. I love the big leaves of tsuru-murasaki, but I had never found them before in France. The shiso was so fragrant, and there was gobo, Japanese burdock root . . . everything was so good that I couldn't believe my taste buds! We're in France!

It all began when Anna was working as an interpreter/coordinator in Algeria on a highway construction project. She started growing her own Japanese vegetables in her garden, and took great pleasure in growing and eating the vegetables from her country. She then left her work and moved to France, driven by a passion to introduce the French to the authentic taste of Japanese vegetables.

Today, the vegetables grown by Yasai are loved by both professionals and individuals, and production continues to grow. This year, they planted lotus roots in their lake. It will be the third year they have attempted to grow them. I can't wait to taste them!

Dashi shojin

VEGAN DASHI

精進だし

VEGAN

Makes 1 liter (4¼ cups) dashi shojin
Preparation: 3 minutes
Resting: 2 hours–overnight

10 g (¼ oz) dried shiitake mushrooms
5 g (⅛ oz) dried kombu
1 liter (4¼ cups) filtered water

Rehydrate the shiitakes and kombu. There are two methods. Method 1: Put the shiitake mushrooms and kombu in a jar. Bring the filtered water to a boil, pour it into the jar, close the lid, and leave to infuse for at least 2 hours. Method 2: Put the shiitake mushrooms and kombu in a jar, pour in the filtered water, close the lid, and leave to infuse overnight.

Dashi shojin can be stored for 3 days in the refrigerator (leaving the kombu and shiitake in the jar) and 1 month in the freezer (removing the ingredients before freezing).

This is very simple to prepare. I make a batch of dashi shojin every 3 to 4 days to always have some on hand. It is the basis of vegan daily cooking and is an excellent source of vitamin D and minerals. With my two-year-old daughter, it's always good to know I have this dashi in the refrigerator so that I can quickly prepare her a good bowl of miso soup every day.

TIPS

To rehydrate the kombu and shiitake, I prefer method 2 because you can taste the flavor of the ingredients better.
—
To use the rehydrated kombu after you've removed it from the dashi, see the recipes for quick pickles (p. 96), kombu kinpira (p. 127), and furikake seasoning (p. 167). Rehydrated shiitake mushrooms can be used in many recipes (gyoza stuffing, p. 40, and bun filling, p. 50) or to replace fresh mushrooms.

野菜

VEGETABLES

Gomadofu

(SESAME TOFU)

 VEGAN

胡麻豆腐

Serves 4
Preparation: 10 minutes
Resting: 4–12 hours
Cooking: 10 minutes

5 g (⅛ oz) dried kombu
400 ml (13½ fl oz) water
50 g (1¾ oz) kuzu (starch thickener)
50 g (1¾ oz) white or black sesame paste
1 pinch salt

Garnish
Wasabi
Grated fresh ginger
Sesame seeds
Rocket flowers
Soy sauce, for drizzling

Rehydrate the kombu in the water for at least 3 hours (ideally overnight). Remove the kombu. Put the kuzu in the kombu soaking water and dissolve completely using a whisk. Add the sesame paste and mix until completely dissolved. Add the salt and mix.

Wet the base of a 12 × 18-cm (4½ × 7-inch) baking tray with edges (or a container).

Heat the mixture in a small saucepan over medium-low heat. Stir continuously with a spatula, touching the bottom of the pan. When the texture thickens and comes away from the bottom of the pan while mixing, reduce the heat to low. Continue mixing for about 5 minutes, stirring in large circles right to the bottom.

Pour the mixture onto the wet tray, flatten the surface, lift the tray and drop it several times onto the work surface to remove the air. Cool to room temperature, then cover the surface with parchment paper or plastic wrap and leave to rest for 1 hour in the refrigerator before eating. Add the garnish of your choice and drizzle with a little soy sauce.

TIP
Kuzu can be found in health food shops or in Japanese grocery stores. It can be substituted with corn flour or arrowroot flour, although kuzu does have a much better taste.

野菜

Kinpira
(JAPANESE-STYLE STIR-FRIED VEGETABLES)

金平

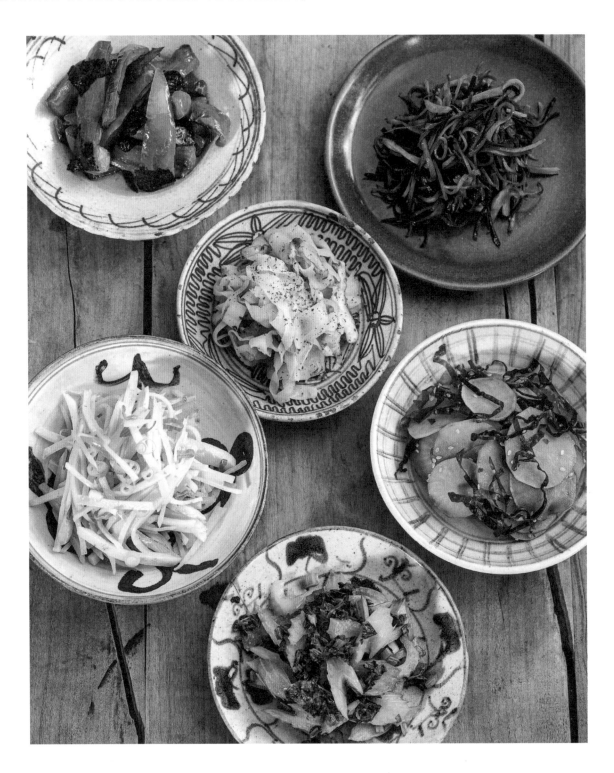

野菜

VEGETABLES

Serves 4

Green bell pepper kinpira VEGAN

1 green bell pepper
1 tablespoon sunflower oil
1 pinch salt
1 tablespoon soy sauce
1 nori sheet

Cut the pepper in half lengthwise and remove the seeds, then cut each half into 8 slices. Lay the pepper pieces in a saucepan, skin-side down. Drizzle with the oil and sprinkle with the salt. Cover and cook for 3 minutes over medium heat. Turn the pepper slices over, add the soy sauce, and cook, uncovered, for 5 minutes, until the pepper is tender. Turn off the heat and sprinkle with roughly torn pieces of nori.

Carrot kinpira VEGAN

1 carrot (90 g/3¼ oz)
2 teaspoons toasted sesame oil
1 tablespoon mirin
1 teaspoon soy sauce
½ teaspoon salt

Peel the carrot and cut into thin matchsticks. Heat the oil in a frying pan and sauté the carrot for 3 minutes over medium heat until cooked but crunchy. Add the mirin, soy sauce, and salt and sauté for 1 minute.

Burdock and shiitake mushroom kinpira VEGAN

1 fresh shiitake mushroom
1 large burdock root or salsify
1 tablespoon sunflower oil
1 tablespoon soy sauce
1 tablespoon mirin
1 teaspoon rice vinegar

Remove the stem from the shiitake mushroom and cut the cap into thin strips. Peel the burdock root and cut it into ribbons using a peeler. Immerse the ribbons in a bowl of water and let stand for 5 minutes, then drain well. Heat the oil in a frying pan and sauté the burdock and mushroom for 2 minutes over medium heat. Add the soy sauce, mirin, and rice vinegar and sauté for 1 minute.

Potato kinpira VEGAN

2 small, firm-fleshed potatoes
2 scallions
1 tablespoon sunflower oil
½ teaspoon salt
½ tablespoon soy sauce
1 tablespoon rice vinegar

Peel the potatoes and cut into thin matchsticks. Put them in a bowl, cover with water, let stand for 30 minutes, drain, and pat dry with paper towels. Finely chop the scallions. Heat the oil in a frying pan and sauté the potatoes for 1 minute over high heat. Add the salt, soy sauce, and rice vinegar and sauté for 1 minute. Add the scallions and turn off the heat.

Jerusalem artichoke and kombu kinpira 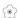 VEGAN

2 Jerusalem artichokes (180 g/6¼ oz)
1 slice kombu, 5 cm (2 inches) square, already used for dashi (p. 122)
1 teaspoon toasted sesame oil
1½ tablespoons mirin
1½ tablespoons soy sauce

Peel the Jerusalem artichokes and cut into thin slices: 2–3 mm (1/16–1/8 inch). Cut the kombu into thin matchsticks. Heat the oil in a frying pan and sauté the Jerusalem artichokes and kombu for 3 minutes over medium heat, until cooked but crunchy. Add the mirin and soy sauce and sauté for 1 minute.

Celery kinpira

2 celery stalks (stalks and leaves)
1 tablespoon sunflower oil
1 pinch salt
1 teaspoon soy sauce
1 teaspoon sugar
1 small handful katsuobushi (dried bonito flakes)

Peel the celery and cut diagonally into slices that are 3–4 mm (1/8–3/16 inch) thick. Heat the oil in a frying pan and sauté the celery for about 3 minutes over medium heat, until cooked but still crunchy. Add the salt, soy sauce, and sugar and sauté for 1 more minute. Add the katsuobushi by rubbing it between your hands to crumble it.

Agebitashi

(FRIED AND MARINATED VEGETABLES)

Serves 4
Preparation: 15 minutes
Marinating: 1–12 hours
Cooking: 15 minutes

1 eggplant
Salt
12 green beans
4 large fresh shiitake mushrooms
2 small carrots
1 zucchini
1 small red bell pepper
1 small yellow bell pepper
Oil, for frying

Marinade
200 ml (7 fl oz) mentsuyu (p. 14)
500 ml (2 cups) water
200 ml (7 fl oz) rice vinegar

Clean all the vegetables. Cut the eggplant into large pieces. Soak in a container of salted water for 5 minutes. Drain and pat dry. Cut the stem end off the beans (keep the end with the pointy tip). Cut the shiitake mushrooms in half and trim the end of the stem. Cut the carrots in half lengthwise, the zucchini into 1-cm (½-inch) rounds, and the peppers into eighths after removing the seeds.

Mix the marinade ingredients together in a large airtight container. Heat a 3 cm (1¼ inch) depth of oil to 170°C (340°F) in a deep frying pan. Fry all the vegetables in several batches, drain, and mix with the marinade while warm. Marinate for at least 1 hour before eating. This dish is even better prepared the day before because the vegetables then have time to fully absorb the umami of the mentsuyu overnight.

Serve with rice or pour the vegetables and sauce over fresh somen noodles (p. 34) for the perfect easy summer meal. Agebitashi will keep for 3 days in the refrigerator.

TIP
Soaking the eggplant in salted water prevents it from absorbing too much oil.

VEGAN VERSION
Replace the mentsuyu with mentsuyu shojin (p. 14).

Korokke
(POTATO FRITTERS)

✽ VEGAN

コロッケ

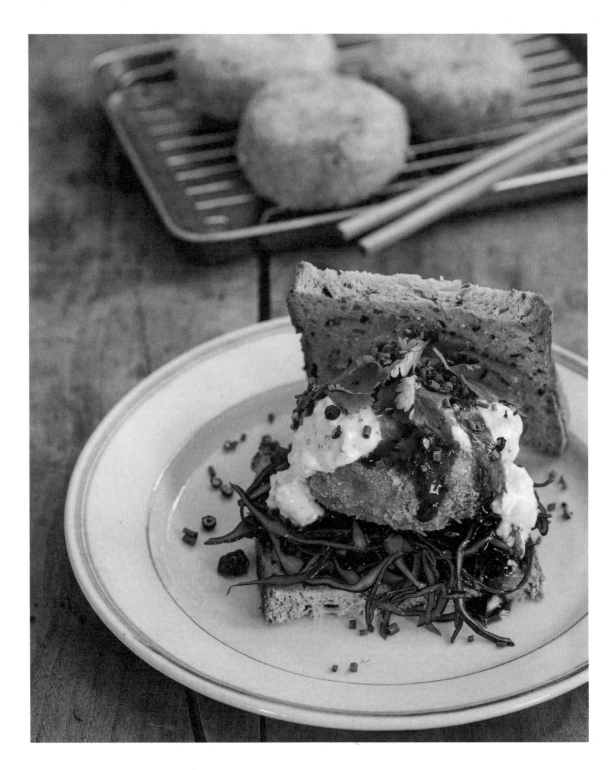

野菜

VEGETABLES

Serves 4
Preparation: 45 minutes
Cooking: 1 hour

½ large onion

60 g (2 oz) fresh shiitake mushrooms or other mushrooms

1 tablespoon extra virgin olive oil

5 g (⅛ oz) fresh ginger, peeled and finely chopped

600 g (1 lb 5 oz) potatoes, waxy or floury

Seasoning A

1 teaspoon soy sauce

1 tablespoon sake

1 pinch salt

Seasoning B

1½ tablespoons soy sauce

1 tablespoon mirin

2 pinches salt, pepper

Breading and frying

6 tablespoons all-purpose flour

6 tablespoons all-purpose flour + 100 ml (3½ fl oz) water

60 g (1 cup) panko breadcrumbs

Oil, for frying

Korokke sandwich

Serves 4

Red coleslaw

160 g (5¾ oz) red cabbage

2 tablespoons golden raisins

1 teaspoon coriander seeds

2 tablespoons rice vinegar

2 pinches salt

1 tablespoon olive oil

Mustard

8 slices toasted bread

4 korokke

Tonkatsu sauce

Tartar sauce (p. 176) without dill

Fresh herbs, like coriander, chives, and dill, finely chopped

Slice the onion into thin rings. Remove the stems from the shiitake mushrooms and cut into thin strips. Heat the oil and ginger in a frying pan over medium heat. Add the onion and cook until golden. Add the shiitake mushrooms and continue cooking until the mushrooms are tender. Add seasoning A and cook for 1 more minute while stirring. Remove from the heat and set aside.

Wash the potatoes and cut in half. Boil or steam until tender. Drain, peel, and crush them with a potato masher or fork. Mix the crushed potato with the onion-shiitake mixture. Add seasoning B, mix well, and shape eight slightly flattened oval patties.

Prepare three plates for breading: One with the flour, one with the flour and water mixed, one with the panko breadcrumbs, and arrange them in that order. Dip each patty in the flour plate, then in the flour-water mixture, and lastly in the panko. Place the patties on a plate.

Heat a 3 cm (1¼ inch) depth of oil to 180°C (355°F) in a deep frying pan. Drop the patties into the oil and fry them for 3 to 4 minutes, turning occasionally, until they are nicely golden brown. Drain on paper towels. Serve with rice, with a side of coleslaw (recipe below) and tonkatsu sauce, or in a sandwich.

Korrokke sandwich

Prepare the coleslaw. Cut the cabbage into thin strips, add the raisins, coriander seeds, vinegar, salt, and olive oil. Mix.

Spread a little mustard on the slices of bread. Top with the coleslaw, a korokke, tonkatsu sauce, tartar sauce, and herbs.

TIP

Cooking the potatoes with the skin preserves the flavors, but if you run out of time, you can peel them before cooking.

Charred eggplant

VEGAN

焼きなす

Serves 4
Preparation: 5 minutes
Resting: 10 minutes
Cooking: 20 minutes

2 eggplant
20 g (¾ oz) fresh ginger
5 shiso leaves (optional)
4 generous pinches katsuobushi (dried bonito flakes) (optional)
Soy sauce

Wash the eggplant. Poke a few holes in the eggplant with a skewer. Peel and grate the ginger. Cut the shiso leaves into thin strips, if using.

Preheat the oven to 250°C (500°F).

Place the eggplant on a sheet pan and put them in the oven to roast for 10 minutes on each side. Using a skewer, check if they are cooked. The eggplant must be tender right to the center and the skin charred and black.

Remove the eggplant and immediately put them in a paper bag on a plate (the steam will soften the skin). Leave to stand for 10 minutes, then remove the skin by hand.

Cut the eggplant in half and arrange on four plates. Sprinkle with the grated ginger and, if desired, the shiso leaves and katsuobushi.

Drizzle with soy sauce just before serving.

I love eating this dish in summer, with the melt-in-your-mouth eggplant and the smoky aromas. It's very simple, but I am always impressed at how it turns out.

TIP

You can also cook the eggplant directly over the flame of a gas burner until the skin is charred well and the eggplant are completely tender. They're even better this way! But I am including the oven method here because not everyone, myself included, has a gas cooktop at home. This dish is also great to make when you are having a barbecue.

野菜

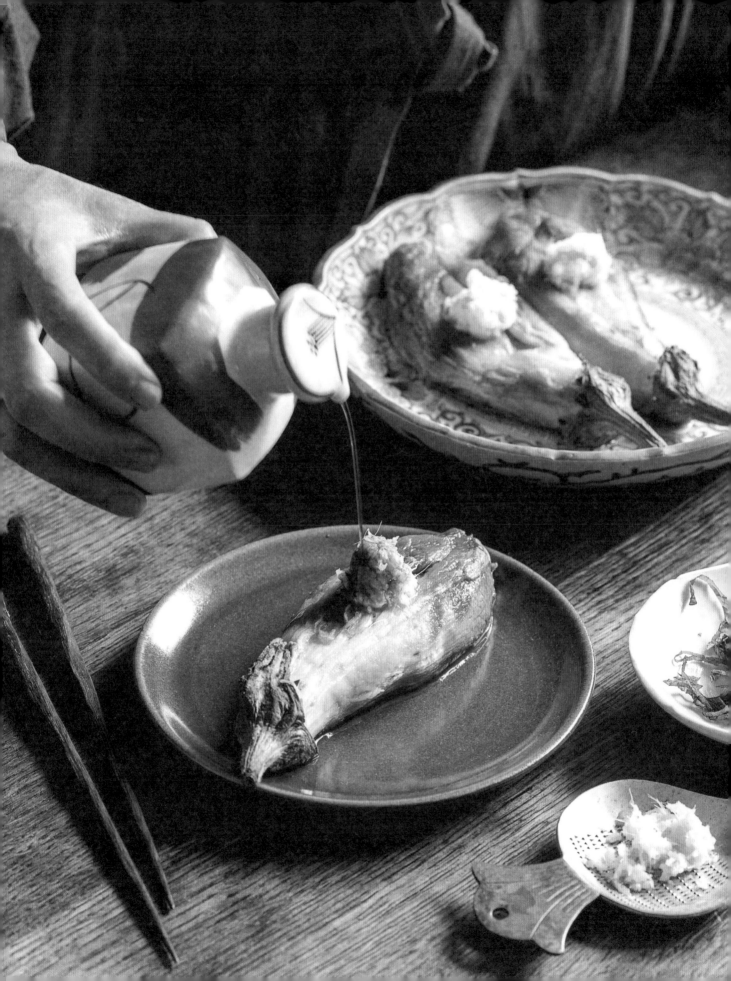

Oven-baked sweet potato

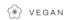 VEGAN

サツマイモのオーブン焼き

Serves 4
Preparation: 10 minutes
Cooking: 40 minutes

Sauce A
1 teaspoon gochujang (Korean pepper paste)
1 teaspoon rice vinegar
1 teaspoon raw sugar
1 teaspoon soy sauce

Sauce B
4 tablespoons soy sauce
½ teaspoon ground cumin
1 teaspoon salt
½ garlic clove, grated
Juice ⅛ lemon

1 sweet potato (approx. 500 g/ 1 lb 2 oz)
1 drizzle extra virgin olive oil

Garnish
1 pinch ground cinnamon
1 pinch raw sugar
4 tablespoons plain yogurt or plain soy yogurt
1 tablespoon extra virgin olive oil
5 crushed pecans
2 pinches ground sumac
Zest ⅛ lemon, cut into thin strips
A few dill leaves
1 pinch sea salt

Preheat the oven to 200°C (400°F).

Prepare the sauces. Mix all the sauce A ingredients together in a bowl and all the sauce B ingredients together in another bowl.

Cut the sweet potato in half lengthwise. Quickly rinse the two halves under water and drizzle with a little olive oil. Wrap each piece in aluminum foil. Bake in the oven for about 40 minutes. The sweet potato is cooked when the flesh is tender all the way through.

Place the sweet potato on a plate. Sprinkle with the cinnamon and sugar. Drizzle with the yogurt, the two sauces, and the olive oil. Sprinkle with the pecans, sumac, lemon zest, and dill, and scatter the sea salt over all.

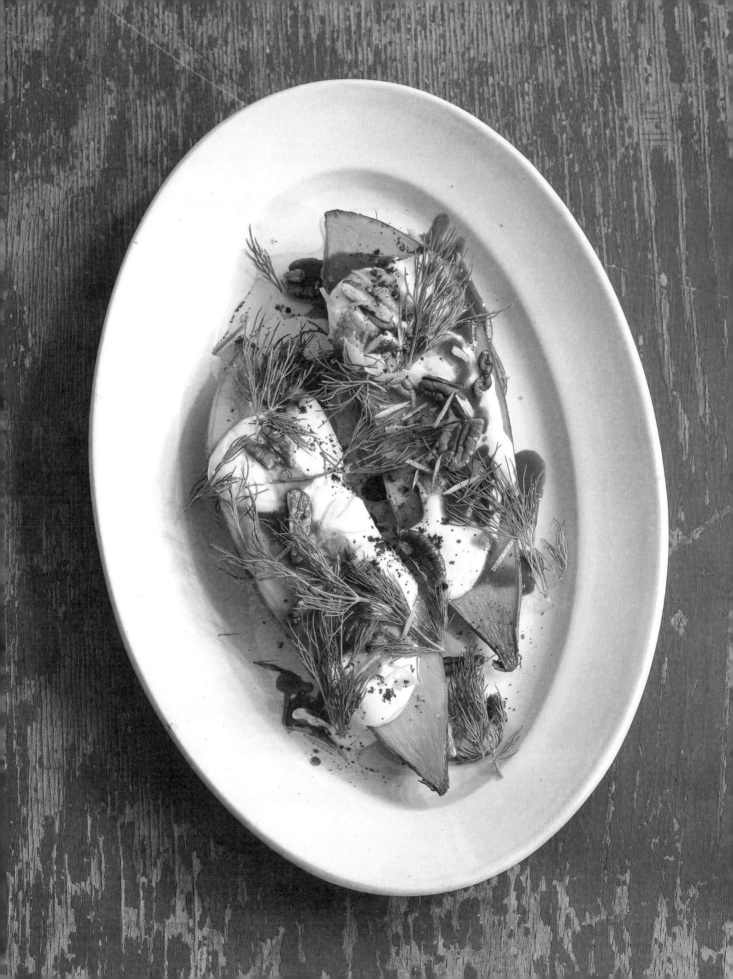

Potato salad

ポテトサラダ

VEGAN

Serves 4
Preparation: 15 minutes
Resting: 10 minutes
Cooking: 11 minutes

¼ red onion
¼ cucumber
Salt
30 g (1 oz) carrot
750 g (1 lb 10 oz) potatoes
6 tablespoons soy mayonnaise (p. 139) or traditional mayonnaise
Pepper

Seasoning
1 tablespoon extra virgin olive oil
½ teaspoon salt
1½ teaspoons raw sugar
1 tablespoon rice vinegar

Peel and slice the red onion into very thin rings. Put them in a bowl of cold water for 5 minutes to remove the bitterness. Drain well by squeezing lightly between your hands. Pat dry with paper towels. Wash the cucumber, cut in half lengthwise, remove the seeds, then slice thinly. Sprinkle with 1 pinch of salt and leave to drain for 10 minutes. Squeeze between your hands to remove excess water. Peel the carrot, cut it in quarters lengthwise, and then into thin slices.

Mix all the seasoning ingredients together in a small bowl.

Peel the potatoes and cut into quarters. Put the potatoes into a large pot and cover with water. Bring to a boil and cook for 10 minutes or until they are tender when poked with a knife. Drain, then put the potatoes back into the pot, add the carrot slices, and heat for about 30 seconds over medium heat, stirring the pot to allow the remaining moisture to evaporate. Remove from the heat.

Add the seasoning and onion slices while the potatoes are hot. They will absorb the flavors of the seasoning and cook the onion slightly. Leave to cool. Add the cucumber and stir in the mayonnaise. Season with pepper, taste, and adjust the seasoning as needed.

This is my favorite childhood salad. With homemade soy mayonnaise, it has a light, fresh taste and it's even better. I highly recommend you try it.

My favorite condiments

自家製調味料

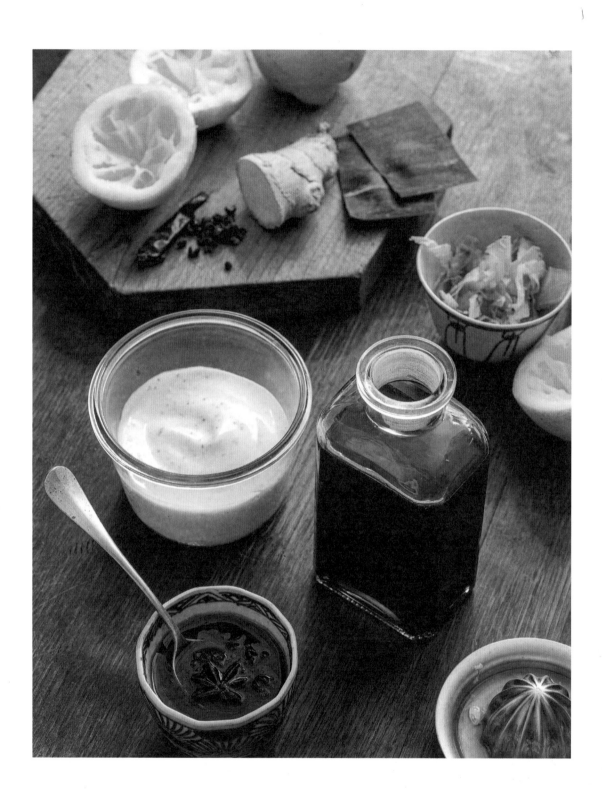

野菜

VEGETABLES

Soy mayonnaise ソイマヨネーズ VEGAN

Makes 120 g (4¼ oz) mayonnaise

50 ml (1¾ fl oz) soy milk with no added sugar or flavoring

60 ml (¼ cup) neutral oil

1 teaspoon Dijon mustard or seeded mustard

2 teaspoons rice vinegar

1 pinch raw sugar

2 pinches salt

Mix all the ingredients together with a spoon in a wide-mouth jar. Close and leave for 2 to 3 hours in the refrigerator. Mix with a stick blender. If the mayonnaise is too runny, leave to cool for an additional 2 hours to thicken. This is the perfect dressing for potato salad (p. 136) or tartar sauce (p. 176). It will keep for 1 week in the refrigerator.

This is my most successful recipe for this condiment. Its taste is so similar (better, in my opinion) to that of a traditional mayonnaise that people hardly notice the difference, but it is much healthier and lighter.

Ra-yu (ginger and spice infused oil) 辣油 VEGAN

Makes 120 ml (½ cup) ra-yu

90 ml (3 fl oz) grapeseed oil, sunflower oil, or cold-pressed sesame oil

15 g (½ oz) red chile flakes

2 dried red chiles, sliced into thin rounds, or mild Korean chiles

1 tablespoon Sichuan pepper

3 star anise

25 g (1 oz) fresh ginger, peeled and grated

½ teaspoon light brown sugar

1 pinch salt

Heat the oil in a small saucepan until it smokes. Put the remaining ingredients into a bowl and pour the oil on top (taking care not to burn yourself or inhale the air, as it can sting the eyes and throat). Mix and allow to cool. Pour into a jar. Ra-yu will keep for 1 month in the refrigerator.

I love using rayu with gyoza (p. 40) or in hiyashi tantan-men (p. 30), but also on sardine sashimi or even on a steamed potato with sea salt!

Ponzu (seasonal citrus sauce) ぽん酢

Makes 525 g (1 lb 3 oz) ponzu

80 ml (⅓ cup) mirin

200 ml (7 fl oz) soy sauce

10 g (¼ oz) dried kombu

15 g (½ oz) katsuobushi (dried bonito flakes)

200 ml (7 fl oz) seasonal citrus juice (bergamot, yuzu, lemon, etc.)

Heat the mirin, soy sauce, kombu, and katsuobushi in a saucepan over medium-low heat. When the mixture comes to a boil, turn off the heat. Leave to cool. Add the juice when the mixture has cooled completely. Strain the mixture with a sieve and extract as much liquid as possible. Transfer the sauce to a jar sterilized with boiling water and allow to mature for at least 3 days. The more the ponzu matures, the better it will be. It will keep for 6 days in an airtight jar in the refrigerator.

Use the ponzu to drizzle on white fish sashimi or tofu, as a hot pot sauce (p. 200), as a substitute for tempura sauce (p. 188), to make a wakame salad dressing (p. 155), or to sauté vegetables.

TIPS

You can find ponzu in Asian grocery stores, but it's often full of flavor enhancers. Nothing better than homemade!

—

If you cannot find mirin, replace it with 75 ml (⅓ cup) sake brought to a boil for 2 minutes + 1½ tablespoons raw sugar.

VEGAN PONZU

Replace the 15 g (½ oz) katsuobushi with 10 g (¼ oz) dried shiitake mushrooms. Leave the dried shiitake mushrooms to rehydrate overnight in the soy sauce and mirin with 40 ml (1¼ fl oz) water. Bring to the boil for 2 minutes with the kombu, then follow the rest of the recipe.

Homemade tofu

自家製豆腐

※ VEGAN

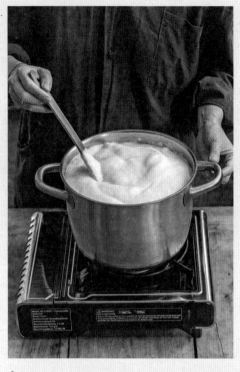

A

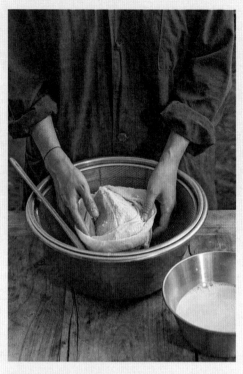

B

Makes 900 g (2 lb) tofu
Preparation: 1 hour
Soaking and restiing: 12–20 hours
Cooking: 20 minutes

300 g (10½ oz) whole yellow soybeans

Water A: 900 ml (30½ fl oz) water

Water B: 1 liter (4¼ cups) water

12 g (½ oz) nigari (food-grade magnesium chloride), diluted in 120 ml (½ cup) water

Utensils

1 muslin bag 25 x 40 cm (10 x 15½ inches)

1 thermometer

1–2 pieces muslin cloth, large enough to line the inside of the tofu container and extend over the edges about 5 cm (2 inches)

1 tofu box 10 x 13 x 8.5 cm (4 x 5 x 3½ inches) (otherwise, use a plastic container with holes poked in the bottom and sides)

Wash the soybeans in a bowl filled with water, changing the water two to three times. Then soak in water A for 20 hours in winter / 15 hours in spring and autumn / 12 hours in summer. To check if a bean is properly soaked, break it in half. If the inside is flat, it is ready; if the inside is sunken, let soak for 1 to 2 more hours then check again.

Use a blender to blend the beans in two or three batches with the soaking liquid, until a smooth and creamy texture is obtained. Pour the mixture (called 具, "go," in Japanese) into a large pot.

To clean the blender, pour 1 cup of water B into it and turn it on. Add the water from the blender and the remaining 3¼ cups of water from water B to the saucepan. Ideally, the go should not exceed one-third of the pot height. If it reaches up to halfway, it may overflow during cooking. Heat the go on high heat, stirring constantly. Use a large wooden spatula all the way to the bottom of the pot, making zigzag and crossways movements (the go burns very easily) **(A)**.

野菜

VEGETABLES

STEP-BY-STEP

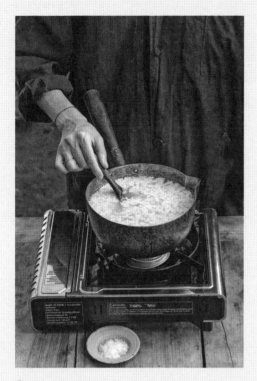

C

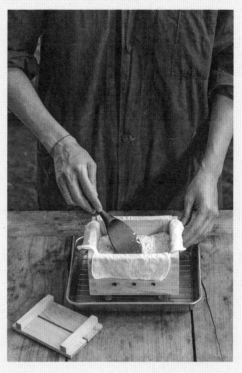

D

When it comes to a boil (be careful, the foam rises suddenly!), turn off the heat and continue stirring in the same way. When the foam has settled back down, return to low heat. Continue cooking for 8–9 minutes, stirring constantly, until the ray soybeans smell more like soymilk.

Prepare the muslin bag and pour the go into it **(B)**. While the go is still warm, squeeze it by hand (with gloves) or with a spatula to get as much liquid out as possible. The liquid becomes your homemade soy milk. The remaining soy pulp is called "okara."

Pour the soy milk into a saucepan. Heat to 80°C (175°F) while gently scraping the bottom of the pan. When small bubbles start to form on the liquid, just before boiling, remove from the heat. Add half of the diluted nigari by pouring it on the spatula, and gently mix by making cross shapes on the bottom of the pan. Add the rest of the nigari in the same way, mix, then gently remove the spatula. The mixture will start to curdle **(C)**. Cover and leave to rest for 10 minutes.

Place the muslin in the tofu box as shown (D). Place the box on a tray to catch the water that drains out. Pour the soy milk mixture into the box. Smooth the surface **(D)**. Fold the muslin over the mixture and place a weight on top of it (this can be a glass or a bowl filled with water). Leave to drain for 30 minutes (or more for a firmer tofu).

Carefully remove the tofu and place it in a container and cover entirely with water. Fresh tofu can be eaten right away, but submerging in water for 30 minutes can help to remove the slightly bitter taste of the nigari.

TIPS

Homemade tofu will keep for 2 to 3 days in an airtight container in the refrigerator. It's even better if you eat it right away!

—

Okara will keep for 3 days in the refrigerator and 1 month in the freezer. It can be used in other recipes (unohana, p. 152, or sesame okara doughnut, p. 234).

Tofu

豆腐

FEATURE

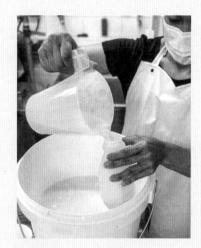
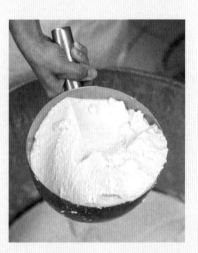

The Japanese who live in Paris are always on the lookout for good tofu. It was through talking to them that I heard of Suzu tofu. I didn't know that "Suzu" came from the name of the brand's founder, "Mr. Suzu," Akira Suzuki, who has dedicated his life to making "real" Japanese tofu in France. He is now retired but passed on his passion and vision to Mrs. Ogawa. Twice a week, with her two colleagues, her day starts by turning on the machines from Japan to crush the soybeans, make the creamiest soy milk I have ever tasted in France, and produce a fresh and tasty tofu. She does all this with the help of the machines, but also through many stages of careful manual work. The soybean vapor and the sweet smell of the soy milk cooking take me back to my childhood.

In my local suburb there was always at least one tofu shop open every day, very early in the morning, for people who wanted to have fresh tofu for their breakfast. It's like a fresh baguette just out of the oven. There is no greater pleasure than having quality fresh tofu in miso soup to start the day!

As is the tradition in Japan, Suzu tofu is delicately cut and stored in water to keep it fresh until it is eaten. Mrs. Ogawa let me taste a piece of freshly cut tofu that was still warm and it had the same rich and delicate flavor I remember from Japan.

Tofu is not bland. It's tasty. You can also make it at home (see step-by-step p. 140). It takes time, it's a lot of work (that's why in Japan you find tofu shops in every suburb!), but your efforts will be rewarded!

Tofu salad

WITH NUTS AND HERBS

木の実とハーブの豆腐サラダ

VEGAN

Serves 4
Preparation: 10 minutes
Cooking: 5 minutes

20 g (¾ oz) sesame seed, walnut, and hazelnut mix
4 chives
4 sprigs cilantro
400 g (14 oz) silken tofu

Sauce
2 tablespoons soy sauce
1 tablespoon raw sugar
1 tablespoon toasted sesame oil

Fried garlic and oil
3 tablespoons neutral oil
2 garlic cloves, thinly sliced

Coarsely chop the walnuts and hazelnuts and mix them with the sesame seeds. Finely chop the chives and cilantro stems. Keep the cilantro leaves for decoration.

Mix all the sauce ingredients together in a bowl.

Pour the neutral oil into a small frying pan, add the garlic, and heat. Fry the garlic over medium-low heat until golden. Drain and keep the oil.

Drain the tofu well and place in a bowl. Add the chives and cilantro stems, drizzle with the sauce and the garlic oil, and sprinkle with the nuts and seeds, cilantro leaves, and garlic slices. Serve immediately.

TIP
Silken tofu can release water quite quickly. If you prepare this dish too much in advance, the sauce will become diluted with tofu water. Cook this dish just before serving it! I just love to put this salad on hot rice!

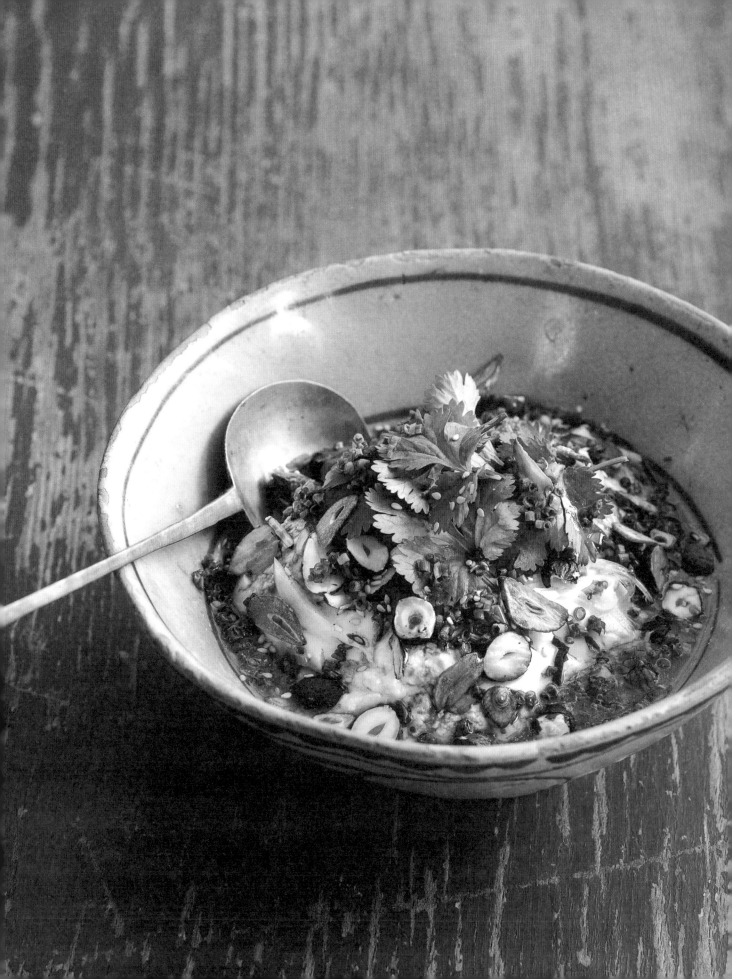

Ganmodoki

(FRIED TOFU DUMPLINGS)

 VEGAN

がんもどき

Serves 4–6
Preparation: 15 minutes
Cooking: 7 minutes

1 small carrot
4 g (1/10 oz) dried hjiki seaweed or 2 g/1/16 oz other dried seaweed
60 g (2 oz) fresh shiitake mushrooms
¼ onion
120 g (4¼ oz) potatoes
500 g (1 lb 2 oz) firm tofu
2 tablespoons toasted sesame seeds
Oil, for frying

Seasoning

2 tablespoons soy sauce
2 pinches salt
2 tablespoons mirin
1 tablespoon potato starch or corn flour

Garnish

50 g (1¾ oz) daikon (white radish) or purple radish, grated
10 g (¼ oz) fresh ginger, peeled and grated
Soy sauce

Peel the carrot and cut into thin matchsticks. Rehydrate the seaweed according to the packet instructions and drain by squeezing between your hands. Cut the shiitake mushrooms into thin strips. Cut the onion into thin slices. Peel and grate the potatoes. In a blender or using a stick blender, blend the tofu completely until you get a paste. Put the tofu, vegetables, seaweed, sesame seeds, and seasoning ingredients in a mixing bowl. Shape 10 balls with your hands (lightly oil your hands to prevent the mixture from sticking to your fingers).

Pour frying oil into a frying pan deep enough to immerse the balls. Heat the oil to 160°C (320°F). Fry the ganmodoki for 6 to 7 minutes, until they are nicely golden. Drain and serve immediately garnished with the radish, grated ginger, and soy sauce.

TIP

Fried ganmodoki can be stored in a ziplock bag in the freezer for a few weeks. They are also delicious in oden (p. 184).

野菜

VEGETABLES

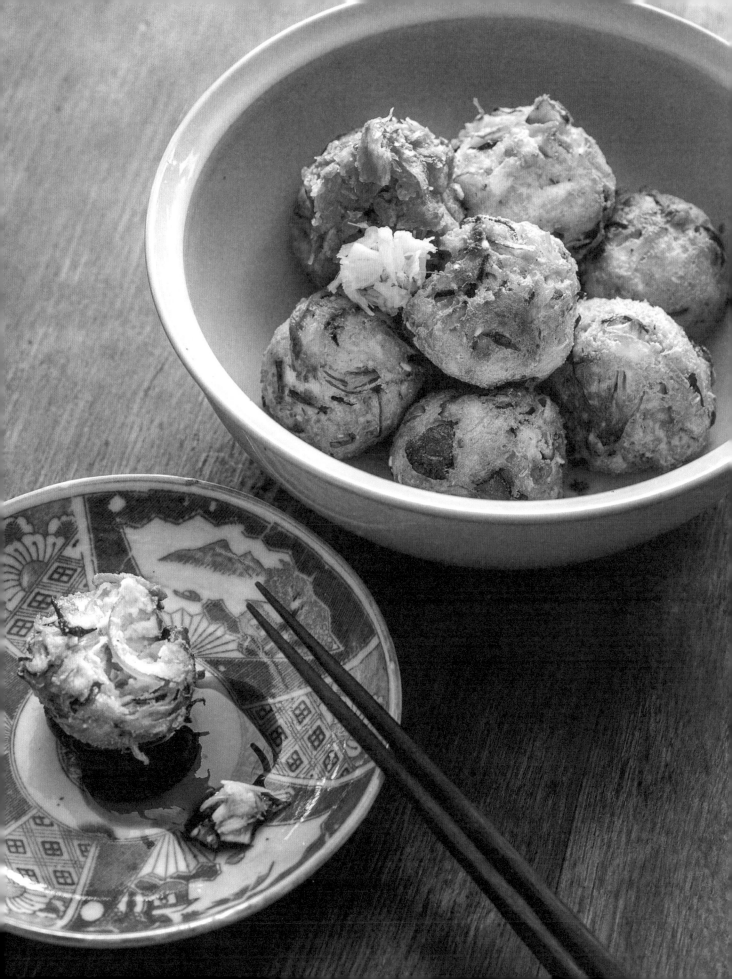

Rice paper rolls
WITH FRIED TOFU AND PEAR

 VEGAN

揚げ豆腐の生春巻き

Serves 4
Preparation: 30 minutes
Cooking: 5 minutes

60 g (2 oz) carrot, peeled
Juice ⅛ lemon or lime
1 teaspoon soy sauce
½ teaspoon raw sugar
125 g (4½ oz) firm tofu
2 tablespoons potato starch or corn flour
2 tablespoons neutral oil
50 g (1¾ oz) rice vermicelli
8 rice paper wrappers
16 mint leaves
Cilantro leaves from 8 sprigs
30 g (1 oz) purple radish or red cabbage, cut into thin strips
½ large Packham pear, peeled and cut into eighths
2 lettuce leaves, washed, spin dried, and halved

Sauce
1 tablespoon peanut butter
1½ tablespoons raw sugar
1 tablespoon fish sauce
2 tablespoons water
Juice ¼ lemon or lime
¼ garlic clove, chopped
2 tablespoons roasted peanuts, chopped

Cut the carrot into thin matchsticks and put in a bowl with the lemon juice, soy sauce, and sugar. Leave to marinate for 5 minutes. Cut the tofu into 8 long sticks. Flour them with the starch. Heat the oil in a frying pan over low heat and brown the tofu on all sides. Drain on paper towels.

Cook the rice vermicelli noodles for 1 minute in a pot of boiling water. Drain well.

Mix all the sauce ingredients together in a bowl.

Rehydrate the rice paper wrappers by soaking fully in water for 1 second (they continue to absorb water when removed)—they will soften after 1 minute. Place them on a work surface or on four large plates. Arrange two mint leaves and an equal amount of cilantro leaves at the edge of each rice paper. Then divide the carrot, tofu, radish, pear pieces, and rice vermicelli among the wrappers. Finish with ½ lettuce leaf per roll.

To roll up, carefully fold the sides over the filling to wrap tightly. Fold the bottom of the wrapper up on top of the filling and roll all the way up to the top. Serve immediately with the sauce.

If you eat them a little later (the same day), keep them in the refrigerator covered with plastic wrap.

NONVEGAN VERSION
Replace the soy sauce with fish sauce.

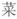

野菜

VEGETABLES

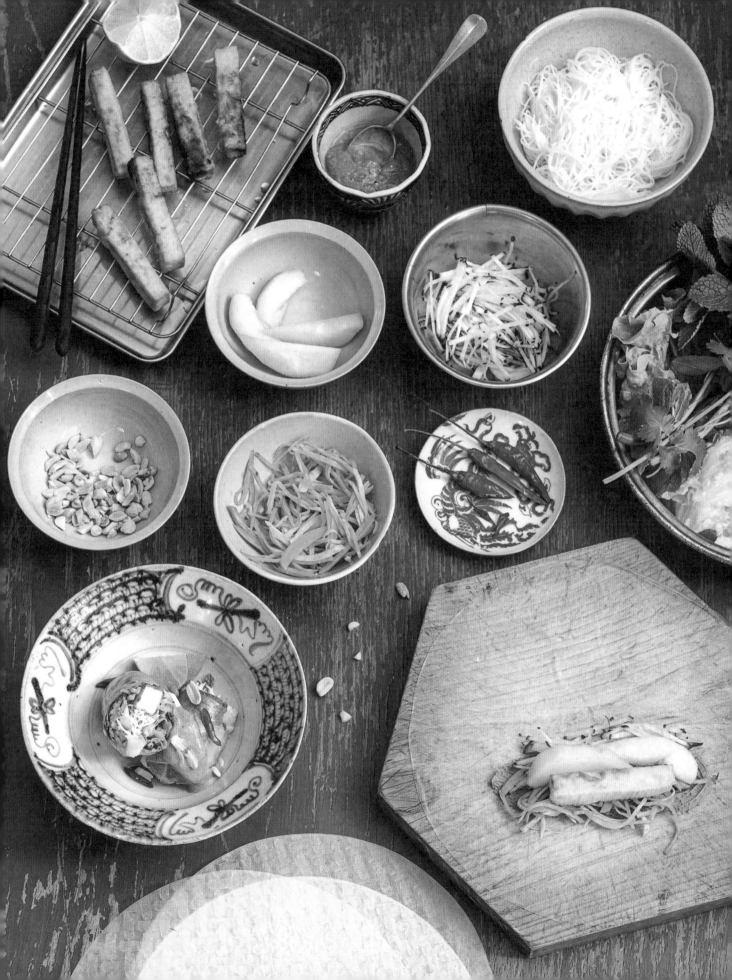

Mabo-doufu

(TOFU WITH SPICY SAUCE)

 VEGAN

麻婆豆腐

Serves 4
Preparation: 20 minutes
Resting: 1–2 hours
Cooking: 20 minutes

Mabo sauce

5 g (⅛ oz) dried shiitake mushrooms

200 ml (7 fl oz) + 2 tablespoons water

2 tablespoons potato starch or corn flour

2 tablespoons neutral vegetable oil

10 g (¼ oz) fresh ginger, peeled and finely chopped

1 garlic clove, chopped

10 cm (4 inches) leek (white part), finely chopped

50 g (1¾ oz) soy protein (small pieces) or 100 g (3½ oz) ground pork

1 red chile, finely chopped

1 tablespoon Sichuan pepper

50 g (1¾ oz) baby bella or cremini mushrooms, chopped

2 tablespoons soy sauce

2 teaspoons raw sugar

1 tablespoon mirin

1 teaspoon brown or red miso

1 teaspoon toasted sesame oil

250 g (8¾ oz) silken tofu

Pepper

A few cilantro leaves

To make the mabo sauce, rehydrate the dried shiitake mushrooms by soaking in the 200 ml (7 fl oz) of water (for at least 2 hours in warm water, 1 hour in boiling water). Drain (but keep the soaking liquid) and finely chop. Rehydrate the soy protein according to the packet instructions. In a small bowl, dilute the potato starch in the remaining 2 tablespoons water.

Put the tofu in a bowl that goes into a steamer (or steamer basket), and steam it over medium heat for 7 minutes.

To finish the mabo sauce, pour the oil into a frying pan and immediately add (before the oil is hot) the chopped ginger, garlic, and leek. Fry over medium heat until the aromas release. If using ground pork instead of soy protein, add it here and stir fry until it's cooked. Add the chile and Sichuan pepper and fry for 1 minute. Add the chopped shiitake mushrooms, baby bella mushrooms, and soy protein and brown until the mushrooms are cooked. Add the shiitake soaking liquid, soy sauce, sugar, mirin, and miso. Cover and leave to simmer for 3 to 4 minutes, stirring occasionally. Add the diluted starch and stir until the texture thickens. Add the sesame oil and turn off the heat.

With a large spoon, divide the tofu onto four plates, making sure you drain the water that has been released. Pour some mabo sauce on top, season with pepper, and sprinkle with cilantro leaves.

This recipe is originally from China but is very popular in Japan. My father makes this dish very well, but he never reduced the amount of chile for his children. This dish was my first introduction to chile! The traditional recipe is made with minced pork and firm tofu cut into 1-cm (½-inch) cubes. I prefer to use silken tofu as it's often easier to find.

野菜

VEGETABLES

Unohana

(OKARA SIMMERED WITH DASHI AND VEGETABLES)

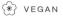 VEGAN

卯の花

Serves 4–6
Preparation: 15 minutes
Resting: 3 hours
Cooking: 12 minutes

10 g (¼ oz) dried shiitake mushrooms
400 ml (13½ fl oz) dashi (p. 166) or vegan dashi shojin (p. 122)
½ zucchini
1 scallion
½ carrot
100 g (3½ oz) Jerusalem artichoke
2 large fresh shiitake mushrooms or other mushrooms
1 tablespoon neutral oil
300 g (10½ oz) okara (p. 141)

Seasoning
2 tablespoons neutral oil
3 tablespoons soy sauce
2 tablespoons mirin
2 tablespoons raw sugar
1 teaspoon salt

Soak the dried shiitake mushrooms in the cold dashi for 3 hours. Drain but keep the dashi for seasoning.

Wash the zucchini and cut it in half lengthwise, then into slices that are 3 mm (⅛ inch) thick. Cut the scallion into thin rounds. Peel the carrot and Jerusalem artichoke, cut them into 3-cm (1¼-inch) slices, and then into thin matchsticks. Finely slice the fresh and rehydrated shiitake mushrooms.

Heat the oil in a saucepan and brown all the vegetables except the scallion for 2 minutes over high heat. Add the okara and mix. Add all the seasoning ingredients. Leave to simmer over medium heat, stirring constantly, for about 10 minutes, until the cooking liquid evaporates and the mixture thickens. At the end of cooking, add the scallion, mix, and serve.

野菜

Aemono

(JAPANESE SALAD WITH THREE SEAWEEDS)

三種の和え物

野菜

VEGETABLES

✻ VEGAN

Asparagus and sea spaghetti salad with tofu-sesame sauce
アスパラガスと海藻の白和え

Serves 4

180 g (6¼ oz) asparagus
Salt
50 g (1¾ oz) rehydrated sea spaghetti or wakame*

Tofu-sesame sauce

250 g (8¾ oz) silken tofu
2 tablespoons white tahini
2 tablespoons toasted sesame seeds
2 teaspoons soy sauce
1 teaspoon mirin
1 teaspoon raw sugar
½ teaspoon salt

Optional

Zest 1 yuzu or other citrus (bergamot, lemon, etc., cut into thin strips)

Peel the asparagus and remove the woody section of the stems. Cook the asparagus for a few minutes in a saucepan of lightly salted water. They need to be cooked but still a little crunchy. Cut into 4-cm (1½-inch) sections.

To prepare the tofu-sesame sauce, blend all the ingredients with a stick blender until you get a smooth texture. In a bowl just before serving, combine the asparagus, sea spaghetti, and sauce. Sprinkle with yuzu zest, if desired.

To get 50 g (1¾ oz) of rehydrated sea spaghetti, use about 35 g (1¼ oz) of fresh salted sea spaghetti.

✻ VEGAN

Avocado and nori salad with sesame oil
アボカドと海苔の和え物

Serves 4

2 avocados
¼ lemon
1 nori sheet

Sauce

2 teaspoons toasted sesame seeds
4 teaspoons toasted sesame oil
2 teaspoons soy sauce
¼ garlic clove, grated
½ teaspoon raw sugar
½ teaspoon salt

Cut the avocados in half and remove the pits and skin. Break them with your fingers into large pieces. If they are too ripe, cut into pieces with a knife. Sprinkle with lemon juice. Roughly tear the nori sheet into pieces.

Mix all the sauce ingredients in a small bowl. In a bowl just before serving, combine the avocados, nori, and sauce.

✻ VEGAN

Wakame, oyster, and cucumber salad with dressing
わかめの和え物

Serves 4

40 g (1½ oz) rehydrated wakame*
120 g (4¼ oz) cucumber
12 oysters
5 g (⅛ oz) fresh ginger, peeled and finely chopped

Dressing

4 tablespoons ponzu (p. 139)
4 tablespoons dashi (p. 122)
2 teaspoons raw sugar
½ teaspoon salt

Cut the wakame into long strips that are 3 cm (1¼ inches) wide. Cut the cucumber in half lengthwise, remove the seeds, and cut into very thin half rounds. Open the oysters, remove them from their shells, wash gently, and pat dry.

Mix all the dressing ingredients together in a small bowl.

Divide the wakame, cucumber, and oysters onto four plates. Sprinkle with the chopped ginger. Drizzle with the dressing just before serving.

To get 40 g (1½ oz) rehydrated wakame, use 4–6 g (⅛ oz) dried wakame or 25 g (1 oz) fresh salted wakame.

Korean-style pancakes
WITH SEAWEED AND POTATO

 VEGAN

韓国風海藻とジャガイモのお好み焼き

Serves 4
Preparation: 10 minutes
Cooking: 20 minutes

Sauce
Juice ½ lemon
3 tablespoons soy sauce
2 teaspoons toasted sesame oil
2 pinches raw sugar
1 teaspoon toasted sesame seeds

Fritters
100 g (3½ oz) carrot
½ red onion
500 g (1 lb 2oz) potatoes with firm flesh
40 g (1½ oz) rehydrated seaweed (wakame, hijiki, sea spaghetti, etc.)*
40 g (1½ oz) rice flour
2 pinches salt
Neutral oil
A few cilantro leaves

*To get 40 g (1½ oz) of rehydrated seaweed, use about 4 g (⅒ oz) dried wakame; about 5 g (⅛ oz) dried hijiki; or about 26 g (1 oz) fresh salted sea spaghetti or wakame.

To make the sauce, mix all the ingredients in a bowl and set aside.

Peel the carrot and onion and cut into thin matchsticks. Peel and grate the potatoes. Cut the rehydrated seaweed into bite-sized pieces (if the seaweed pieces are very large). Combine the carrot, onion, and seaweed in a bowl and mix together. Add the grated potatoes and mix well by hand. Add the rice flour, salt, and mix well by hand. Shape into 16 fritters.

Heat 2 tablespoons of oil in a frying pan over medium-high heat. Once the oil is hot, fit as many fritters in the pan as you can without them touching. Cook until one side is golden brown, 2-3 minutes. Turn the fritters over and cook the other side, 2-3 minutes, until golden brown. Repeat the process until all the fritters are made, using generous amounts of cooking oil to grease the pan. In my frying pan, I made four batches of four fritters.

Serve with the sauce. Garnish with the cilantro.

This is a dish inspired by the Korean savory pancake chijimi, which is very popular in Japan. You can also add seafood, such as shrimp or oysters.

野菜

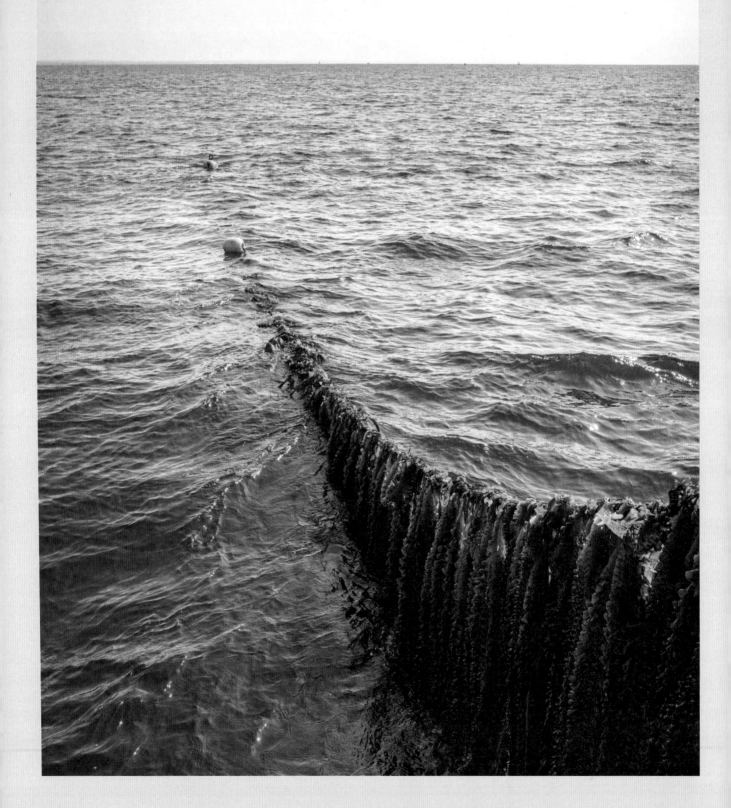

Seaweed

海藻

Seaweed is one of the essential ingredients of Japanese cuisine, but since living in France I haven't used it much because I don't really like buying it in plastic packets imported from far away. So I bought plenty of seaweed every time I returned to Japan, and when my stock ran out, I didn't cook dishes with seaweed anymore. Until the day when Julie, founder of Hep Ken, contacted me to introduce me to her products (she is also a fantastic cook who has many original recipes). Hep Ken sells organic algae from Brittany, including fresh wakame and kombu, and salts it using traditional Japanese techniques.

I was thrilled that she had contacted me, and even happier after tasting her products! Her wakame is as good as what you get in Japan. As for kombu, it is slightly different, but it still makes a good dashi. She also sells sea spaghetti, which doesn't exist in Japan, but I immediately fell in love with it when I starting using it in my cooking. I am pleased that I can now find good seaweed locally produced in France.

I met with her supplier, Algolesko, an algae producer in Loctudy. These people are so passionate about seaweed that they discuss methods with farmers in Tokushima, the region known for producing Japan's best wakame. The Breton team went there to work in the wakame farms and learn how to produce it. In return, the Japanese team came to watch the French team's algae cultivation in Brittany. They told me all about these enriching exchanges. Cooking with seaweed is still little known in France, but I am sure this won't be the case for long, thanks to these passionate people who produce quality seaweed.

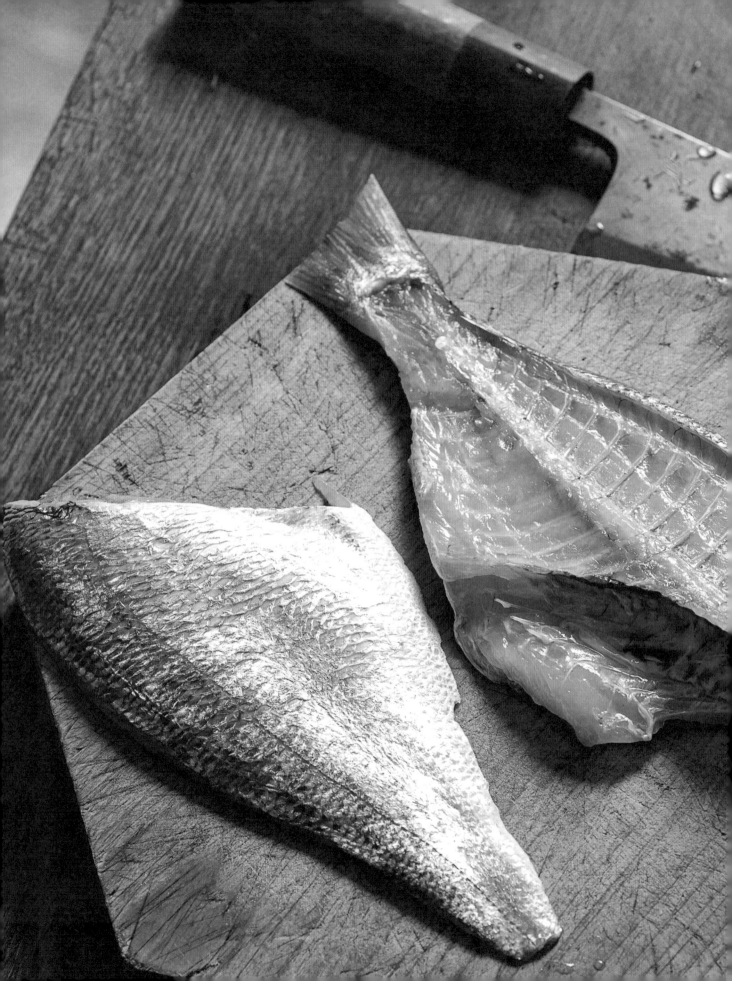

魚

FISH

Sashimi salad

刺身サラダ

Serves 4
Preparation: 15 minutes
Cooking: 3 minutes

10 grapes
½ cucumber
1 carrot
1 sheet filo dough
Oil, for frying
300 g (10½ oz) wild sea bream, tuna, or sardine, sashimi quality*
2 tablespoons roughly chopped peanuts
A few sprigs chervil
Pepper
Sea salt

Seasoning

Juice 1 lemon
2 tablespoons sesame oil
2 tablespoons sunflower oil
3 tablespoons soy sauce
¼ garlic clove, grated

*Check with your fishmonger that the fish is fresh enough to be eaten raw.

Cut the sea bream into thin slices. Cut the grapes in half. Wash the cucumber, cut in half lengthwise, remove the seeds, and cut into thin matchsticks. Peel the carrot and cut into thin matchsticks. Cut the filo dough into thin strips that are 5 cm (2 inches) long.

Pour 2 cm (¾ inch) of the frying oil into a frying pan, heat over medium heat, and fry the filo strips until crispy and golden, about 3 minutes. Drain on paper towels.

Mix all the seasoning ingredients together. Cut the sea bream into thin slices.

Divide the grapes, vegetables, and sashimi slices onto four plates. Sprinkle with the peanuts, crispy filo strips, and chervil. Just before serving, drizzle with the seasoning, and mix. Sprinkle with a little pepper and sea salt. Enjoy.

TIP

This salad is also very good with other fruits, such as peaches, persimmons, or strawberries.

VEGAN VERSION ❀

Replace the fish with 250 g (9 oz) firm tofu cut into thin 7-mm (¼-inch) slices and marinated with 1 tablespoon of soy sauce and 3 g (⅒ oz) of grated fresh ginger. Flour with potato starch or corn flour and panfry.

FISH

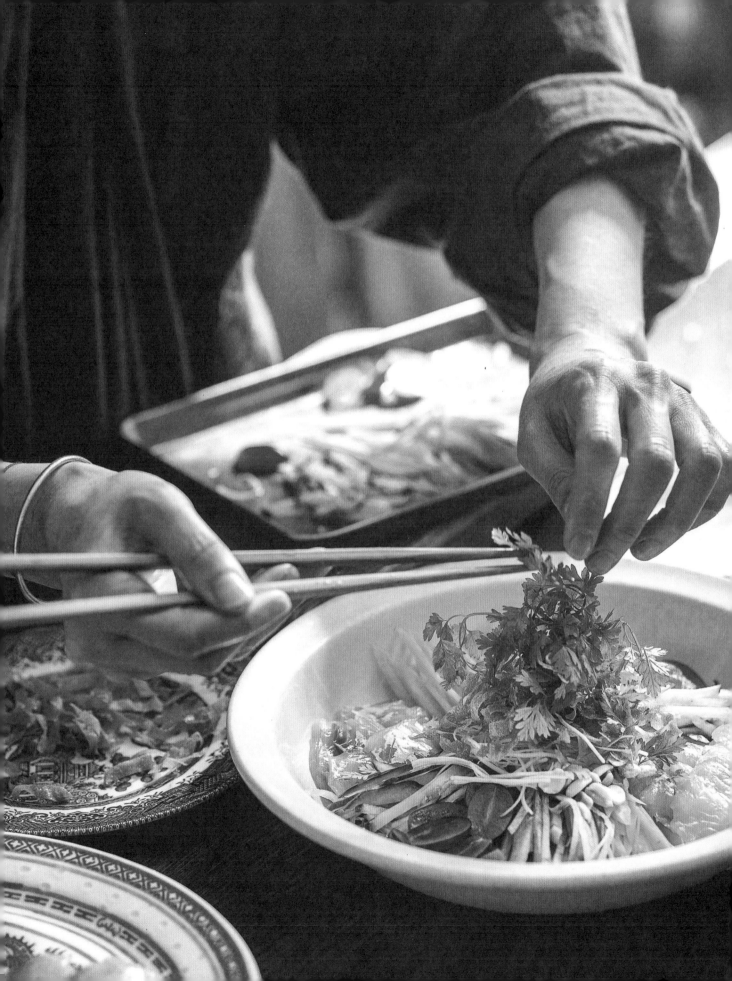

Grilled horse mackerel

鯵の南蛮漬け

Serves 4
Preparation: 30 minutes
Marinating: 1–24 hours
Cooking: 30 minutes

8 horse mackerel (approx. 10 cm/ 4 inches)
4 tablespoons potato starch or corn flour
Oil, for frying
12 cherry tomatoes
⅛ red onion, finely chopped
1 sprig dill, chopped

Marinade
300 ml (10 fl oz) dashi (p. 166)
70 ml (2¼ fl oz) rice vinegar
60 ml (¼ cup) soy sauce
2 tablespoons raw sugar
2 tablespoons mirin
1 slice dried kombu, 3 cm (1¼ inches) square
1 dried whole red chile (optional)

Clean the horse mackerel by opening the fish below the head. Slide your fingers inside each side of the throat and gently pull to remove the gills, throat area, and intestine all at once. You can also just cut off the head and remove the intestine, but the fried head is so good that it's a pity to waste it! Wash the fish thoroughly inside and pat dry with paper towels. Flour completely with the starch, inside and out, and place on a plate.

Mix all the marinade ingredients together in an airtight container.

Pour 3 cm (1¼ inches) of frying oil into a saucepan, heat the oil to 160°C (320°F), and fry the mackerel for 25 minutes, turning them halfway through. Increase the temperature to 180°C (355°F) and fry for another 2 minutes to make them crispy. Drain well on paper towels and mix them with the marinade while they are hot.

Briefly immerse the cherry tomatoes into the pan of frying oil, about 30 seconds, drain, and add to the marinade. Marinate between 1 and 24 hours before eating. Serve with the red onion and dill.

TIPS
The long cooking in oil at low temperature allows the horse mackerel to be eaten whole. Believe me, it's really good!
—
You can wear gloves while cleaning the horse mackerel to avoid being pricked.

魚

FISH

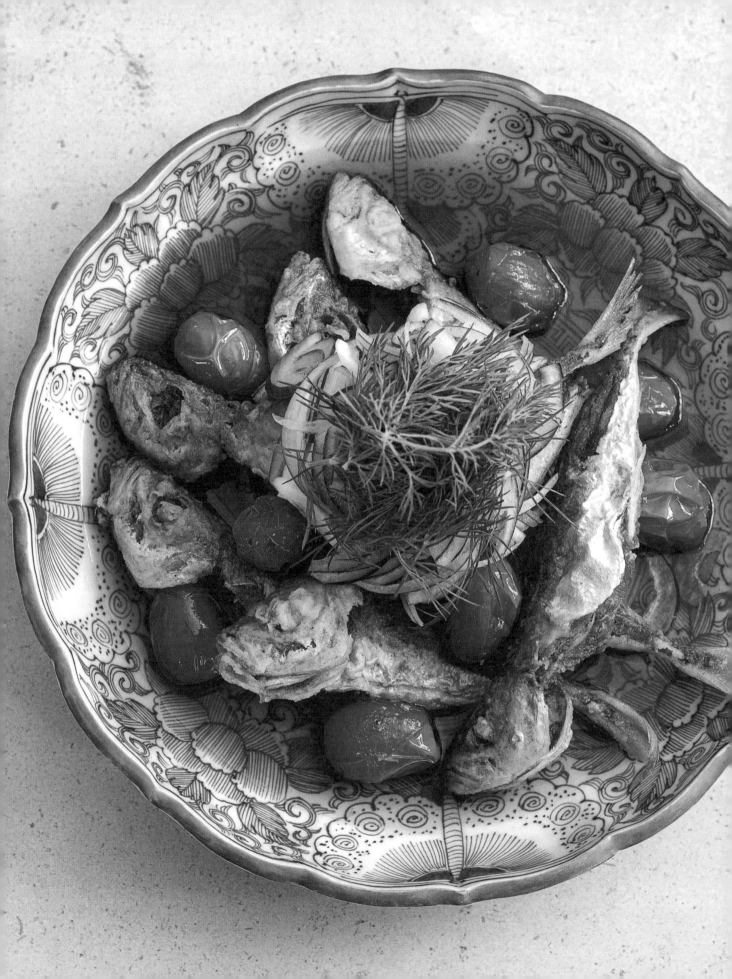

Dashi

(KATSUOBUSHI AND KOMBU)

鰹出汁

A

B

Makes 1 liter (4¼ cups) dashi
Preparation: 5 minutes
Resting: 40 minutes–overnight
Cooking: 15 minutes

1 liter (4¼ cups) water
10 g (¼ oz) dried kombu, cut in half
10 g (¼ oz) katsuobushi (dried bonito flakes)

There is nothing better than homemade dashi. The recipe seems complicated at first, but it is actually simpler to make than Western stocks. Powdered or liquid versions of dashi concentrate are available in Asian stores, but they are often enriched with glutamate, amino acids, and all kinds of artificial flavor enhancers.

Pour the water into a saucepan and soak the kombu for at least 30 minutes (or overnight) **(A)**. Then heat the water for about 15 minutes over low heat until it is simmering. Remove the kombu just before boiling (to avoid the overly salty taste of the kombu in the dashi) and add the katsuobushi **(B)**. Cook for 1 minute and turn off the heat. Leave to infuse for 10 minutes.

Filter the dashi into a large bowl, using a strainer. Press gently to extract as much dashi as possible **(C-D)**. Dashi will keep for 3 days in the refrigerator and 1 month in the freezer.

Never throw away remaining katsuobushi or kombu! They can be used as delicious condiments to put on rice, in onigiri (p. 74), and even on Italian pasta dishes!

TIP
For the katsuobushi and kombu quantities, use 1% of the water amount.

魚

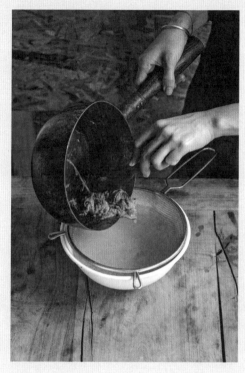

C

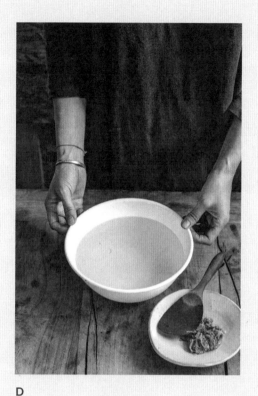

D

Furikake seasoning

Katsuobushi from making 1 liter (4¼ cups) dashi

Kombu from making 1 liter (4¼ cups) dashi

1 tablespoon toasted sesame seeds

1 teaspoon toasted sesame oil

1 tablespoon soy sauce

1 tablespoon mirin

½ tablespoon sugar

1 teaspoon rice vinegar

Spread the katsuobushi on a plate or a zaru and let it dry for 3 hours. Cut the kombu into thin 2-cm (¾-inch) strips. Dry out the katsuobushi by heating in a frying pan over medium heat, stirring occasionally. In just a few minutes, the katsuobushi will become dry and resemble small pieces of paper. Add the sesame seeds, kombu, and sesame oil. Fry for 1 minute. Add the soy sauce, mirin, sugar, and rice vinegar. Evaporate the liquid over medium-low heat, stirring continuously. The seasoning will keep for 10 days in an airtight container in the refrigerator.

Chawanmushi with clams

(SAVOURY EGG CUSTARD)

あさりの茶碗蒸し

Serves 4
Preparation: 15 minutes
Soaking: 2–3 hours
Cooking: 20 minutes

1 teaspoon salt
280 ml (9½ fl oz) water
16 clams
300 ml (10 fl oz) dashi (p. 166), cooled completely
2 eggs
1 teaspoon soy sauce
1 teaspoon neutral vegetable oil
2 chives, chopped

Dissolve the salt in 200 ml (7 fl oz) of the water. Remove the sand from the clams by soaking them in the salt water for 2 to 3 hours. Wash them. Bring the remaining 80 ml (2½ fl oz) water to a boil in a saucepan, immerse the clams and cover.

As soon as the clams open, take them out and let them cool. Discard any unopened clams. Keep the cooking water in a large bowl, leave to cool completely and then add the dashi (also cooled).

Beat the eggs with a whisk in a second large bowl. Add the dashi–cooking water mixture. Mix and strain the mixture with a strainer into a third large bowl (which fits into a steamer basket) or into four small cups. Prepare the steamer basket, heat up water, put the bowl (or cups) in the steamer basket, and cook for 15 minutes (large bowl) or 10 minutes (cups) over low heat. If the center of the mixture is still a little runny, continue cooking for 2 to 3 minutes and check again. Distribute the clams on top of the custard and cook for another 1 minute. Remove the bowl or cups from the steamer basket, drizzle with the soy sauce and oil, and sprinkle with the chives.

TIP

It's easy to improvise with this recipe. The base is 1 volume of beaten egg for 3 volumes of cold broth (otherwise the egg hardens when you mix it all together). You can prepare it with chicken or seafood broth and vary the toppings (mushrooms, carrots, peas, prawns, meat, fish, etc.), making sure you cut them into smallish pieces to allow the ingredients to cook quickly.

Himono
(DRIED FISH)

魚の干物

魚

FISH

Serves 4
Preparation: 30 minutes
Resting: 2–4½ hours
Cooking: 10 minutes

Salt brine

4 medium-sized horse mackerel

400 ml (13½ fl oz) water

48 g (1¾ oz) salt (or 12% quantity of water)

Open the back of the horse mackerel with a knife by splitting its head right in the middle and going down the backbone (deviating by 5 mm/¼ inch to the side when you get to the dorsal fin). Push the knife in until you can split the horse mackerel open as shown in the photo. Remove the internal organs and gills. Rinse the fish and pat dry well with paper towels.

Mix the water and salt together in a container big enough to hold the fish, then immerse the horse mackerel in the brine. If the fish are not fully immersed, make more brine, ensuring the salt ratio is correct. Marinate for 20 minutes at room temperature (the longer the fish marinate, the saltier they will be).

To dry the horse mackerel, place them on a rack or zaru. You can also hang them with clothespins outside in the sun (or even when it's not sunny). The important thing is that the air flows well around them. Cover with a large fine-mesh strainer to protect the fish from flies and cats, and allow to dry for 3 to 4 hours. Start by drying the insides, and once those surfaces are dry, turn them over to dry the skin sides. The surfaces must be dry but the flesh must remain soft. Dried horse mackerel can be stored in the refrigerator for 4 to 5 days, wrapped in plastic wrap.

On a grill, grill the skin sides of the horse mackerel over medium-low heat, until the skin is well marked and the flesh turns white. Turn over and grill the other side. To cook in a frying pan, place a piece of parchment paper in the bottom of the pan and cook the fish over medium heat, starting with the skin sides down.

TIP

This salting and drying method also works with other fish, such as sole, mackerel, barracuda, and even with squid. What is important is to properly gut the fish, removing the internal organs and gills. Fish can also be dried in nets.

This recipe helps to preserve the fish, but we love eating himono simply because it's delicious. The amino acids in the fish flesh become concentrated through the drying process. This is what creates the highly pronounced umami flavor. If you buy really fresh fish and the weather is nice, try this recipe!

Sweet-sour brine with mirin

4 sardines, filleted (step-by-step p. 178 or by the fishmonger), opened as shown in the photo

100 ml (3½ fl oz) soy sauce

100 ml (3½ fl oz) mirin

Toasted sesame seeds

Rinse the fish and pat dry well with paper towels. Mix the soy sauce and mirin together in a container big enough to hold the fish, then immerse the sardines in the brine. Marinate for 1 hour at room temperature, turning the fish after 30 minutes. Remove the sardines from the brine and sprinkle both sides with toasted sesame seeds.

To dry the sardines, do the same as with the horse mackerel and leave to dry for 1 hour. Dried sardines will keep in the refrigerator for 4 to 5 days, wrapped in plastic wrap.

To grill the sardines, cook the same way as the horse mackerel, but over low heat, as the mirin burns easily.

TIP

This brine can also be used with horse mackerel or small mackerel.

Ikameshi

(SQUID STUFFED WITH GLUTINOUS RICE)

いか飯

Serves 4
Preparation: 30 minutes
Soaking: 1 hour
Cooking: 45 minutes

90 ml (3 fl oz) glutinous rice*

1 teaspoon soy sauce

1 teaspoon sake

1 fresh shiitake mushroom or other mushroom, finely chopped

4 squid (150–200 g / 5¼–7 oz each)

Broth

450 ml (15½ fl oz) dashi (p. 166)

2 tablespoons soy sauce

2 tablespoons sake

3 tablespoons mirin

1 teaspoon raw sugar

*Based on the graduations of your measuring cup.

Wash the glutinous rice. In a medium bowl, soak the rice for 1 hour in three times its volume of water, then drain. Add the soy sauce, sake, and chopped shiitake mushroom and mix.

Clean the squid. Remove the mantle from the head by holding the head under the eyes and pulling gently. Gut the inside of the mantle. Keep the tentacles by cutting them just under the eyes. Remove the beak. Wash the mantles and tentacles and wipe clean. Stuff each squid mantle with glutinous rice, taking care not to fill them more than 60 percent, as the rice will swell during cooking. Close with a toothpick.

Pour all the broth ingredients into a large saucepan and arrange the stuffed squid in the pan (not the tentacles); the squid may touch a little but should not overlap. Then heat until boiling. Skim off the foam and reduce the heat to low. Place a lid smaller than the diameter of the pan directly onto the squid (or use a piece of aluminum foil with several holes poked in it and place it on the surface of the water to cover the squid). Cook for about 40 minutes. Then remove the lid and add the tentacles. Cook and reduce the sauce for 5 minutes. Cut each ikameshi into four or five pieces, drizzle with sauce, and serve.

TIP

The "dropped lid" or otoshi-buta technique allows the squid to cook evenly.

魚

FISH

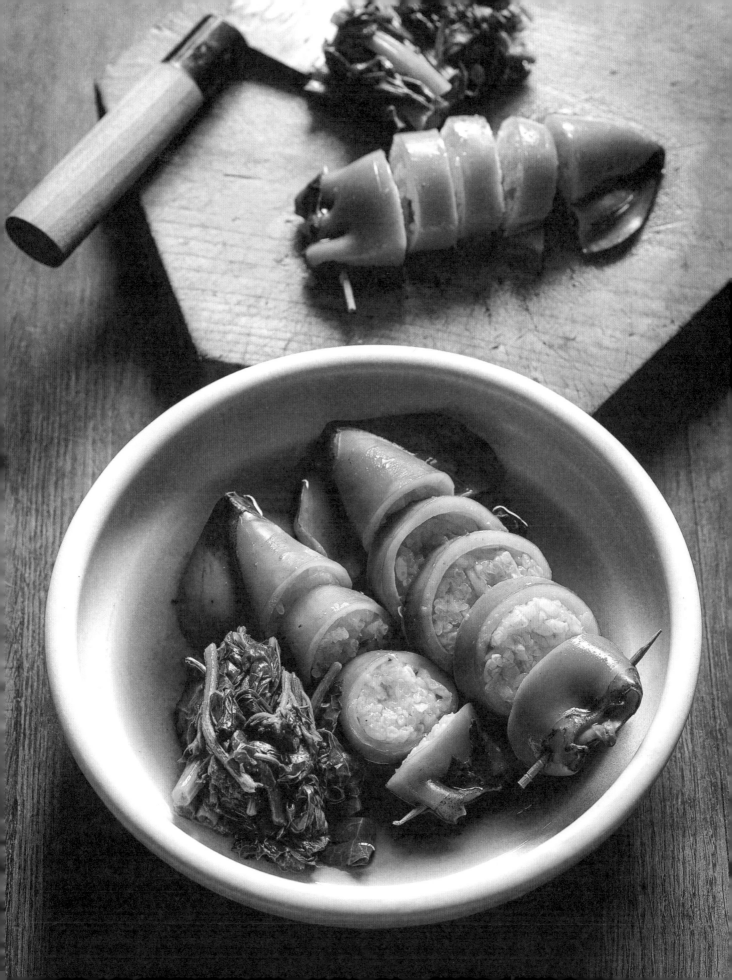

Fish bento

鮭海苔弁

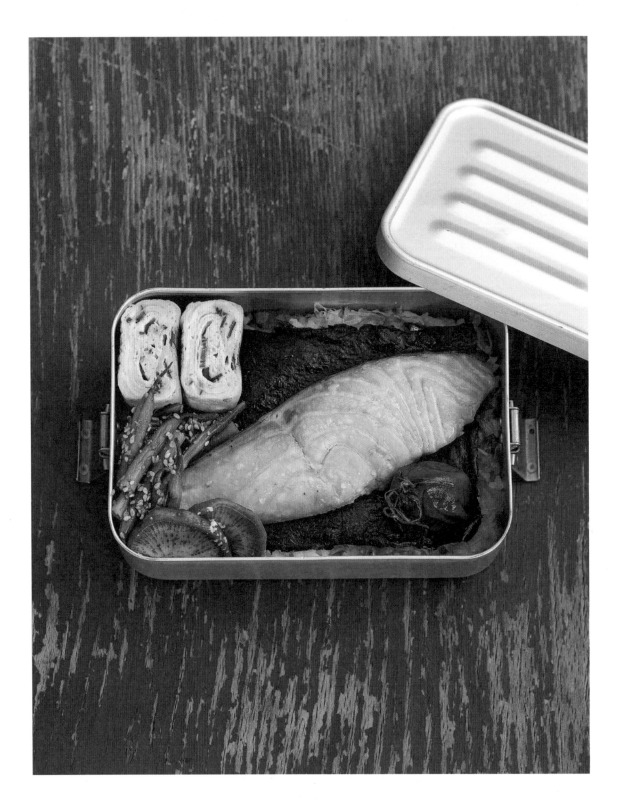

魚

FISH

Serves 4
Preparation: 40 minutes
Resting: 1 hour
Cooking: 20 minutes

4 umeboshi
8 sweet-savory radishes with shiokōji (p. 96)

Nori-okaka gohan (katsuobushi and nori rice)

Cooked rice for 4 people (p. 56)
1 handful katsuobushi (dried bonito flakes)
4 teaspoons soy sauce
2 nori sheets, cut into quarters

Salmon marinated in shiokōji

4 salmon fillets (approx. 120 g/4¼ oz), skin on
4 tablespoons shiokōji (p. 98)
1 teaspoon sunflower oil

Place the salmon steaks in a dish and brush them with shiokōji, using a pastry brush. Leave to rest for at least 1 hour in the refrigerator. Wipe off the shiokōji with a paper towel. Grease a frying pan well with the oil and heat over medium-low heat. Place the salmon steaks into the pan and cook for 4 to 5 minutes on one side, then turn and cook for another 2 to 3 minutes.

Tamagoyaki (Japanese omelette)

3 eggs
1 teaspoon raw sugar
½ teaspoon soy sauce
2 chives, finely chopped
1 teaspoon neutral vegetable oil

In a bowl, beat the eggs well with a fork, then beat in the sugar, soy sauce, and chives. Heat a frying pan (20–22 cm/8–8 ½ inches in diameter) over TK heat. Oil the entire surface of the pan and remove the excess oil with a paper towel. Pour a quarter of the mixture into the pan and spread it out, as for a crepe. When cooked, but not completely dry on top, roll the omelette toward one side of the pan. Pour another quarter of the mixture into the pan to form a thin layer, allowing some to run under the first roll. When cooked, but not completely dry on top, roll the first omelette back over the second omelette toward the opposite side of the pan. Repeat this process to get four thin omelettes rolled around each other. Slide the omelette onto a bamboo sushi mat (makisu) and roll it up to form a nice rectangular shape. Leave to rest in the bamboo mat for 1 minute, remove the mat, and cut the omelette into eight pieces.

Green beans

20 green beans
1 pinch salt
2 teaspoons soy sauce
½ teaspoon raw sugar
1 tablespoon toasted sesame seeds

Cook the green beans for 1 to 2 minutes in a saucepan of salted boiling water. They should be cooked but still crunchy. Cut them in half. Mix the beans with the soy sauce, sugar, and sesame seeds in a bowl.

Bento

Divide the items for the bento among the four bento boxes. Spread the cooked rice, while still warm, on the bottoms of four bento boxes. Sprinkle each with katsuobushi, drizzle with 1 teaspoon soy sauce, and place 2 pieces of nori on top. Allow the rice to cool completely. On top of the cooled rice in each box, place 1 salmon steak, 1 umeboshi, 2 radishes, 2 slices of tamagoyaki, and 10 green bean halves.

TIP

Bento is a takeout dish that you eat several hours after it has been prepared. It is important to wait until all the ingredients have cooled properly before putting them in the box, and in fact they can be prepared in advance. Because cold rice is difficult to handle, it is spread out while still warm and left to cool in the box. Real umeboshi are also supposedly good for preventing bacteria.

Every day for thirteen years my mother prepared me a bento box to take to school. What a job! Every day, I waited impatiently for lunchtime. For me, a bento box is a box of happiness and love. Preparing bento for me and my family is one of my most favorite things in life.

Panko-fried oysters

カキフライ

Serves 4
Preparation: 20 minutes
Cooking: 2–3 minutes

Tartar sauce

4 tablespoons soy mayonnaise (p. 139) or traditional mayonnaise

2 small cornichons (dill pickles), chopped

1 tablespoon chopped red onion

1 teaspoon finely chopped dill

1 tablespoon lemon juice

Pepper

24 oysters

Oil, for frying

4–6 leaves pointed cabbage, finely chopped

½ lemon, quartered

Tonkatsu sauce or Worcestershire sauce

Breading

6 tablespoons all-purpose flour

6 tablespoons all-purpose flour + 100 ml (3½ fl oz) water

60 g (1 cup) panko breadcrumbs

To prepare the tartar sauce, mix all the ingredients together in a bowl.

Open the oysters, remove them from their shells, and place them on paper towels to gently remove excess water.

Prepare three plates for breading: One with the flour, one with the flour and water mixed, and one with the panko breadcrumbs, and arrange them in that order. Dip an oyster in the flour plate, then in the flour-water mixture, and finally in the panko. Place the oyster on a plate and repeat the process with the remaining oysters.

Heat a 3 cm (1¼ inch) depth of oil to 170–180°C (340–355°F) in a deep frying pan. Drop the oysters into the oil and fry them for 2 to 3 minutes, turning occasionally, until they are nicely golden brown. Drain well on paper towels. Serve immediately with the cabbage, lemon, tartar sauce, and tonkatsu sauce.

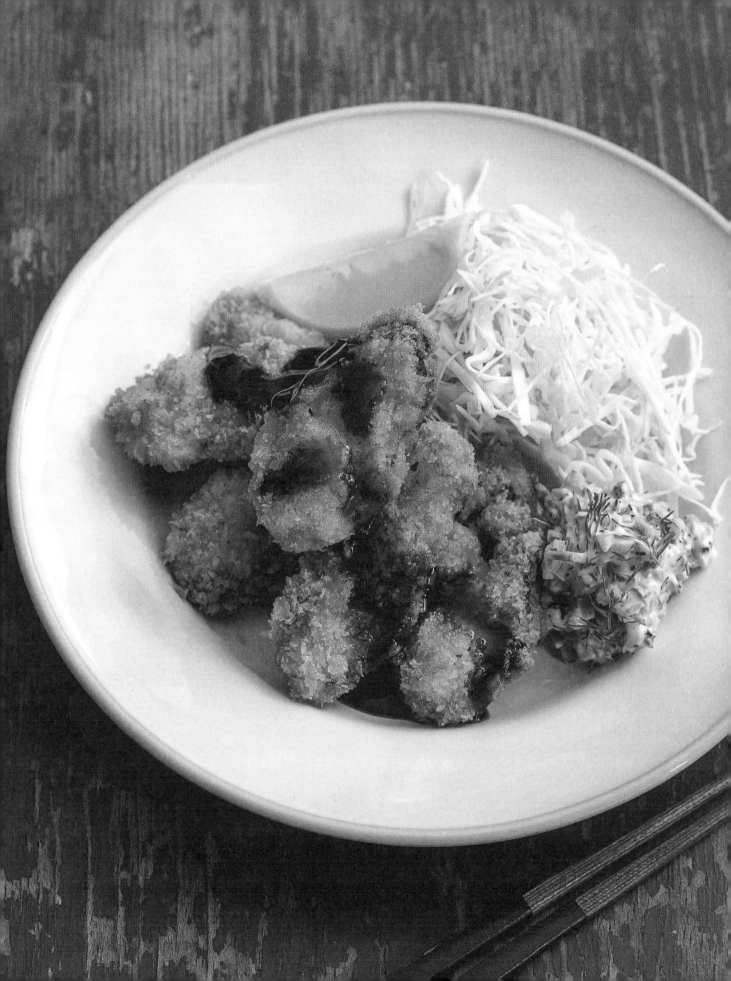

Filleting sardines

鰯の手開き

Descale the sardines using your thumb under cold running water. Remove the head and intestines. Wash the inside of the sardine thoroughly.

Using your thumb, open the body of the sardine along the backbone. Slide your thumb under the edge of the head toward the tail, then from the tail toward the head. **(A–B)**

Break the backbone just before the tail, then carefully remove the bone. **(C–D–E)**

Pat the fillets dry between two sheets of paper towels.

Remove the skin from the sardines by pulling gently from the head.

Set the fillets aside in a cool place.

TIP
The backbones can be used to make fried sardine bones (p. 182).

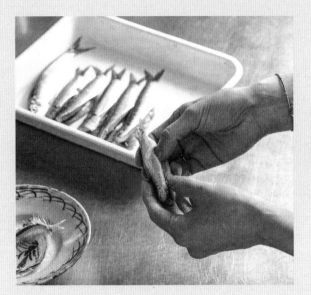

A

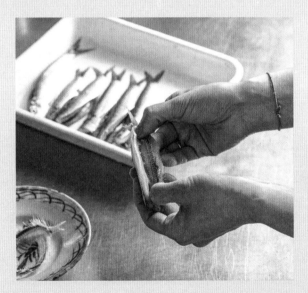

B

魚

FISH 178

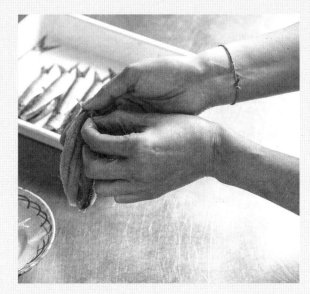

C

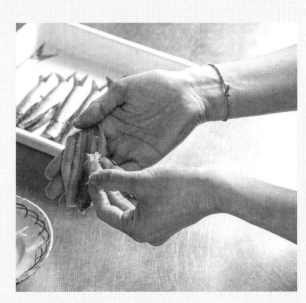

D

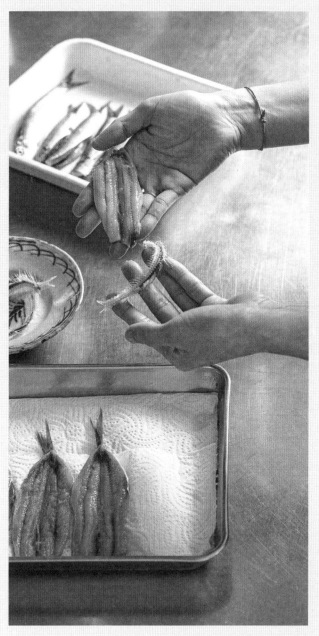

E

Sardine sashimi roll

鰯のレタス巻き

Serves 4
Preparation: 20 minutes
Resting: 10 minutes

Sauce

2 tablespoons brown or red miso paste

1 tablespoon gochujang (spicy Korean paste)

1 tablespoon raw sugar

1 tablespoon mirin

2 tablespoons toasted sesame oil

2 teaspoons soy sauce

1 tablespoon toasted sesame seeds

5 g (⅛ oz) fresh ginger, peeled and finely chopped

½ garlic clove, grated

3 cm (1¼ inches) leek (white part), finely chopped

12 medium-sized sardines, filleted (step-by-step p. 178 or by fishmonger)*

1 leek (white part)

12 lettuce or oakleaf lettuce leaves

12 shiso leaves

A few sprigs aromatic herbs (chives, dill, cilantro, mint, etc.)

¼ red onion

½ carrot

2 pinches salt

Juice ⅛ lemon

*Check with your fishmonger that the fish is fresh enough to be eaten raw.

Mix all the sauce ingredients together in a bowl.

Pat the sardine fillets dry with paper towels and remove the skin by gently pulling from the head side. Cut them into bite-sized pieces, place them on a plate, cover, and set aside in the refrigerator until ready to serve.

Cut the leek white into 3-cm (1¼-inch) sections, then into very thin matchsticks, and soak for 10 minutes in a bowl filled with water. Drain well. Wash and spin dry the lettuce, shiso, and herbs. Slice the onion into thin rings and soak for 10 minutes in a bowl filled with water, then drain. Peel the carrot and cut into very thin matchsticks, then mix together with the salt and lemon juice in a bowl. Place all the ingredients in serving dishes and serve at the table with the bowl of sauce.

To eat, take a lettuce leaf in your hand and arrange the herbs, sardines, and toppings of your choice with 1 teaspoon of sauce on top. You can also top with a little cooked rice. Roll it all up in the lettuce leaf and open your mouth wide!

This is a recipe inspired by Korean cuisine and is my favorite sardine dish. When I return to Japan and my mother asks what I'd like to eat, I always request this dish. The combination of herbs, fish, and sweet chile sauce is like a party of flavors in your mouth. It's so tasty and so refreshing!

TIPS

You can use other extremely fresh fish, such as horse mackerel, bonito, sea bream, and even oysters.

VEGAN VERSION

Replace the sardines with 1 eggplant cut in half lengthwise and then into 7-mm (¼-inch) slices. Grease a frying pan with 1 tablespoon oil and sear on each side. Sprinkle with a pinch of salt and leave to cool.

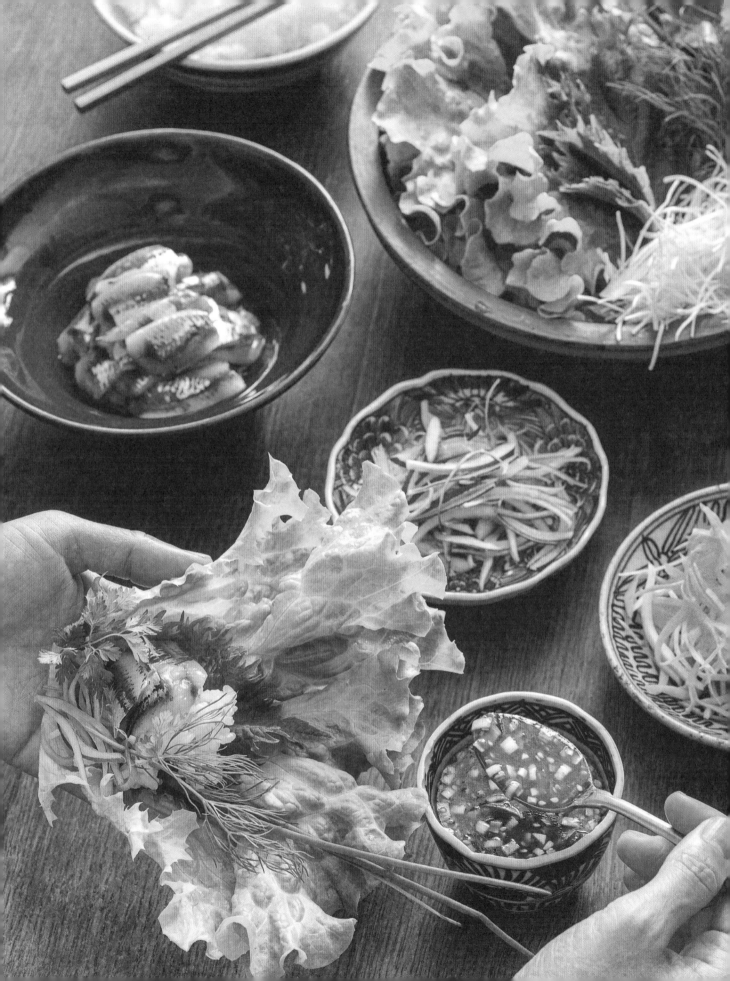

Fried sardine bones

イワシの骨の唐揚げ

Preparation: 5 minutes
Drying: 1–2 hours
Cooking: 5 minutes

Sardine bones (remaining from the filleting, see p. 178)
Oil, for frying
Salt
Chile powder (optional)

Rinse the bones and remove any remaining flesh. Pat dry well with paper towels, all the way to the tail. Leave to dry for 1 to 2 hours to get a crispy texture.

Heat a 3 cm (1¼ inch) depth of oil to 170°C (340°F) in a deep frying pan. Fry the sardine bones in the oil, turning occasionally, until they are nicely golden brown, about 5 minutes. When the bubbles around the bones become very small, increase the temperature to 180°C (355°F) and fry for another 10 seconds. Drain on paper towels and sprinkle with salt and chile powder, if desired.

TIP

If you tried the step-by-step instructions for filleting sardines (p. 178), you absolutely have to try this recipe. It sounds weird, and even frightening, but you will be surprised at how tasty the result is. Japanese culture typically has a zero-waste attitude, which is why we eat the bones. They are also a great source of calcium. My mother made these often and I love them. When I serve them to people, at first they are scared and ask me: "Are you sure they're edible?" But once they taste them, their expression completely changes and they tell me, "Oh yes, they're very good!"

魚

FISH

Oden

(HOT POT WITH SARDINE BALLS)

おでん

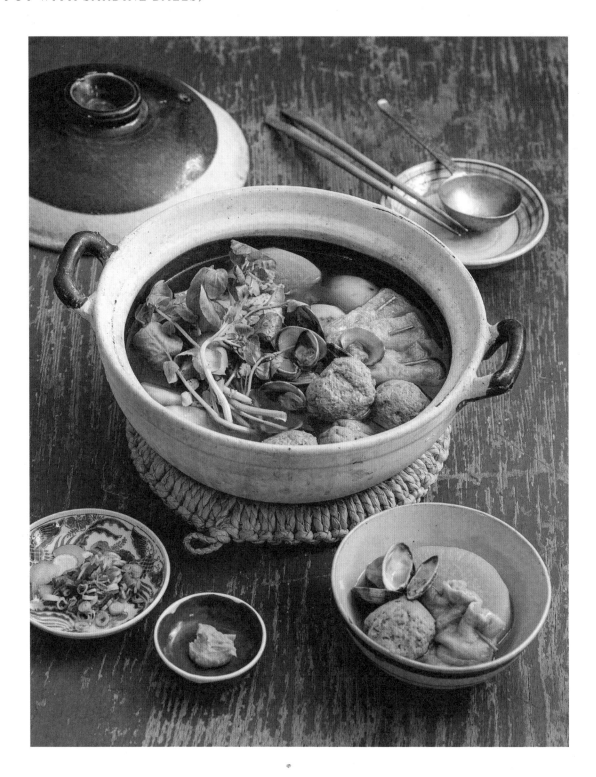

魚

FISH

Serves 4
Preparation: 30 minutes
Resting: 2 hours
Cooking: 1¼ hours

1 teaspoon salt
280 ml (9½ fl oz) water
10 clams
200 g (7 oz) daikon (white radish)
1 tablespoon Japanese rice
4 small potatoes
2 Jerusalem artichokes
½ bunch watercress or
1 handful rocket

Mochi kinchaku (mochi bags)
2 sheets of aburaage (fried tofu)
2 mochi (rice cakes)

Sardine balls
8 sardine fillets (step-by-step p. 178 or by fishmonger)*
3 cm (1¼ inches) leek (white part)
5 g (⅛ oz) fresh ginger, peeled
1 teaspoon soy sauce
½ teaspoon salt
1 pinch raw sugar
1 tablespoon potato starch or corn flour

Soup
1.5 liters (6¼ cups) dashi (p. 166) or vegan dashi shojin (p. 122)
60 ml (¼ cup) soy sauce
60 ml (¼ cup) mirin
1 tablespoon sugar
Salt

Garnish
Karashi (Japanese mustard)
1 yuzu, zested
1 scallion, finely chopped

Dissolve the salt in 200 ml (7 fl oz) of the water. Remove the sand from the clams by soaking them in the salt water for 2 to 3 hours. Rinse the clams. Bring the remaining 80 ml (2 fl oz) of water to a boil in a saucepan, then immerse the clams and cover. As soon as the clams open, take them out and let them cool. Discard any unopened clams.

Peel the daikon, cut it into rounds that are 3 cm (1¼ inches) thick, then cut the rounds in half. Trim the sharp corners of the edges slightly to round them off. Put the radish pieces in a saucepan with the rice (to remove the bitterness of the radish) and cover completely with cold water. Bring to a boil and cook for 30 minutes over medium-low heat. Drain and rinse. Discard the rice.

Prepare the mochi kinchaku. Cook the aburaage in a saucepan of boiling water for 1 minute to remove excess oil. Allow to cool, then gently squeeze between your hands to drain. Cut each sheet in half and carefully open each half to form four pockets. If the sheets are difficult to open, gently press a rolling pin over the aburaage. Cut each piece of mochi in half and place a piece inside each pocket. Close with a toothpick to form four bags.

Prepare the sardine balls. Roughly chop the leek and ginger before blending all the ingredients together using a blender or food processor. Shape eight balls with your hands (lightly oil your hands to prevent the mixture from sticking to your fingers). Set the balls aside in the refrigerator.

Peel the potatoes. Peel the Jerusalem artichokes and cut in half. Wash the watercress and spin dry.

Put all the soup ingredients into a large pot. Bring to a boil. Add the radish mixture, potatoes, and Jerusalem artichokes. Cover and cook for around 15 minutes over medium-low heat, until the potatoes are cooked inside. Add the sardine balls and cook, covered, for a further 10 minutes over medium-low heat. Add the mochi kinchaku and cook, covered, for another 10 minutes.

Just before serving, add the clams and watercress. Serve in the pot at the table and eat with karashi. Sprinkle with the yuzu zest and finely chopped scallion.

TIP
Sardine balls freeze very well.
—
You can also add ganmodoki (p. 146) to this dish; add it to the pot at the same time as the mochi kinchaku.

Salmon and mushroom
PARCELS

鮭のホイル焼き

Serves 4
Preparation: 10 minutes
Resting: 30 minutes
Cooking: 15 minutes

4 salmon steaks approx. 125 g (4½ oz each), skin on
2 pinches salt
2 pinches raw sugar
100 g (3½ oz) enoki mushrooms (or oyster or button mushrooms)
100 g (3½ oz) fresh shiitake mushrooms
1 onion
1 tablespoon soy sauce
1 tablespoon extra virgin olive oil
1 tablespoon sake
Pepper
Sea salt
1 scallion, cut into thin rounds
1 lemon, quartered

Sprinkle the salmon steaks with the salt and sugar. Leave to rest for 30 minutes in the refrigerator and gently pat the surface with paper towels. Cut off the mushroom stems. Roughly separate the enoki strands and quarter the shiitake caps. Peel the onion and cut into slices that are 7 mm (⅛ inch) thick.

Preheat the oven to 200°C (400°F). Prepare four sheets of aluminium foil (30 cm/12 inches square). Spread the onion slices on the foil. Place the salmon steaks on top, then the mushrooms. Drizzle with the soy sauce, olive oil, and sake, and season with pepper. Close the foil to form four parcels. Fold the top and bottom of the sheet and join the two sides over the ingredients, then fold several times to close the parcel tightly. Bake for 15 minutes.

Serve immediately, sprinkled with sea salt and scallion rounds and with a lemon wedge on the side.

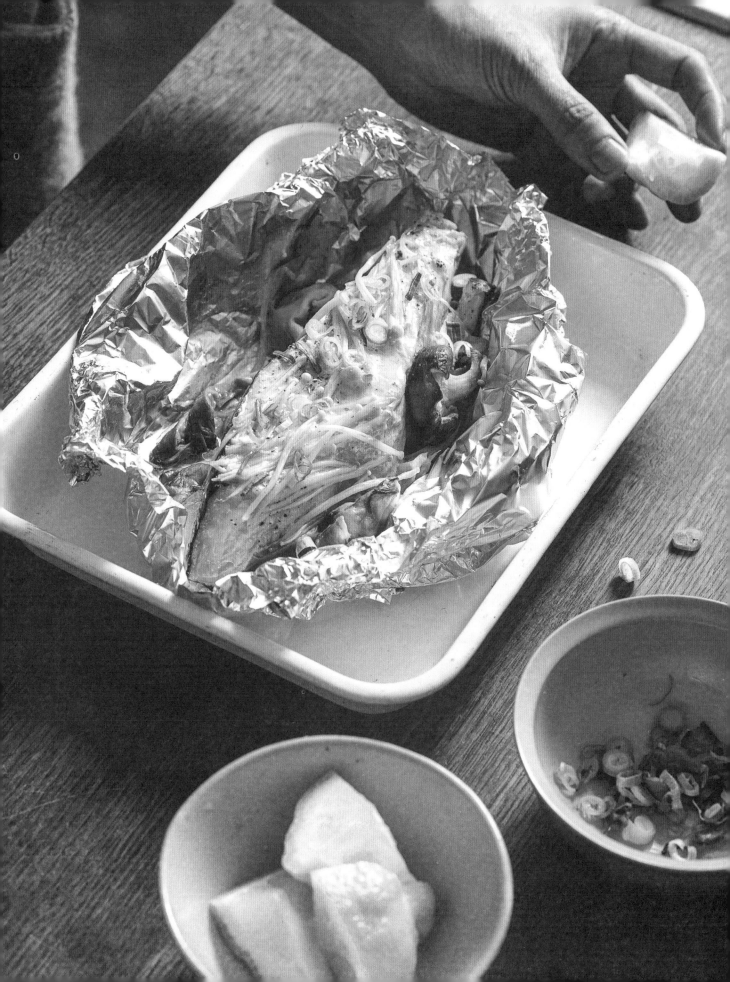

Fish tempura

白身魚の天ぷら

Serves 4
Preparation: 25 minutes
Cooking: 3–5 minutes

Sauce
90 ml (3 fl oz) mentsuyu (p. 14)
150 ml (5 fl oz) water
1 teaspoon raw sugar

300 g (10½ oz) white boneless fish fillets (red mullet, as in the photo, wild sea bream, cod, and haddock, etc.)
Salt
150 g (5¼) oyster mushrooms
6 oysters
Oil, for frying

Tempura batter
30 g (1 oz) all-purpose flour
70 g (2½ oz) corn flour
130 ml (4½ oz) chilled sparkling water

Garnish
40 g (1½ oz) daikon (white radish), peeled and grated
10 g (¼ oz) fresh ginger, peeled and grated
Salt
½ teaspoon crushed Sichuan pepper
½ lemon, quartered

Mix all the sauce ingredients together and divide into four individual bowls.

Cut the fish into large pieces. Sprinkle with a small pinch of salt. Sprinkle a little salt over the oyster mushrooms. Open the oysters and remove them from their shells. Gently wipe the fish, oyster mushrooms, and oysters with paper towels.

Prepare the tempura batter. Beat the flour and corn flour with a whisk in a bowl. Pour in the sparkling water and mix well.

Heat a 3 cm (1¼ inch) depth of oil to 170°C (340°F) in a deep frying pan.

Dip the fish, oyster mushrooms, and oysters in the tempura batter and fry for 3 to 5 minutes, turning occasionally. Drain on paper towels.

Serve the tempura with the dipping sauce, daikon, and ginger. It is also delicious with salt, Sichuan pepper, and a little lemon juice.

VEGAN VERSION

You can fry whatever you like! Eggplant, asparagus, onion, any kind of mushroom, etc. And substitute the mentsuyu in the sauce with mentsuyu shojin (p. 14).

魚

FISH

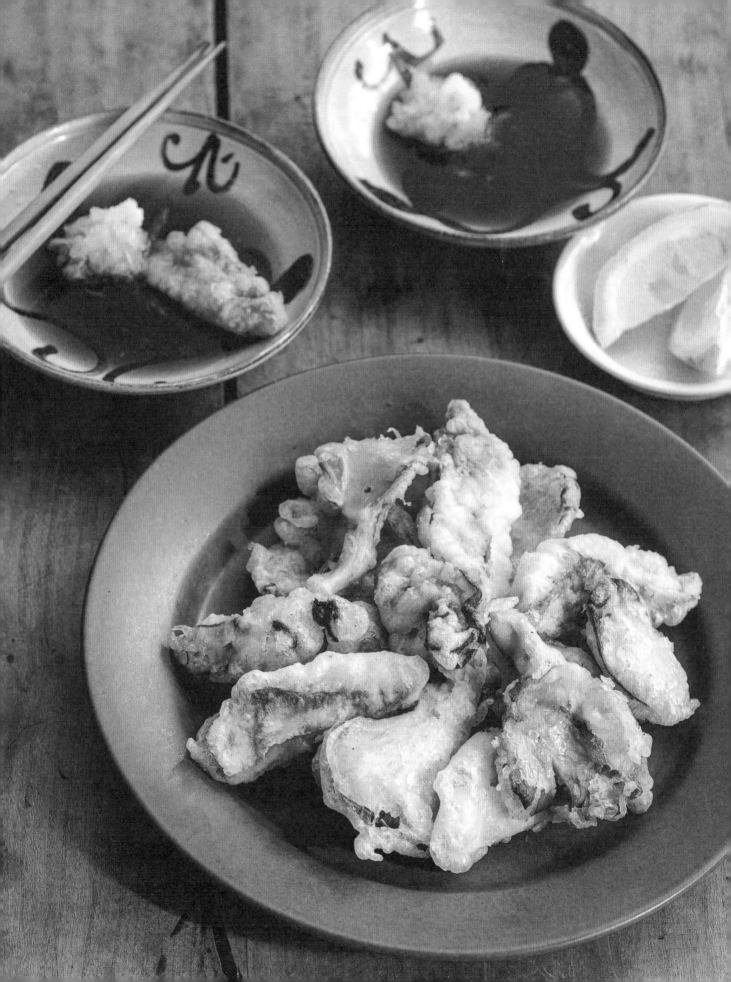

肉

MEAT

Roasted lemongrass chicken
STUFFED WITH RICE AND MUSHROOMS

鶏の丸焼き

肉

MEAT

Serves 4–6
Preparation: 40 minutes
Marinating: 5 hours–overnight
Cooking: 2¼ hours

1 free-range chicken
(1.2–1.5 kg/2 lb 10 oz–3 lb 5 oz)
1 tablespoon olive oil
2 tablespoons soy sauce

Brine
500 ml (2 cups) water
25 g (5 teaspoons) salt
25 g (5 teaspoons) raw sugar
2 stalks lemongrass, cut into strips
2 thin slices fresh ginger
1 garlic clove, sliced
10 Sichuan peppercorns

Vegetables
2 potatoes
4 carrots
2 small turnips
2 small beets
2 stalks lemongrass
4 scallions, peeled and trimmed
1 tablespoon olive oil
1 teaspoon salt
Pepper

Rice
70 g (2½ oz) mushrooms
2 tablespoons sunflower oil
5 g (⅛ oz) fresh ginger, peeled and chopped
1 garlic clove, chopped
½ onion, finely chopped
180 ml (¾ cup)* short-grain white rice, washed and drained well (p. 56)
1 tablespoon glutinous rice (optional)
6 precooked chestnuts (optional)
200 ml (7 fl oz) water or stock
½ tablespoon fish sauce
1 tablespoon mirin
1 teaspoon soy sauce
Pepper

Remove the offal from inside the chicken, clean the chicken, and pat the inside dry with paper towels.

Prepare the brine. Mix the water, salt, and sugar in a large bowl until completely dissolved. Add the remaining brine ingredients. Put the chicken and brine into a sufficiently large and sturdy ziplock bag, press out the air, and seal the bag. Place in a dish and marinate for at least 5 hours, or overnight, in the refrigerator.

Prepare the vegetables. Peel (unless organic) and cut the potatoes, carrots, turnips, and beets in half (lengthwise for the carrots). Cut the lemongrass in half lengthwise. Mix the vegetables, whole scallions, olive oil, salt, and pepper in a mixing bowl.

Prepare the rice. Clean the mushrooms and cut into large even-sized pieces. Heat the oil in a saucepan over medium heat and brown the ginger, garlic, and onion. When the aromas start to release, add the mushrooms and sauté for 1 minute. Add the rice and the glutinous rice and chestnuts, if using, and mix. In a rice cooker, cook the rice with the water or stock, the fish sauce, mirin, soy sauce, and some pepper (or see p. 56 for the stovetop method). Leave to cool.

To prepare the chicken, remove it from the brine bag and pat dry with paper towels. Preheat the oven to 200°C (400°F). Stuff the inside of the chicken with the mushroom rice. Close by securing the legs together with kitchen twine. Brush the chicken with the 1 tablespoon olive oil.

Arrange the chicken and vegetables in a baking dish. Cover the chicken completely with aluminum foil. Bake for 1 hour. Remove the foil. Baste the chicken with its juices and cook for a further 40 to 50 minutes, until the skin is golden brown. To check for doneness, insert a skewer between a thigh and the body. If the juices run clear, the chicken is done; if the juices show a little blood, then cook for another 10 minutes and check again.

Remove from the oven, pour the cooking juices into a serving dish, and mix with the soy sauce. Serve the chicken and vegetables with the sauce.

*Based on the graduations of your measuring cup.

Kara-age

(FRIED CHICKEN WITH SWEET-CHILE SAUCE)

鶏の唐揚げピリ辛ソース

Serves 4
Preparation: 15 minutes
Marinating: 1 hour
Cooking: 6 minutes

600 g (1 lb 5 oz) boneless chicken legs (2 thighs and 2 drumsticks)
3 tablespoons all-purpose flour
3 tablespoons corn flour
Oil, for frying

Marinade

6 tablespoons sake
1 garlic clove, grated
5 g (⅛ oz) fresh ginger, peeled and grated
1 teaspoon sea salt
1 teaspoon raw sugar
1 teaspoon toasted sesame oil
Pepper

Sauce

2 tablespoons soy sauce
1 tablespoon apricot jam or marmalade
1 tablespoon toasted sesame oil
½ tablespoon miso paste (brown or red)
1 tablespoon mirin
½ garlic clove, chopped
1–2 teaspoons chile powder
1 tablespoon rice vinegar
2 cm (¾ inch) leek (white part), finely chopped

Cut each chicken leg into about 6 pieces (the thigh into 4 pieces and the drumstick into 2 pieces).

Mix all the marinade ingredients together in a bowl. Add the chicken pieces and massage in the marinade a bit. Marinate for 1 hour in the refrigerator.

Mix all the sauce ingredients together in a bowl and set aside.

Mix the flour and corn flour together on a plate. Put the chicken on the plate and flour the pieces well. Heat a 3 cm (1¼ inch) depth of oil to 170°C (340°F) in a deep frying pan. Drop the chicken pieces into the oil and fry for about 4 minutes. Increase the temperature to 180°C (355°F) and cook for a further 2 minutes or so. Check if the chicken is cooked by piercing it with a skewer—if the liquid that comes out is transparent, the chicken is cooked.

Drizzle with sauce and serve.

TIP

It is very important to use the chicken leg and not the breast. It is the fat and the skin that make this dish so tasty and moist. If you can't find boneless chicken legs with the skin on at your local grocery store, buy the bone-in chicken and debone them yourself. Also, the result is much better with free-range chicken.

VEGAN VERSION ✽

Replace the chicken with rehydrated soy protein (large pieces) or seitan, marinating it the same way as for the chicken.

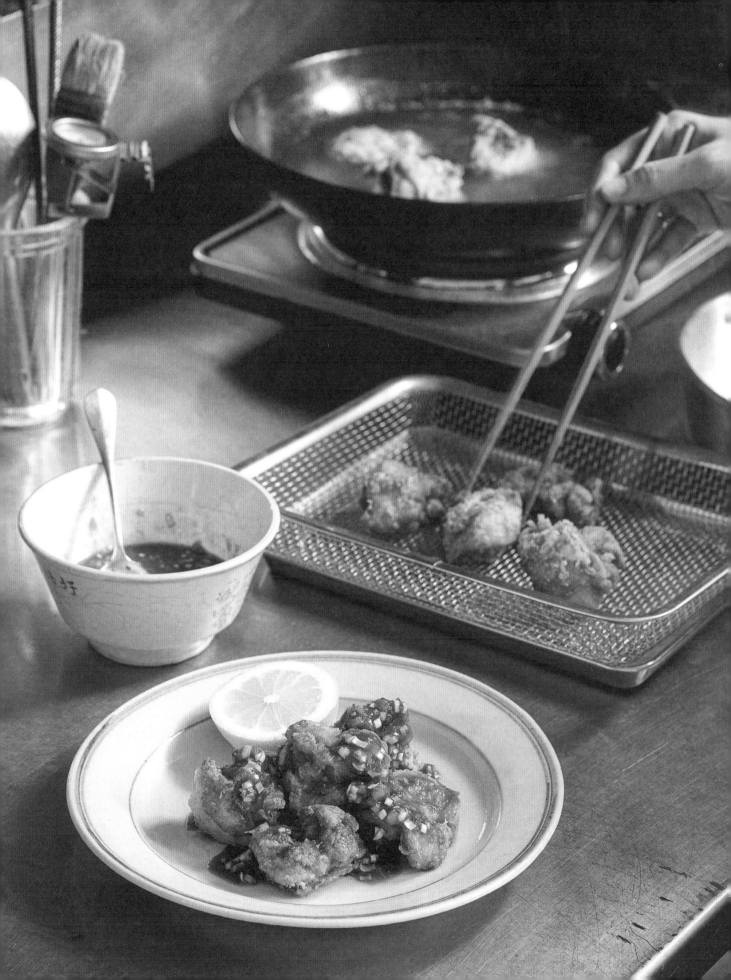

Meat bento

鶏の生姜蜂蜜唐揚げ弁当

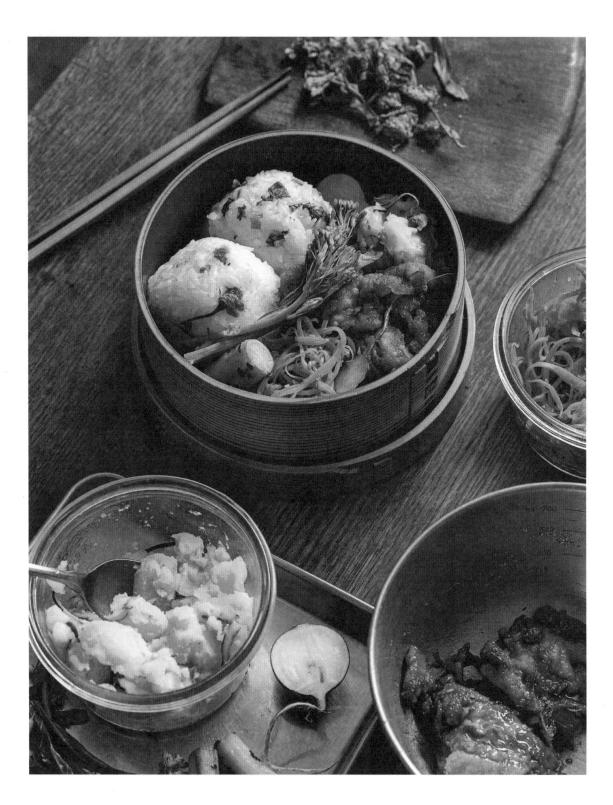

MEAT

Serves 4
Preparation: 1 hour
Cooking: 25 minutes

Carrot kinpira (p. 127)

Potato salad (p. 136)

Onigiri

Cooked rice for 4 people (p. 56)

Nameshi: 35 g (1¼ oz) green leaves and stalks (turnip, radish, or kale), ½ teaspoon + 1 small pinch salt, ½ tablespoon toasted sesame seeds

12 salted cherry blossoms (p. 116)

Make 4 small nameshi onigiri (p. 74).

Make 4 small cherry blossom onigiri. Soak the flowers in water for 2 minutes to remove the salt and pat dry between two sheets of paper towels. Mix them with half the quantity of rice and shape the onigiri (step-by-step p. 72).

Salted radish

4 different colored radishes

Salt

Wash the radishes, cut them in half, and sprinkle with a little salt.

Blanched cabbage flowers (optional)

1 handful cabbage, broccoli, kale, or Swiss chard flowers

1 teaspoon neutral vegetable oil

Blanch the flowers for 1 minute with the oil in a pot of salted boiling water. Drain and squeeze out any excess liquid with your hands.

Kara-age with honey and ginger

600 g (1 lb 5 oz) boneless chicken legs (2 thighs and 2 drumsticks)

3 tablespoons sake

1 teaspoon fine sea salt

4 tablespoons soy sauce

3 tablespoons honey

10 g (¼ oz) fresh ginger, grated

3 tablespoons all-purpose flour

3 tablespoons corn flour

Oil, for frying

Pepper

Cut each chicken leg into approximately 6 pieces (the thigh into 4 pieces and the drumstick into 2 pieces). Mix the sake and salt together well in a bowl to make the marinade. Add the chicken pieces and lightly massage the marinade into the meat. Leave to marinate for 1 hour in the refrigerator.

Mix the soy sauce, honey, and ginger in a bowl for the sauce.

Mix the flour and corn flour together on a plate. Put the chicken onto the plate and flour the pieces well. Heat a 3 cm (1¼ inch) depth of oil to 170°C (340°F) in a deep frying pan. Drop the chicken pieces in the oil and fry for about 4 minutes. Increase the temperature to 180°C (355°F) and cook for a further 2 minutes. Check if the chicken is cooked by piercing it with a skewer. If the liquid that comes out is transparent, the chicken is cooked. Mix the hot chicken with the sauce and season with pepper.

Sautéed burdock

2 small burdock roots or salsify

2 teaspoons soy sauce

1 teaspoon mirin

1 teaspoon rice vinegar

1 teaspoon toasted sesame oil

Peel the burdock and cut into slices that are 3 cm (1¼ inches) thick. Cook the burdock for 5 minutes in a saucepan of salted boiling water, until cooked but still crunchy. Drain. Pour the remaining ingredients into a small saucepan, heat over medium heat, and stir in the burdock. Mix until the sauce evaporates, then turn off the heat.

Bento

Allow all the items to cool completely and then arrange them as shown in the photo, making sure they fit snugly together to prevent them from moving around when traveling.

TIP

Bento is a takeout dish that is eaten several hours after it has been prepared. It is important to wait until all the ingredients have cooled properly before putting them in the container. This prevents bacteria from forming.

Simmered pork

AND SOFT-BOILED EGG

豚の角煮

Serves 4
Preparation: 20 minutes
Cooking: 2½ hours

4 eggs, at room temperature
800 g (1 lb 12 oz) pork belly

First cooking
1 leek (green part)
4 thin slices fresh ginger
1 garlic clove

Second cooking
400 ml (13½ fl oz) water from first cooking
100 ml (3½ fl oz) sake
3 tablespoons soy sauce
4 tablespoons mirin
1 tablespoon raw sugar
2 thin slices fresh ginger

Garnish
3 cm (1¼ inches) leek (white part), cut into thin matchsticks

For the garnish, soak the thin leek matchsticks for 30 minutes in a bowl of water, then drain well and set aside. Bring water to a boil in a saucepan and boil the eggs for 6½ minutes. Run them under the tap to stop them cooking, peel, and set aside.

For the first round of pork cooking, put the pork belly and all the first cooking ingredients in a large pot. Cover the pork with water. Bring to a boil and simmer for 1 hour over medium-low heat with the lid slightly offset. Add a small amount of water regularly as the water evaporates so that the pork is always covered.

Drain, keeping the cooking water. Wash the pot and put the pork back in. Add all the second cooking ingredients. Bring to a boil. Cover and simmer for 50 minutes over low heat. Remove the lid and increase the heat to medium. Continue cooking for 30 minutes.

Turn off the heat, add the eggs, and leave to cool. Reheat the dish over low heat just before serving.

TIP
The cooling-reheating stage allows the pork to absorb the flavors, which makes the dish tastier. This dish can therefore be prepared the day before.

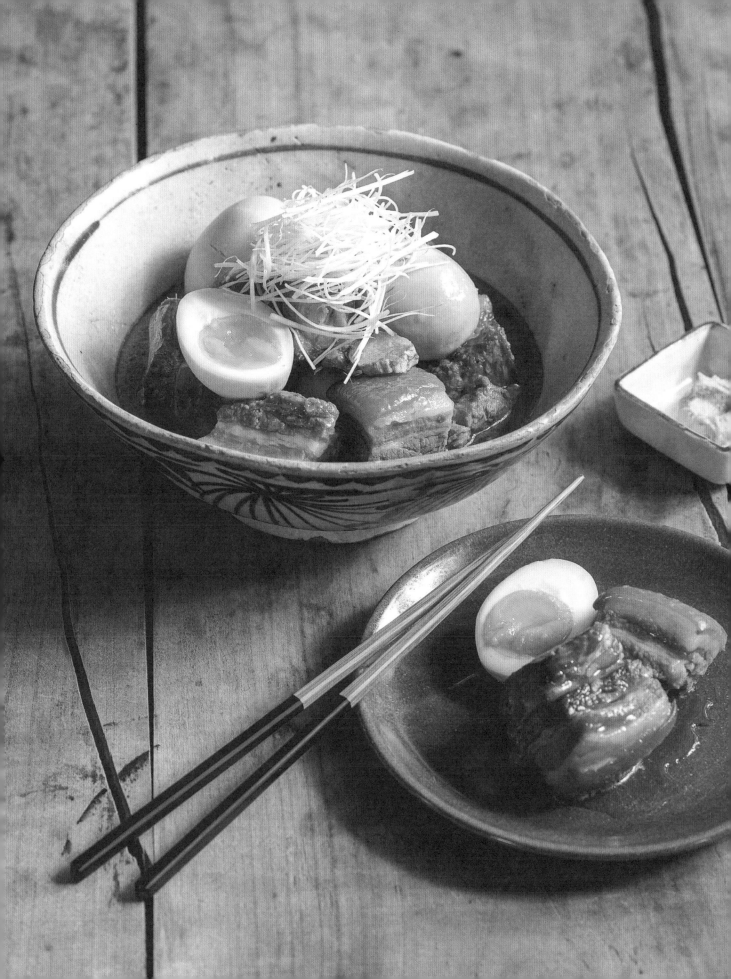

Duck and watercress hot pot

鴨とクレソンの鍋

Serves 4
Preparation: 20 minutes
Cooking: 10 minutes + cooking at the table

600 g (1 lb 5 oz) duck breast fillets
1 bunch watercress
6 large fresh shiitake mushrooms
120–240 g (4¼–8½ oz) dried soba noodles (depending on appetite)

Broth
1 liter (4¼ cups) dashi (p. 166) (+ 400 ml/13½ fl oz to add when necessary while eating the hot pot)
1 tablespoon mirin
1 tablespoon soy sauce
1 teaspoon salt

Condiments
5 cm (2 inches) daikon (white radish), grated
4 pieces yuzu or bergamot zest (optional)
2 scallions, cut into thin rounds
Ponzu (p. 139) or 60 ml (¼ cup) soy sauce + 40 ml (1¼ fl oz) rice vinegar + 20 ml (4 teaspoons) mirin

Cut the duck breasts into slices that are 1 cm (½ inch) thick. Wash the watercress. Remove the stems from the shiitake mushrooms and cut the caps into 2-cm (¾-inch) slices. Cook the soba noodles in a pot of boiling water for 1 minute less than the time indicated on the packet. Drain them in a fine-mesh strainer and rinse well by swishing them with your hand under cold running water until the starch layer on the noodles has been removed. Lightly squeeze the noodles with your hand to drain completely. Divide the slices of duck, watercress, and shiitake mushrooms onto four plates. Set out four bowls.

Pour all the broth ingredients into a pot and place at the table on a portable stove. When the broth is simmering, each person can add the duck, watercress, and shiitake little by little and let cook according to each person's preferences before serving into their own bowls. Serve with the daikon, yuzu zest, scallion, and sauce. At the end of the hot pot, dip the soba noodles in the remaining broth for 1 minute and enjoy.

Putting starch in the pot at the end of the hot pot is called shime ("closed" in English). The starch can be cooked rice or cooked noodles. It absorbs the taste of all the ingredients in the broth and is said to be the best part of the hot pot!

肉

MEAT

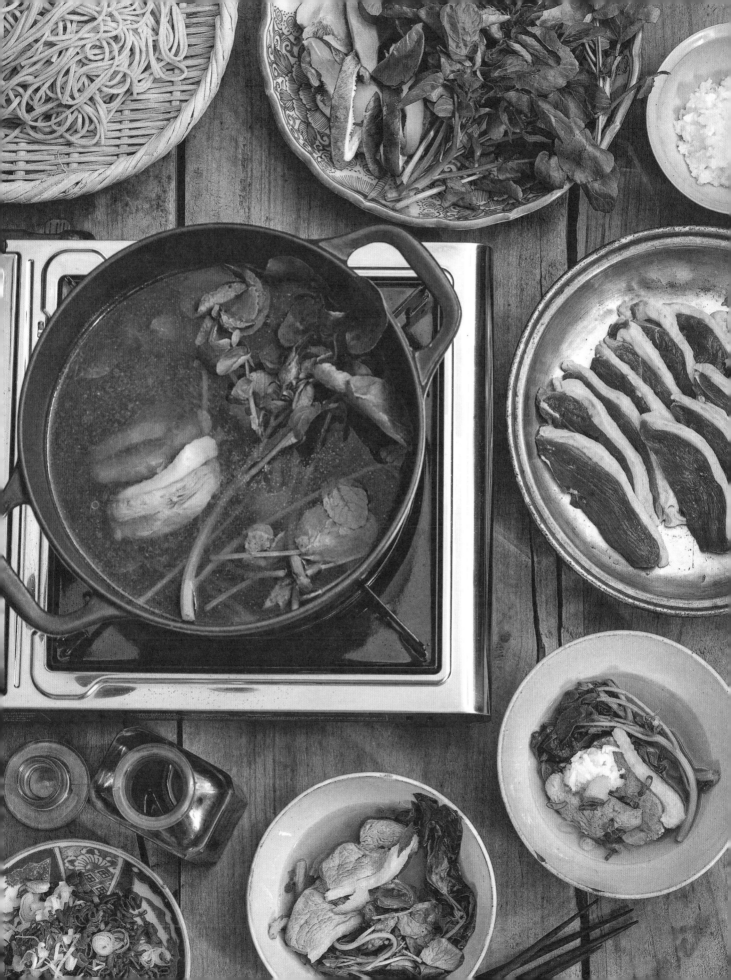

Subuta with prunes

(SWEET-AND-SOUR BLACK VINEGAR PORK)

酢豚

Serves 4
Preparation: 20 minutes
Soaking: 30 minutes
Cooking: 15 minutes

400 g (14 oz) pork shoulder
1 teaspoon soy sauce
1 teaspoon sake
1 teaspoon toasted sesame oil
Pepper
4–5 tablespoons potato starch or corn flour
6 tablespoons oil, for frying
½ medium onion
1 small yellow pepper
1 tablespoon neutral vegetable oil
12 pitted prunes

Seasoning
1 garlic clove, chopped
100 ml (3½ fl oz) black vinegar
4 tablespoons raw sugar
3 tablespoons oyster sauce
1 tablespoon soy sauce
1 pinch salt
2 tablespoons potato starch or corn flour
Pepper

Garnish
3 cm (1¼ inches) leek (white part), cut into thin matchsticks

To prepare the seasoning, mix all the ingredients together in a bowl until well combined.

For the garnish, soak the thin leek matchsticks for 30 minutes in a bowl of water and drain well.

Slice the pork 5 mm (¼ inch) thick. Then cut the slices into pieces that are 3 × 5 cm (1¼ × 2 inches). Mix the soy sauce, sake, and sesame oil together in a bowl and brush over the pork using your fingers. The pork can be cooked right away, but resting for 15 minutes is recommended. Season with pepper and then liberally coat the pork with the starch. Heat the frying oil in a frying pan and fry the pork over medium heat until it is cooked and the surface is crispy. Set aside and clean the pan.

Peel the onion and cut into pieces that are 3 cm (1¼ inches) square. Wash the pepper and remove the seeds, cut it lengthwise into eight pieces and then in half. Heat the oil in the frying pan over medium heat. Sauté the onion and pepper for 3 minutes, until cooked but still crunchy. Return the pork pieces and the prunes to the pan and add the seasoning. Cook for a further 2 minutes, stirring until the sauce thickens. Serve on a large plate, sprinkled with the thin leek matchsticks.

VEGAN VERSION ✤

Replace the pork with rehydrated soy protein patties, seitan, or firm tofu, cut into pieces (for the tofu, cut 1 cm/½ inch thick instead of 5 mm/¼ inch) and marinated in the same seasoning as for the pork. Replace the oyster sauce with vegetarian oyster sauce.

肉

MEAT

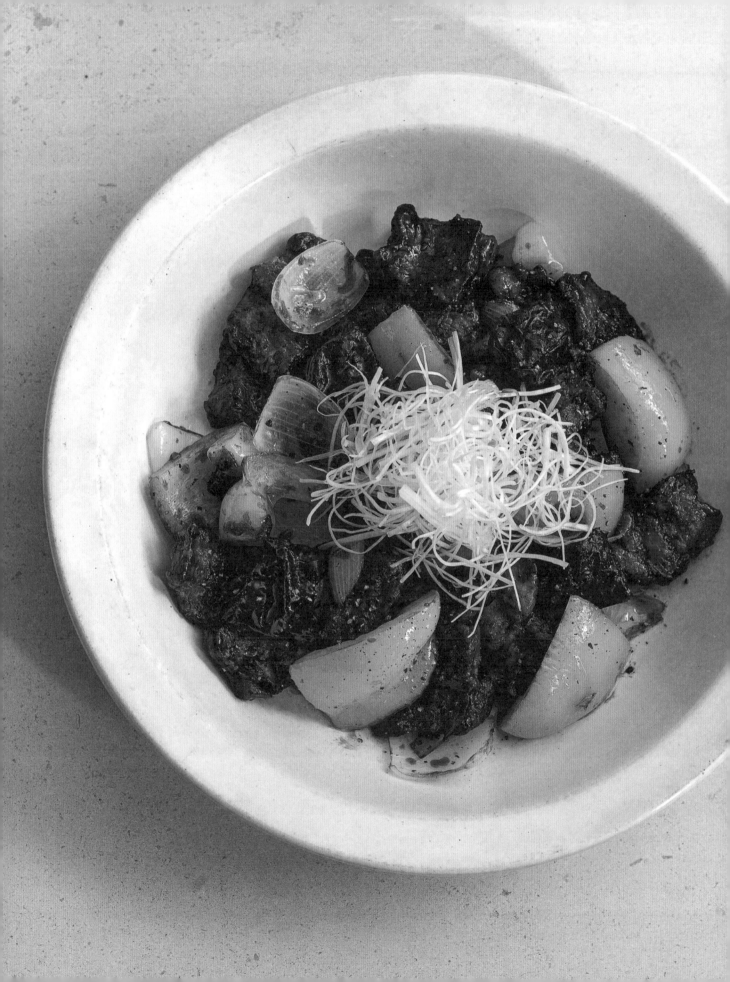

Japanese-style stuffed cabbage

ロールキャベツ

Serves 4
Preparation: 30 minutes
Resting: 2 hours–overnight
Cooking: 50 minutes

Stuffing
5 g (⅛ oz) dried shiitake mushrooms
200 ml (7 fl oz) water
2 fresh shiitake mushrooms or other mushrooms
350 g (12 oz) ground pork
60 g (2 oz) cooked cooled rice or 2 heaping tablespoons breadcrumbs or panko
1 small onion, finely chopped
5 g (⅛ oz) fresh ginger, peeled and chopped
2 teaspoons soy sauce
2 teaspoons mirin
1 teaspoon toasted sesame oil
Pepper

8 pointed cabbage or curly cabbage leaves

Broth
500 ml (2 cups) dashi (p. 166)
Soaking liquid from dried shiitake mushrooms
3 tablespoons soy sauce
2 tablespoons mirin
2 tablespoons sake
Salt

Rehydrate the dried shiitake mushrooms by soaking in the water for at least 2 hours (or overnight in a sealed container in the refrigerator). Drain, keeping the soaking liquid for the broth. Finely chop the fresh shiitake mushroom caps after removing the stems. Mix all the stuffing ingredients together in a bowl, combine well, and set aside in the refrigerator.

Detach the cabbage leaves without breaking them by removing the hard core and letting running water run down the middle vein to remove the leaves more easily. Blanch each cabbage leaf for 2 minutes in a large pot of boiling water, remove, and drain well. This is to soften the leaves so they can be used to wrap the stuffing. Remove the hard layer at the base of the cabbage using a knife.

Place a cabbage leaf on a work surface with the stem side facing you. Place an eighth of the stuffing at the bottom of the leaf, leaving the sides free to fold in. Roll the bottom of the leaf up once to enclose the stuffing, fold the sides over the stuffing, then finish rolling all the way up. Secure with toothpicks or with string like a present.

Prepare the broth. Heat the dashi, shiitake soaking liquid, soy sauce, mirin, and sake in a large saucepan. When boiling, drop the stuffed cabbage leaves into the broth and simmer for 30 minutes over medium-low heat. Taste and adjust the seasoning with salt as needed.

VEGAN VERSION

For the stuffing, replace the meat with the same quantity of firm tofu. Add 1 tablespoon malted or nutritional yeast and 2 tablespoons potato starch or corn flour. For the broth, replace the dashi with dashi shojin (p. 122). To cook: in a saucepan with 1 tablespoon of oil, brown 100 g (3½ oz) mushrooms (shiitake mushrooms, enoki mushrooms, or others) cut into large pieces. Then pour in the dashi shojin.

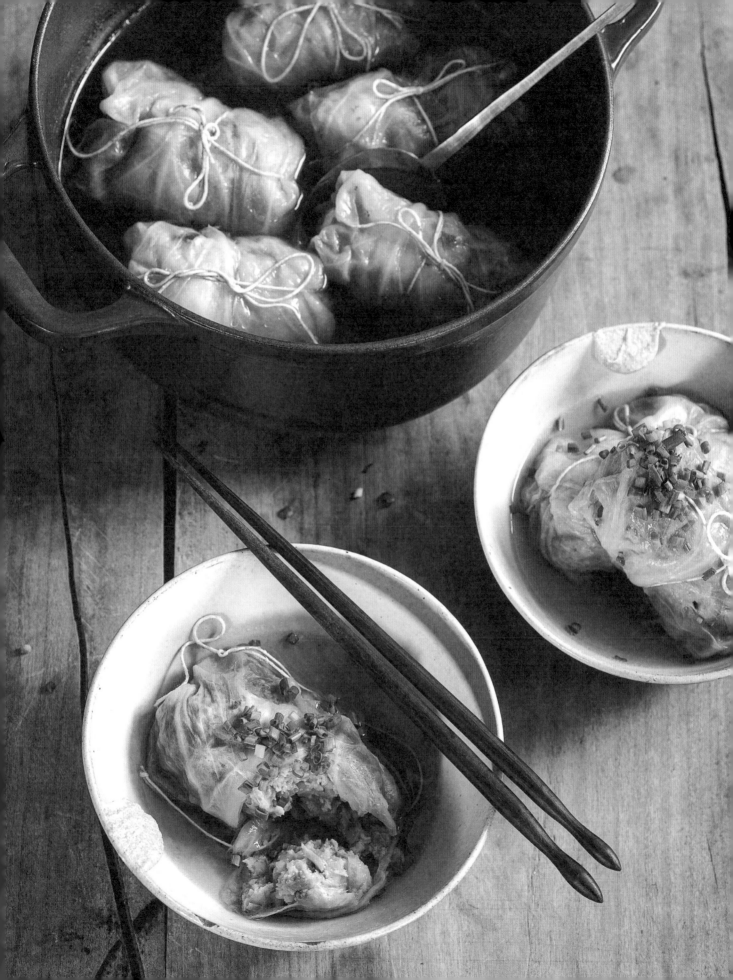

Tonkatsu

(BREADED PORK CUTLET)

豚
カ
ツ

Serves 4
Preparation: 15 minutes
Cooking: 5 minutes

4 pork cutlets, 1.5–2 cm (⅝–¾ inch) thick
2 pinches salt
Pepper
Oil, for frying
Tonkatsu sauce
Cabbage, finely chopped, or coleslaw (p. 208) ½ lemon, quartered

Breading

2 tablespoons all-purpose flour
2 tablespoons all-purpose flour + 3 tablespoons water
50 g (1¾ oz) panko breadcrumbs

Take the pork out of the refrigerator 30 minutes before cooking. Season each piece with the salt and pepper on both sides.

Prepare three plates for breading: one with the flour, one with the flour and water mixed, and one with the panko breadcrumbs, and arrange them in that order. Dip each piece of pork in the flour plate, then in the flour-water mixture, and finally in the panko, pressing the meat lightly with your hand to make the panko stick.

In a large frying pan (the pieces of meat must not overlap; cook in two batches if needed), heat 3 cm (1¼ inches) of frying oil to 180°C (355°F). Fry the pork for 2 minutes on one side, turn over, and cook for another 3 minutes, until the meat is nicely golden brown. When the bubbles around the meat become smaller, it means the pork is cooked. Drain on paper towels and leave to rest for 3 minutes before serving with tonkatsu sauce and finely chopped cabbage or coleslaw.

TO REPLACE THE TONKATSU SAUCE

Heat 4 tablespoons Worcestershire sauce, 2 tablespoons ketchup, 1 tablespoon mirin, and ½ teaspoon soy sauce in a small saucepan over low heat and stir until the sauce thickens.

VEGAN VERSION ✽

Replace the pork with 4 slices cauliflower, cut 1.5–2 cm (⅝–¾ inch) thick. Steam for 3 to 4 minutes, until tender inside, but not too soft, to prevent breaking. Sprinkle each side of the slices with ½ teaspoon malted or nutritional yeast, a pinch of curry powder, and a pinch of salt. Bread and panfry as for the pork.

肉

MEAT

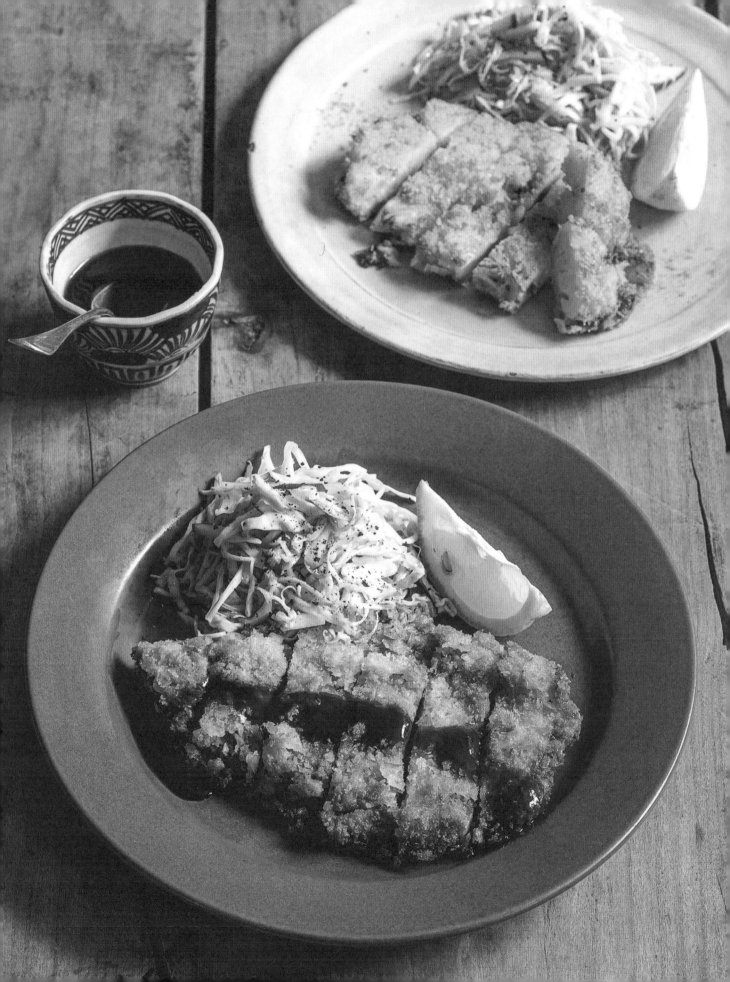

Homemade hot dog

AND SPICY KETCHUP

ホットドッグ

Serves 4
Preparation: 20 minutes
Cooking: 10 minutes

Homemade sausages

400 g (14 oz) pork shoulder, cut into large pieces

½ garlic clove, chopped

3 g (1⁄10 oz) fresh ginger, peeled and finely chopped

1⁄6 onion, finely chopped

1 teaspoon fish sauce

1 teaspoon lemon juice

1 teaspoon raw sugar

Pepper

Spicy ketchup

2 tablespoons ketchup

40 g (1½ oz) cherry tomatoes, halved

1 teaspoon fish sauce

1 teaspoon raw sugar

1 red chile, chopped

Coleslaw

150 g (5¼ oz) cabbage, cut into thin strips

⅛ small red onion, sliced

1 teaspoon coriander seeds

1 tablespoon olive oil

1 teaspoon fish sauce

4 long hot dog buns

4 teaspoons mustard

4 teaspoons soy mayonnaise (p. 139) or traditional mayonnaise

A few cilantro leaves (optional)

1 red chile, sliced (optional)

Neutral oil

To make the sausages, mince the pork in a food processor or using a knife. Put the pork, garlic, ginger, onion, fish sauce, lemon juice, and sugar into a bowl. Season with pepper and mix well. Form four sausages with the diameter of a hot dog. Place each sausage in a piece of parchment paper and wrap it by twisting the ends like a candy wrapper. Wrap each roll in a sheet of aluminum foil and twist closed in the same way. Heat 2 cm (¾ inch) of water in a large pot. When boiling, lower the heat to medium-low, place the sausages in the base of the pot, and cover. Cook for 7 minutes. Drain and leave to cool.

To prepare the ketchup, mix all the ingredients together in a bowl.

To prepare the coleslaw, mix all the ingredients together in a bowl.

Unwrap the sausages from their wrapping. Heat a little oil in a frying pan and cook the sausages over medium heat for 2 to 3 minutes, until golden.

Open the hot dog buns and toast lightly in the oven. Spread 1 teaspoon mustard on one side of each bun and 1 teaspoon mayonnaise on the other. Add some coleslaw, a sausage, and ketchup. You can top with a few cilantro leaves and a few slices of fresh chile, if desired.

VEGAN VERSION

Replace the sausages with vegetable sausages. I like to cut firm tofu into sticks (125 g [4½ oz] for four people) and marinate for 30 minutes with 1 garlic clove, 1 tablespoon soy sauce, and 1 teaspoon raw sugar. Pat dry and coat with potato starch. Panfry. Season with pepper

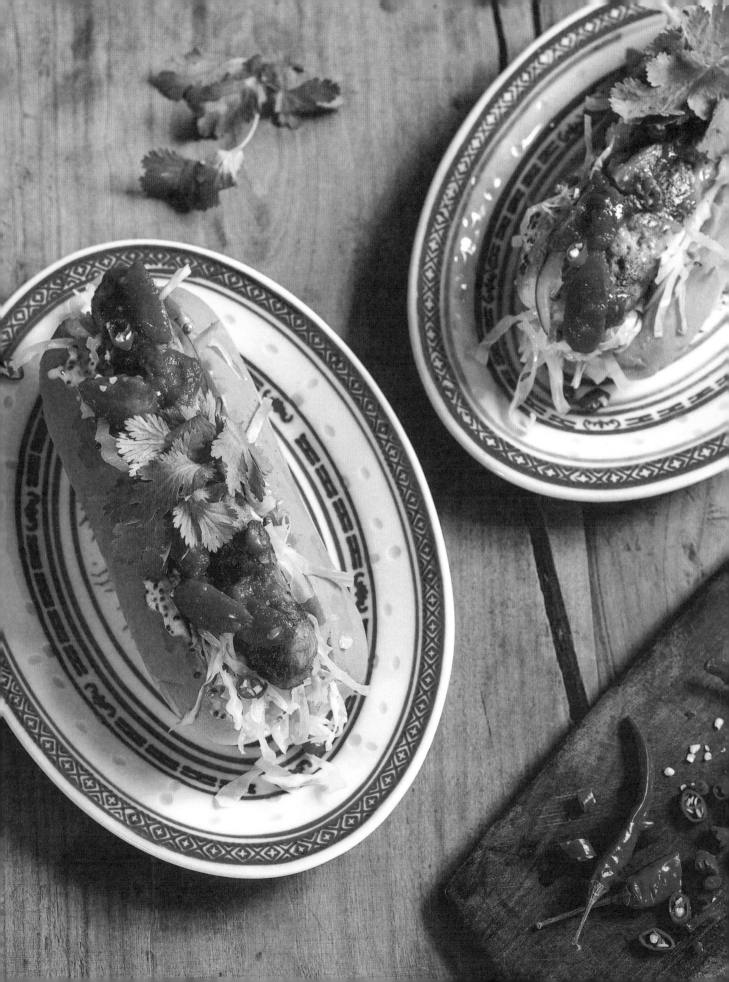

Hamburg steak

(JAPANESE-STYLE BEEF PATTY)

ハンバーグステーキ

Serves 4
Preparation: 20 minutes
Cooking: 20 minutes

60 g (1 cup) panko breadcrumbs
2 tablespoons milk
Neutral oil
1 onion, chopped
400 g (14 oz) ground beef
200 g (7 oz) ground pork
1 egg
½ teaspoon ground nutmeg
1 teaspoon salt
Pepper
20 ml (4 teaspoons) sake

Sauce
10 g (¼ oz) lightly salted butter
2 tablespoons ketchup
2 tablespoons red wine
2 tablespoons mirin
2 tablespoons soy sauce
2 tablespoons Worcestershire sauce
Pepper

Mix the panko and milk in a bowl and allow the panko to absorb the liquid.

Heat 1 tablespoon of oil in a frying pan and fry the chopped onion until translucent. Set aside and leave to cool.

Combine the beef and pork, egg, panko, onion, and nutmeg in a mixing bowl. Season with the salt and pepper and knead by hand until you get a smooth, well-combined mixture. Shape into four patties. Grease a deep frying pan with 1 teaspoon of oil. Heat over medium heat, add the patties, and cover immediately, making sure that the lid fits the pan well to allow for steaming. Cook for 3 minutes, turn the patties over, and cook for a further 10 minutes on low heat, still covered. Pour the sake into the frying pan, cover, and cook for 1 minute over medium heat. Remove the patties from the pan.

Melt the butter in the frying pan and add all the sauce ingredients. Cook over medium heat, stirring. When the sauce thickens, pour it over the patties.

This is no longer the type of food I eat, but this recipe still makes me nostalgic, as my mother often made it for me as a child. Served with mayo spaghetti and a green salad, it was a classic dish in our home!

VEGAN VERSION

Mix 200 g (7 oz) tofu, 100 g (3½ oz) rolled oats, and 10 g (¼ oz) chopped hazelnuts. Sauté 1 finely chopped onion and 100 g (3½ oz) chopped button mushrooms in a little oil until the onion is translucent. Mix with 50 g (1¾ oz) grated potato, 2 tablespoons potato starch, 1 teaspoon soy sauce, 1 teaspoon mirin, and 2 pinches salt. Make four meatballs and cook as above. To make the sauce, omit the butter.

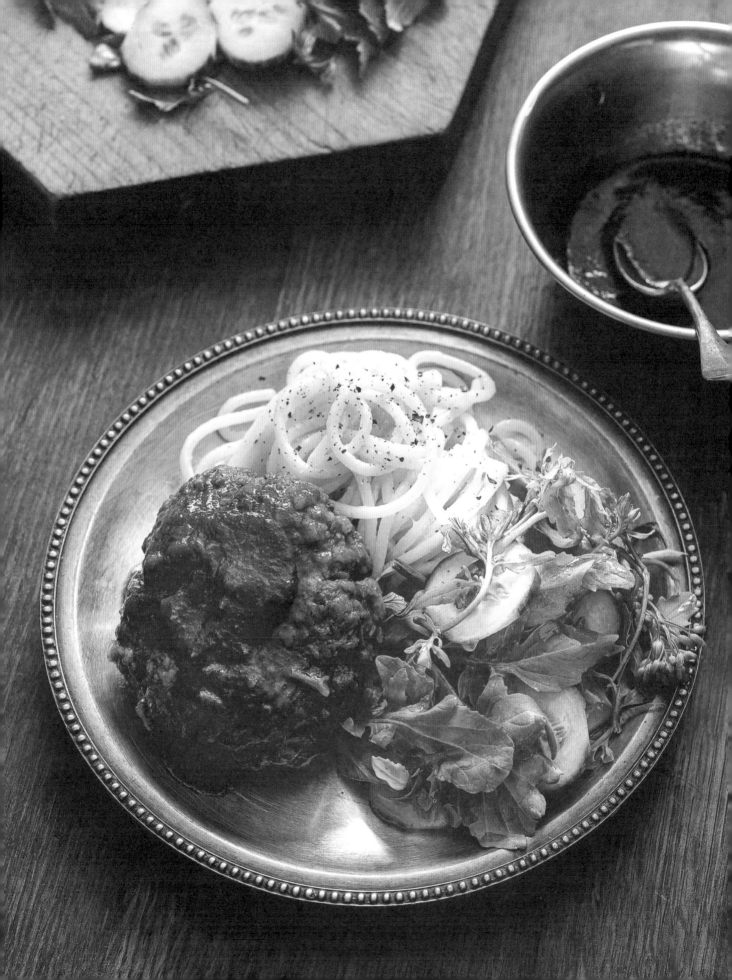

Japanese curry

ルーから作るカレー

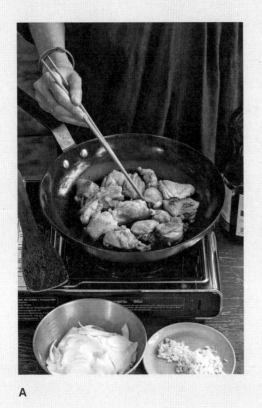

A B

Serves 4
Preparation: 20 minutes
Cooking: 1 hour

Curry roux
2 tablespoons neutral oil
2 boneless chicken thighs, cut into bite-sized pieces
2 onions, finely chopped
1 garlic clove, chopped
3 cm (1¼ inches) fresh ginger, peeled and chopped
1 celery stalk, finely chopped
1 carrot, grated
1 apple, finely chopped or grated
3 tablespoons curry powder
240 ml (8 fl oz) crushed tomatoes

4 tablespoons all-purpose flour
600 ml (20 fl oz) dashi (p. 166) or chicken stock
2 potatoes, peeled and quartered

Seasoning
1 tablespoon Worcestershire or tonkatsu sauce
1 tablespoon malted or nutritional yeast
1 tablespoon soy sauce
2–3 teaspoons salt

Sides
½ eggplant
½ zucchini
½ bell pepper
8 green beans
Oil for frying
Cooked rice for 4 people (p. 56)

肉

MEAT

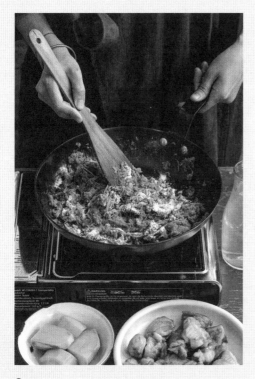

C

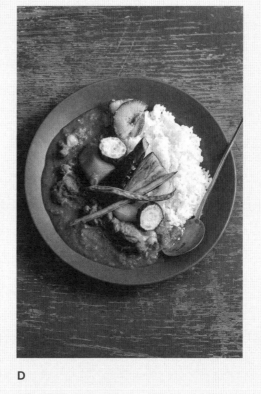

D

Prepare the curry roux. Heat 1 tablespoon of the oil in a deep frying pan over medium heat. Place the chicken pieces in, skin-side down, and cook for 1 minute each side **(A)**.

Remove the chicken. Add the remaining tablespoon of oil to the frying pan with the chicken fat and fry the onions, garlic, and ginger until they are nicely golden, almost caramelized. Add the celery, carrot, and apple and cook for 10 minutes **(B)**.

Remove from the heat, stir in the curry powder, and mix well. Return to the heat, stir in the tomatoes, and simmer for 2 minutes. Remove from the heat and stir in the flour. Return to medium heat and stir for 1 to 2 minutes. Gradually pour in the dashi or stock. Add in the chicken, potatoes, and all the seasoning ingredients, then leave to simmer for 20 minutes over medium-low heat **(C)**.

Cut the eggplant into large cubes, zucchini into 1-cm (½-inch) slices, and the pepper into strips. Cut the wide stem end off the beans (keep the end with the pointy tip). Heat 3 cm (1¼ inches) of frying oil to 180°C (355°F) in a frying pan and fry the vegetables until they are golden brown.

Divide the rice onto four plates, add the curry, and serve the vegetables on top **(D)**.

GOURMET VERSION

Serve the curry with tonkatsu pork (p. 206) instead of the chicken.

VEGAN VERSION

Omit the chicken thighs and use the dashi shojin (p. 122) in the roux.

Japanese drinks

日本のアルコール

I grew up with a father who loved to drink. In the evening he would drink an aperitif alone, before everyone else was at the table, along with one or two small dishes my mother had prepared and a plate of bonito sashimi. He would choose his alcohol depending on the dishes served: a very cold beer to start with or a glass of sake, or in winter, a shochu with hot water. In Japan, as in France, people like to drink a lot while eating and there is a wide choice of alcoholic drinks to accompany meals.

Sake 酒

An alcoholic drink made from rice. The polishing of rice removes the layer of the grain containing proteins and fats. The more polished the grain, the finer and more delicate the taste of the sake.

Futsu-shu is a relatively cheap table sake.

The high-quality tokutei-meishoshu is formulated according to strict rules to guarantee quality and authenticity. Tokutei-meishoshu categories are determined by whether or not sterilized alcohol is added and by the degree of rice grain polishing.

Junmai-shu (literally "pure rice") is made solely of rice, water, and kōji. It generally has more flavor and character than honjozo, and you can really taste the rice flavor.

Honjozo-shu is made with the same ingredients as junmai, with a little alcohol added (often pure distilled cane alcohol). Some prefer it to junmai because the distilled alcohol makes the rice aroma more subtle, giving it a milder taste and making it easier to drink.

Ginjyo-shu is made with 40% polished rice (60% of the grain size is kept). It is fermented at low temperatures, which gives the sake a very delicate and fruity aroma. When it is made solely of rice, kōji, and water, it is called junmai-ginjyo.

Daginjo-shu is made using the same process as ginjyo-shu, but with rice polishing greater than 50%. When it is made solely of rice, kōji, and water, it is called junmai-daiminjo.

Daiginjo sakes are the highest quality, with a delicate and subtle taste, but they may not be your favorite. If you are looking for a sake with more character, a stronger cereal taste, or more body, choose a junmai-shu.

Mini sake glossary: namazake = unpasteurized sake; genshu = sake without added water at the end of fermentation; happo-shu = sparkling sake; nigorizake = unfiltered sake; koshu = aged sake with a very particular and pronounced taste.

Where to buy it? On the internet.

Umeshu 梅酒

An alcoholic drink based on a neutral alcohol (shochu, sake, mirin, or even brandy), in which Japanese plums (ume) are macerated, often with sugar. Its flavor is very fruity and sweet, perfect as an aperitif. Umeshu can be enjoyed in a small glass, but it is even better with sparkling water and ice cubes.

It is common to make homemade umeshu. My grandmother was very gifted and made it every year during the plum season. She let me taste it secretly when I was young, which was my first experience with alcohol. She also let me taste her umeshu, which had been macerated for thirty years. It still remains the best umeshu I've tasted.

飲み物

FOCUS

Shochu 焼酎

A Japanese distilled spirit made from different base ingredients (rice, barley, wheat, buckwheat, or sweet potato). It is consumed as an aperitif, digestive, or during the meal and in various ways (with ice, dry, with hot water, sparkling water, mixed with other drinks such as tea, etc.).

The ingredients determine the character of the shochu. Barley shochu is considered the "easiest" to drink because its aroma is mild. If you're a sake lover, you may enjoy the round, fruity taste of rice shochu. Sweet potato shochu has more character, with a strong sweet aroma. Some people find it too strong. But my maternal family comes from Kagoshima, a region famous for its excellent sweet potato shochu, so it's definitely my favorite!

Beer ビール

Beer is the most consumed alcohol in Japan. At the beginning of the meal, especially when you go out to an izakaya (Japanese tapas bar), you often hear the phrase "*Toriaezu biru*"—"Let's start with a beer!"

Pilsner, a mild and refreshing pale ale with a fairly moderate alcohol level, is the most popular in Japan. When you talk about beer in Japan, "the feeling in your throat" is very important. The refreshing sensation must come first. We like to drink beer extremely cold, like water. Nowadays outside of Japan, you can find good craft beers made by Japanese microbreweries, as well as the main Japanese beer brands like Kirin and Asahi.

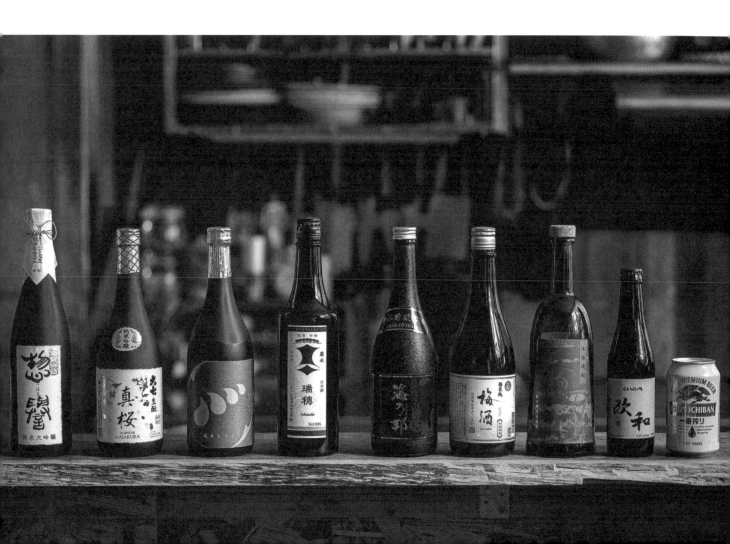

Easy cocktails

カクテル

Serves 1

Hot sake with cherry blossom 桜酒 VEGAN

1 salted cherry blossom (p. 116)

100 ml (3½ fl oz) sake

Rinse the cherry blossom in warm water and place it in the bottom of a glass. Pour the sake into a tokkuri (bottle to serve the sake), or a heatproof cup or glass. Place the tokkuri or cup/glass in a saucepan and fill with water to 80% of the sake height. Remove the tokkuri from the pan, bring the water to a boil, turn off the heat, then stand the tokkuri in the hot water and leave to heat for about 3 minutes, until the sake reaches 50°C (120°F). Pour the hot sake over the flower and wait until it opens before drinking.

CHOOSING SAKE

Use junmai-shu (see p. 214), which has a pronounced character and can be heated, or ask your sake supplier for advice.

Ginger beer ジンジャービール

50 ml (1¾ fl oz) ginger syrup from the second step (p. 238)

330 ml (11 fl oz) beer

1 slice candied ginger (p. 238)

Pour the ginger syrup into a glass. Add the beer and slice of candied ginger. Serve.

Umeboshi shochu 梅干し焼酎 VEGAN

1 umeboshi

100 ml (3½ fl oz) shochu

Place the umeboshi in the bottom of a glass, pour in the shochu, and serve.

TIPS

I really like using rice shochu for this cocktail, but you can choose whichever shochu you like.

—

Try to buy umeboshi at organic stores or online to ensure they are made the traditional way, without artificial flavors.

飲み物

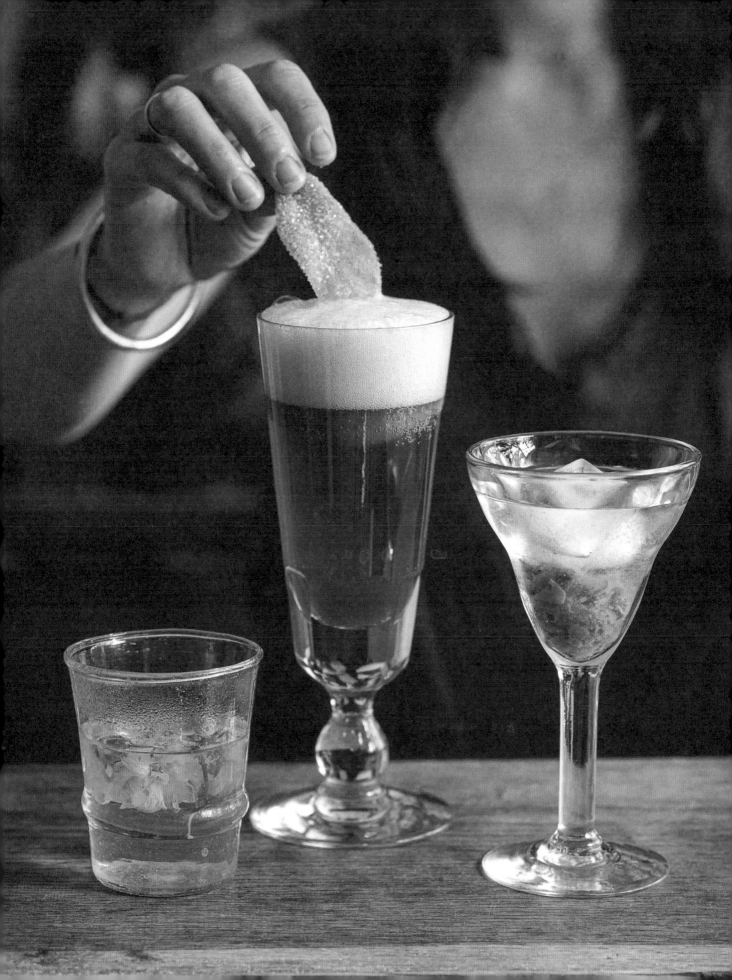

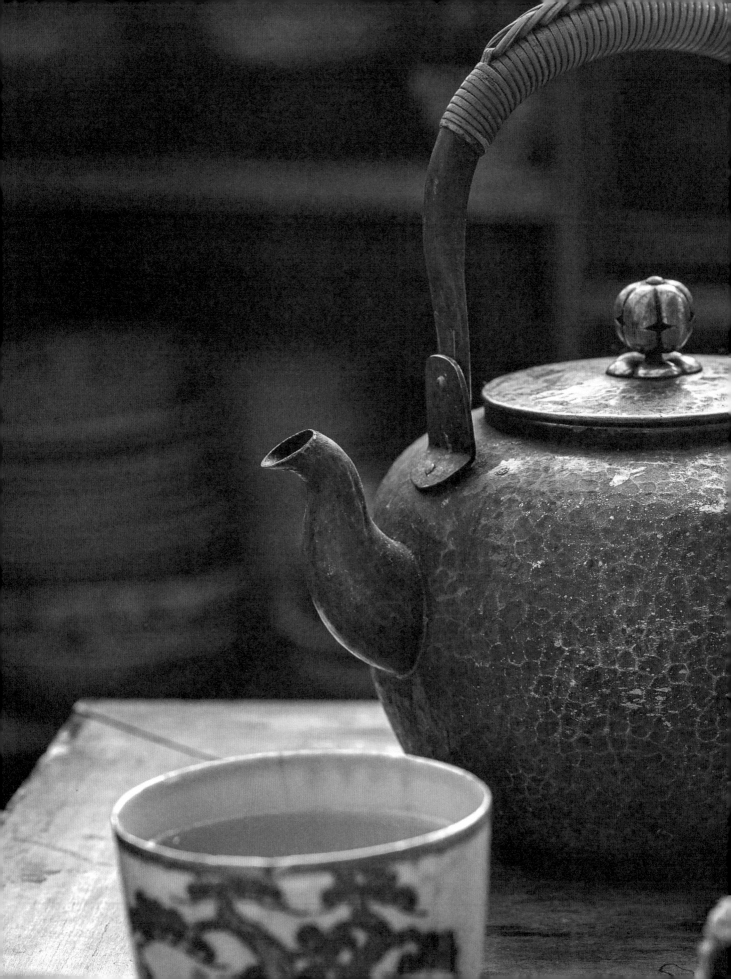

お茶のお供

TEA AND SWEETS

Tea

茶

Morning, afternoon, or evening—in Japan, tea is consumed every day. And not only is it the drink of our daily life, but it is also served with sweets. In France, a meal ends with dessert. In Japan, this is not necessarily the case, perhaps because our dishes already contain quite a lot of sugar. On the other hand, when you go to a coffee shop or tea room in Japan, you often order pastries and drinks for afternoon tea (*oyatsu*). It's the same at home. We enjoy something sweet with a nice cup of tea as a treat.

Sencha

This is the most popular tea in Japan. It has a nice green color and a slightly salty and delicately bitter taste. Young tea shoots are harvested and steamed immediately to maintain their green color and prevent fermentation.

Preparation: 1 teaspoon tea leaves in a small teapot (kyu-su) for 200 ml (7 fl oz) hot water. For quality tea, heat the water to 70°C (160°F) to gently bring the umami out of the tea. For medium quality tea, heat to 80°C (175°F). Do not boil the water, as this makes the bitterness release too quickly. Allow to infuse between 30 seconds and 1 minute. The same tea can be brewed two or three times.

Genmaicha

This is a green tea mixed with roasted rice. Its hazelnut and roasted rice flavor enhances the green tea taste. It is good to drink during or after a meal.

Preparation: 1 teaspoon of tea in a small teapot (kyu-su) for 200 ml (7 fl oz) of water at 90–95°C (195–205°F). Using very hot water is recommended in order to bring out the roasted rice aroma. Allow to infuse between 30 seconds and 1 minute.

Houjicha

This is a roasted green tea, made up of leaves and/or fine stems generally harvested later than sencha. It is brown in color and its theine content is very low. It is not bitter and has a very mild, slightly sweet taste and is consumed during meals. Its pleasant roasted taste makes it easy to drink.

Preparation: 1 teaspoon of tea in a small teapot (kyu-su) for 200 ml (7 fl oz) of water at 90–95°C (195–205°F). Using very hot water is recommended in order to bring out the roasted aroma of the green tea. Allow to infuse between 30 seconds and 1 minute.

Matcha

This tea comes in the form of a green powder. It is already well known in the world of pastry making. In Japan, it is enjoyed at a tea ceremony. It is uncommon to drink this tea every day. But you can also enjoy a good cup of matcha at home. It is also very nice as a cold drink (p. 222).

Preparation with a chasen (small bamboo whisk) to form a nice foam: 1 heaped teaspoon of matcha sifted into a bowl. Dissolve the powder with a chasen by gently pouring in 60–70 ml (2–2¼ fl oz) of water at 80°C (175°F). Move the chasen gently but quickly to draw an M shape from right to left and left to right. Finish by drawing an O and lift the chasen from the center of the bowl.

Preparation without chasen: 1 teaspoon matcha, sifted into a cup and fully dissolved in 1 teaspoon of water. Gently add 60–70 ml (2–2¼ fl oz) of water at 80–90°C (175–195°F).

Mugicha

This is grilled barley herbal tea. Without theine and with a very pleasant scent of roasted barley, it is the tea that is offered to children from a young age. It is usually consumed cold in the summer. When I was a little girl, the first thing I did when I got back from school was to drink a big glass of the mugicha that my mother had prepared ready in the refrigerator.

Preparation: Depending on the brand, infuse it in hot or cold water. It is delicious cold with ice cubes, but it is also very warming to drink hot.

Sobacha

This is an infusion of roasted buckwheat kernels. I love this infusion—it takes me right back to Japan. It has a delicate roasted buckwheat aroma and its taste is very mild. It is perfect for after a meal or during a short break to relax. It is also very healthy as it is rich in minerals and antioxidants.

Preparation: 1 heaped teaspoon of tea per 200 ml (7 fl oz) of water at 90°C (195°F). Allow to infuse for 3 to 4 minutes.

To roast the buckwheat yourself, put buckwheat kernels in a frying pan and heat over medium heat. Once the pan is hot, reduce the heat to low and roast for about 10 minutes, stirring regularly.

Tea-based drinks

Serves 1

Sparkling matcha tea

1 teaspoon honey

2 g (1 teaspoon) matcha tea

1 tablespoon warm water

200 ml (7 fl oz) sparkling water

Dash lemon juice (optional)

In a bowl, dissolve the honey and matcha tea thoroughly in the warm water. Pour into a glass. Add the sparkling water gradually, mixing well. Add 1 or 2 ice cubes and squeeze in a dash of lemon juice, if desired.

Houjicha with soy milk

9 g (¼ oz) houjicha

50 ml (1¾ fl oz) water

160 ml (5½ fl oz) soy milk

1 pinch ground cinnamon

Red chile powder (optional)

1 teaspoon honey

A few buckwheat kernels

Heat the houjicha and water in a small saucepan over medium heat until boiling. Lower the heat, add the soy milk and cinnamon, and simmer for 3 minutes. Strain into a cup. Sprinkle with a little red chile powder, if desired. Add the honey and buckwheat kernels.

Umesho-bancha VEGAN

4 g (2 teaspoons) bancha (green tea)

200 ml (7 fl oz) boiling water

1 umeboshi

1 teaspoon soy sauce

1 teaspoon fresh ginger, grated and pressed for juice

Put the bancha in a teapot. Pour in the boiling water and allow to infuse for 30 seconds to 1 minute. Place the umeboshi in a cup and add the soy sauce and the ginger juice. Pour in the tea.

Bancha is a green tea made with leaves that are harvested later than for sencha. The bancha leaves are therefore larger, contain less caffeine, and are rich in minerals. It has quite a light taste.

This recipe is considered to be a medicine against colds and fatigue. My mother used to prepare it whenever I caught a cold.

Anko

(SWEET RED BEAN PASTE)

 VEGAN

あんこ

Makes 490 g (1 lb 1 oz) anko
Preparation: 5 minutes
Cooking: 1¼ hours

250 g (8¾ oz) dried red adzuki beans
240 g (8½ oz) raw sugar
1 pinch salt

Wash the adzuki beans and put them in a saucepan with four times their volume of water. Heat over medium heat and cook for 15 minutes once the water starts boiling. Drain using a colander, then rinse under running water. Wash the pan and put the beans back into the pan with three times their volume of water. Bring to a boil, reduce the heat to medium-low, skim off the foam, and leave to simmer for 30 minutes. During cooking, make sure that the beans remain covered with water, adding a little more if necessary. After 30 minutes, check the cooking. Take an adzuki bean between your fingers and crush it. If it crushes very easily, it is cooked. If not, continue cooking. Drain in a colander, reserving the cooking water in a bowl.

Let the water stand for a few minutes until it separates from the starch. Then carefully pour off the water and keep the starch that has settled in the bottom of the bowl. Put this starch back into the pan with the cooked adzuki beans.

Add the sugar to the pan and cook for 30 minutes over medium-low heat. The surface must be bubbling at all times. Mix regularly with a spatula, scraping the bottom of the pan. After about 30 minutes, the liquid will evaporate and you should be able to see the bottom of the pan when mixing. The mixture will harden slightly as it cools. Stop cooking when you get a thick consistency. Add the salt and mix in. Allow to cool in the pan, then pour into a dish and cover with plastic wrap touching the anko.

Anko will keep for 3 to 4 days in an airtight container in the refrigerator and 1 month in the freezer (divide the anko into small portions, wrapped in plastic wrap).

This type of anko, made with whole beans, is called tsubu-an (tsubu means "grain"). Koshi-an ("strained anko" in Japanese) is smooth because the bean husks are removed by straining the mixture.

お茶のお供

TEA AND SWEETS

Dorayaki

(RED BEAN PANCAKES)

どら焼き

Makes 4 dorayaki
Preparation: 10 minutes
Resting: 30 minutes
Cooking: 20 minutes

80 g (2¾ oz) all-purpose flour
½ tablespoon baking powder
1 egg
40 g (1½ oz) raw sugar
½ tablespoon honey
1 tablespoon mirin
40 ml (1¼ fl oz) soy milk
Neutral oil, for greasing
160 g (5¾ oz) anko (red bean paste, p. 224), store-bought tsubu-an (anko with whole beans), or koshi-an (smooth anko)

Sift the flour and baking powder into a bowl and mix. Break the egg into another mixing bowl, and add the sugar, honey, mirin, and soy milk. Mix well with a whisk. Add in the flour and baking powder and mix well. Cover and leave to rest for 30 minutes in the refrigerator.

Heat a frying pan over medium heat. When it is nice and hot, grease it with a little oil, wiping the excess with paper towels. Reduce the heat to low. Pour a small ladle of batter into the pan and let it spread to form a round about 8 cm (3¼ inches) in diameter. To get a nice round, keep the ladle still as you pour in the batter. Cook for about 2 minutes, until small bubbles form on the entire surface. Turn and cook for between 30 seconds and 1 minute, until the bottom is golden brown. Repeat the process until all the batter is used up, to make 8 pancakes. Leave to cool, then spread 40 g (1½ oz) anko on each of four of the pancakes and cover with the other pancakes.

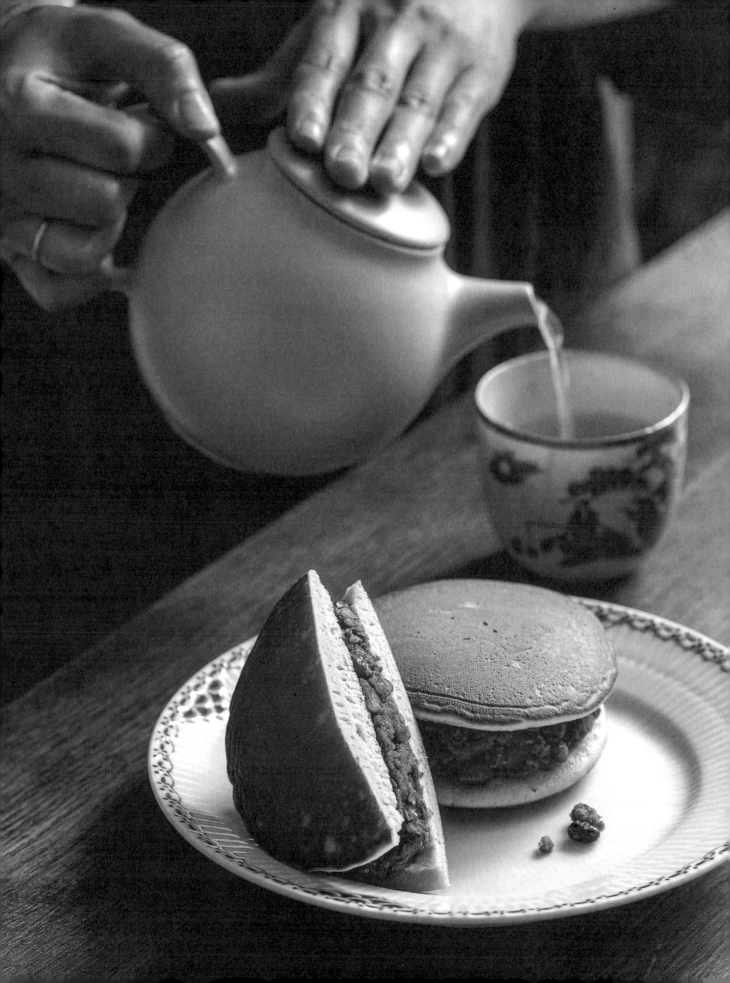

Strawberry daifuku

(STRAWBERRY AND ANKO MOCHI)

 VEGAN

苺大福

Makes 4 rice cakes (mochi)
Preparation: 35 minutes
Cooking: 12 minutes

Filling
4 fresh strawberries
120 g (4¼ oz) anko (red bean paste, p. 224)

Mochi dough
70 g (2½ oz) glutinous rice flour*
75 ml (⅓ cup) water
10 g (2½ teaspoons) granulated sugar

For working the dough
Potato starch or corn flour

*This recipe does not work with normal rice flour. Glutinous rice flour can be found in Asian or Japanese grocery stores (called "mochiko" or "shiratamako" in Japanese).

Prepare the filling. Wash the strawberries, pat dry, and hull. With wet hands, form four balls of anko. Flatten them to form four small rounds, place a strawberry in the middle of each, and close the rounds to enclose the strawberries.

Prepare the mochi dough. Mix the rice flour and water together well in a bowl that fits in a steamer basket. Add the sugar and mix. Heat water to prepare the steamer, place the bowl in the steamer basket, and cook for 12 minutes on high heat. At the end of the steaming process, remove the bowl from the steamer basket. Mix the paste with a silicone spatula while it is hot. It is a little difficult at first, then the dough becomes elastic after 1 minute.

Liberally sprinkle a clean surface with potato starch. Place the mochi dough on the starch and coat well. Always make sure to have starch on your hands, as the dough sticks as soon as it touches a surface without starch. Cut the dough into four pieces. Flatten each piece to get four rounds, removing any excess starch from the palms of your hands. Place an anko and strawberry ball in the middle of each round of mochi dough. Fold the dough over the ball and pinch to close securely. Turn the daifuku upside down with the closed side underneath.

Eat the same day.

MICROWAVE MOCHI DOUGH

Put the mixture in a glass bowl and cover with plastic wrap. Cook for 2 minutes at 600 W.

Mix the dough well using a silicone spatula.

Cook again for 2 minutes, then mix well.

TEA AND SWEETS

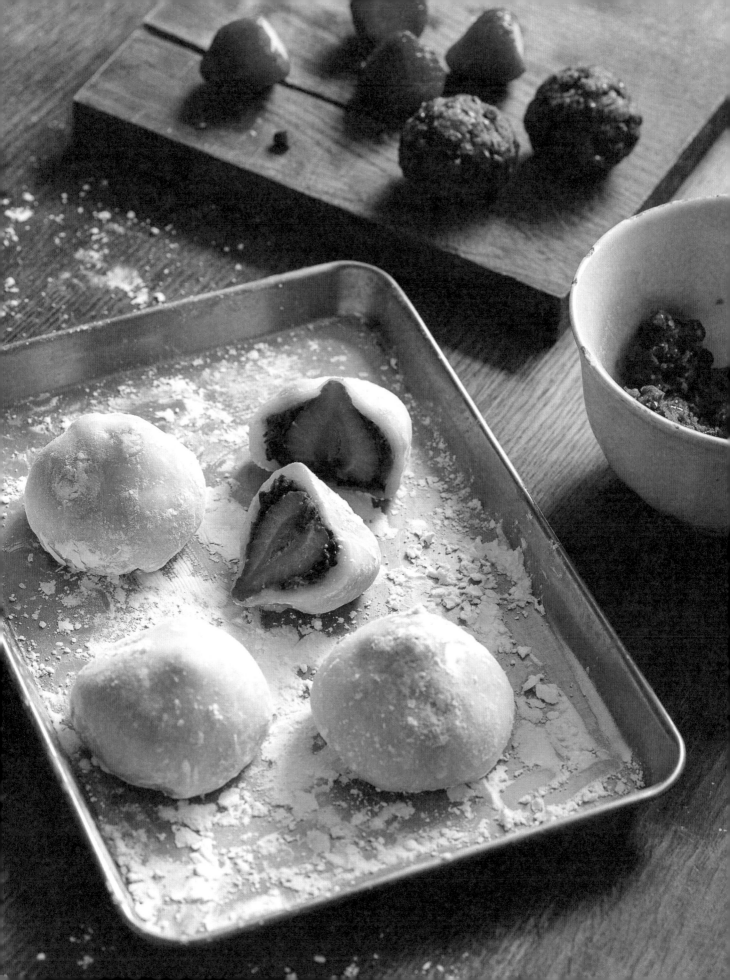

Shiratama dango
(GLUTINOUS RICE BALLS)

 VEGAN

白玉団子

Serves 4
Preparation: 10 minutes
Cooking: 10 minutes

Shiratama balls

120 g (4¼ oz) shiratamako (glutinous rice powder)
1 tablespoon granulated sugar
120 ml (½ cup) water

Mix the sugar and shiratamako in a bowl. Add 80 ml (⅓ cup) of the water and mix by hand. Add the remaining 40 ml (1¼ fl oz) of water little by little while mixing. Form balls 1.5–2 cm (⅝–¾ inch) in diameter by rolling the dough between the palms of your hands. Press the center of the balls a little to ensure they cook evenly.

Drop the balls into a pot of boiling water and wait until they rise to the surface. Stop the cooking by refreshing the balls in a bowl of chilled water. Drain.

This recipe can be used to create the following variations, the black sesame shiratama and shiratama with adzuki soup. The variations use half of this recipe, but if you would like to make just one kind, double the ingredient amounts and use the entire shiratama balls recipe.

Black sesame shiratama
Serves 2

6 tablespoons toasted black sesame seeds
5 tablespoons raw sugar
1 pinch salt
Half of the shiratama balls (recipe above)

Crush the black sesame seeds with a mortar or in a food processor. Mix with the sugar and salt. Sprinkle the black sesame mixture over the shiratama balls.

Shiratama with adzuki soup
Serves 2

400 g (14 oz) anko (red bean paste, p. 224) or store-bought tsubu-an (anko with whole beans)
200 ml (7 fl oz) water
Raw sugar (optional)
Half of the shiratama balls (recipe opposite)

Dissolve the anko in the water in a saucepan. Add sugar, if desired. Heat over a low heat. Once boiling, add the shiratama balls and heat for another 2 minutes.

Serve in individual small bowls with spoons.

お茶のお供

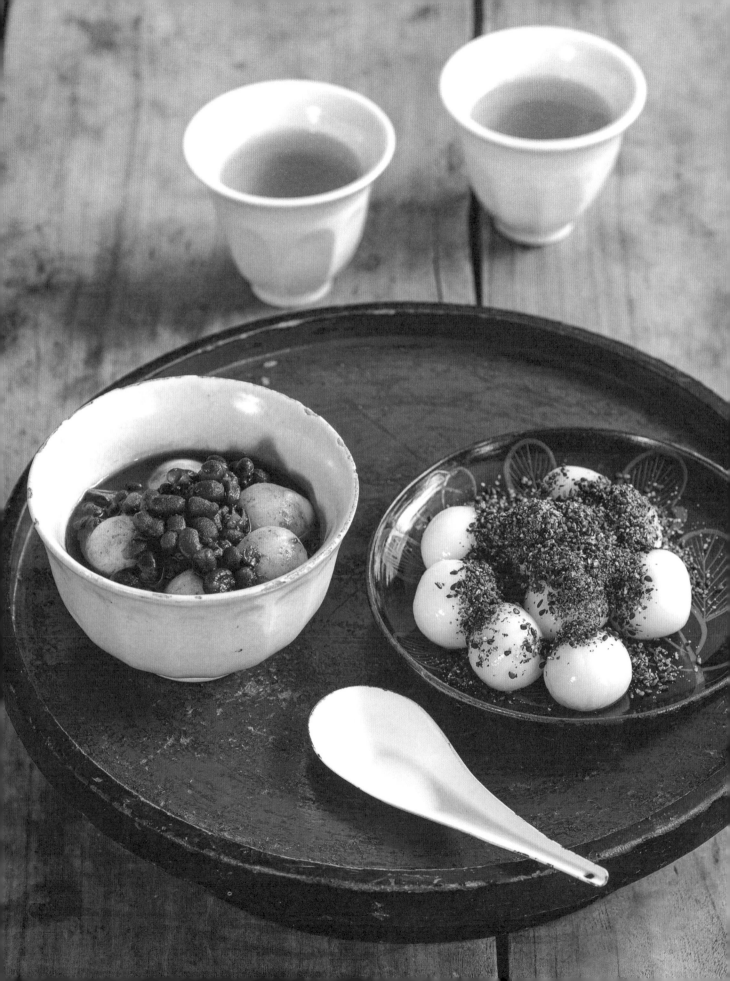

Soba manjyu
(SWEET BUCKWHEAT BUNS)

 VEGAN

Makes 6 buns
Preparation: 15 minutes
Cooking: 10 minutes

250 g (8¾ oz) anko (red bean paste, p. 224), store-bought tsubu-an (anko with whole beans), or koshi-an (smooth anko)
70 g (2½ oz) raw sugar
50 ml (1¾ fl oz) water
½ tablespoon baking powder
50 g (⅓ cup) all-purpose flour, plus extra for dusting
50 g (1¾ oz) buckwheat flour

Divide the anko into six and form six balls.

In a bowl, dissolve the sugar in the water. Add the baking powder and flours and mix. Flour the work surface. Divide the dough into six pieces. Roll into balls and flatten them to form six small rounds.

Place a ball of anko in the middle of each round and fold the rounds to enclose. Turn the dough over with the closed side underneath. Place the balls on squares of parchment paper larger than the diameter of the balls.

Prepare a steamer basket, place the buns, with the parchment paper squares, into the basket, and steam for 10 minutes over high heat.

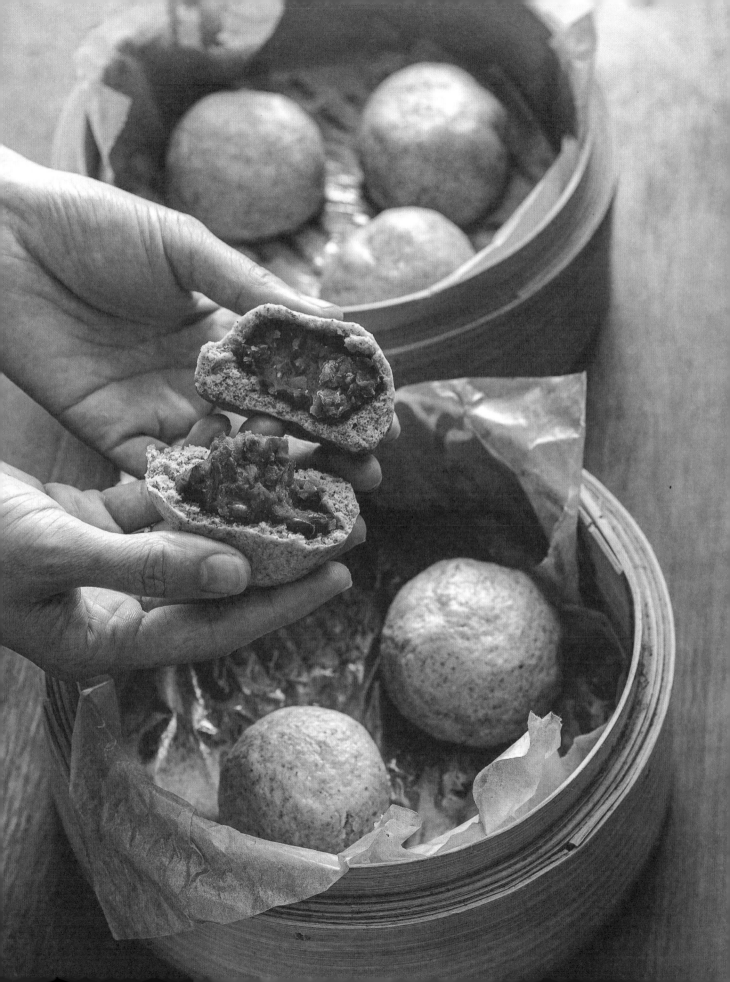

Sesame okara doughnuts

 VEGAN

胡麻とおからのドーナッツ

Serves 4
Preparation: 20 minutes
Cooking: 15 minutes

1 tablespoon chia seeds +
3 tablespoons water, or 1 egg
100 g (3½ oz) okara (p. 141)
1 tablespoon neutral oil
20 ml (4 teaspoons) soy milk
100 g (⅔ cup) all-purpose flour
1 teaspoon baking powder
60 g (2 oz) sugar

Shaping and cooking
Neutral oil
2 tablespoons sesame seeds (toasted white or black)
Oil, for frying

In a bowl, soak the chia seeds in the water for about 2 minutes.

Put the okara, oil, and soy milk in another bowl. Mix with a spatula. Add the chia seed mixture, or egg, if using, and mix. Add the flour, baking powder, and sugar. Mix.

Brush the palms of your hands with oil and make 12 balls. Pour the sesame seeds onto a plate and roll the balls in the seeds.

Pour the frying oil into a deep frying pan up to the height of the balls. Heat the oil to 120°C (250°F). Drop the balls in the oil and slowly increase the temperature to 160°C (320°F). The surface of the doughnuts will open as if they were smiling. Increase the temperature again, to 180°C (355°F), and fry the doughnuts, turning occasionally, until they are golden brown. Drain before eating.

お茶のお供

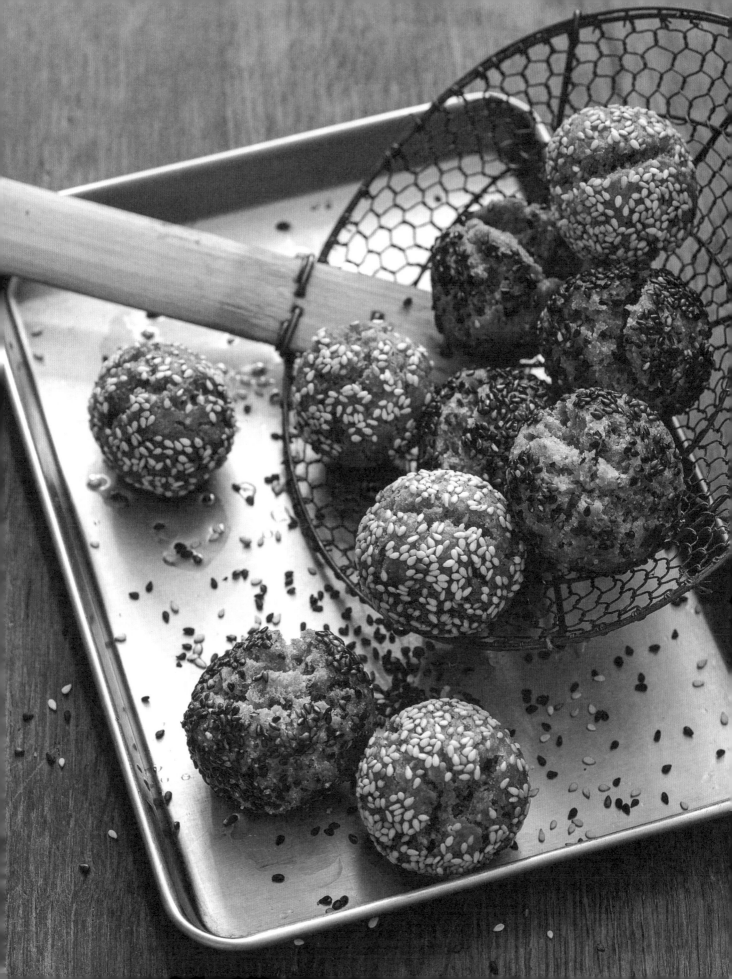

Karintou

WITH BLACK SUGAR AND PEANUTS
(JAPANESE COOKIES)

 VEGAN

Serves 4
Preparation: 15 minutes
Resting: 30 minutes
Cooking: 10 minutes

60 g (2 oz) all-purpose flour
40 g (1½ oz) buckwheat flour
2 g (1/16 oz) baking powder
20 g (¾ oz) raw sugar
40 ml (1¼ fl oz) water
2 teaspoons oil
20 g (¾ oz) peanuts, finely chopped
Oil, for frying

Coating
100 g (½ cup) muscovado sugar or Amami black sugar
2 tablespoons water
20 g (¾ oz) peanuts, finely chopped

Mix the flours, baking powder, and sugar in a bowl. Add the water and oil and mix. Add the chopped peanuts and mix well with your hand until a smooth dough forms. Form the dough into a ball, wrap in plastic wrap, and leave to rest for 30 minutes in the refrigerator.

Place the ball on a work surface, lightly flouring the surface if the dough sticks. Divide the ball into two logs and flatten them. Keep one log covered with plastic wrap to prevent it from drying. Cut the other into 30 small pieces. Carefully roll each piece by hand to obtain sticks that are 5–7 mm (¼ inch) in diameter (it doesn't matter if they are different lengths). Repeat the process with the other log.

Heat 2 cm (¾ inch) of frying oil to 170°C (340°F) in a saucepan. Fry the sticks, in batches, for about 5 minutes, until they are crispy and the bubbles around them are tiny and few. Drain the karintou on paper towels.

Pour the sugar and water into a saucepan. Heat over medium heat to dissolve the sugar completely, stirring constantly. When it boils and the mixture thickens, add the karintou and peanuts. Mix together. Remove the karintou from the pan and dry on parchment paper or on a clean work surface.

Candied ginger

生姜の砂糖漬け

Serves 4
Preparation: 15 minutes
Resting: 4 days
Cooking: 30 minutes

100 g (3½ oz) fresh ginger
60 g (2 oz) + 2 tablespoons granulated sugar
100 ml (3½ fl oz) water
30 g (4 teaspoons) honey
1 tablespoon lemon juice

Peel the ginger and slice it very finely (1–2 mm/¹⁄₁₆ inch thick, ideally). Cook the ginger in a saucepan of boiling water for 5 minutes. Drain and keep the cooking water. Put the ginger back into the pan, sprinkle with 60 g (2¼ oz) of sugar, and let stand for 30 minutes.

Add the water and honey to the pan and heat over medium heat. After it comes to a boil, reduce the heat to low and simmer for 20 to 25 minutes, until it becomes syrupy. Stir in the lemon juice. Drain and keep the syrup. Put the ginger back into the pan and heat gently for 1 minute, stirring constantly, to allow the remaining syrup to evaporate (be careful not to burn the ginger!).

Place the ginger on a zaru or on parchment paper. Allow to dry for 1 day at room temperature or 30 minutes in the oven at 100°C (210°F) on parchment paper. Sprinkle with the remaining 2 tablespoons of sugar. Leave to dry for 2 to 3 days at room temperature. The candied ginger will keep for 1 month in a jar at room temperature.

TIP

The water used to boil the ginger in the first step is delicious. I drink it hot or cold, mixed with honey. The syrup left over after draining the ginger in the second step can be used to sweeten yogurt, to make ginger beer (recipe p. 216), or to flavor other beverages.

お茶のお供

TEA AND SWEETS

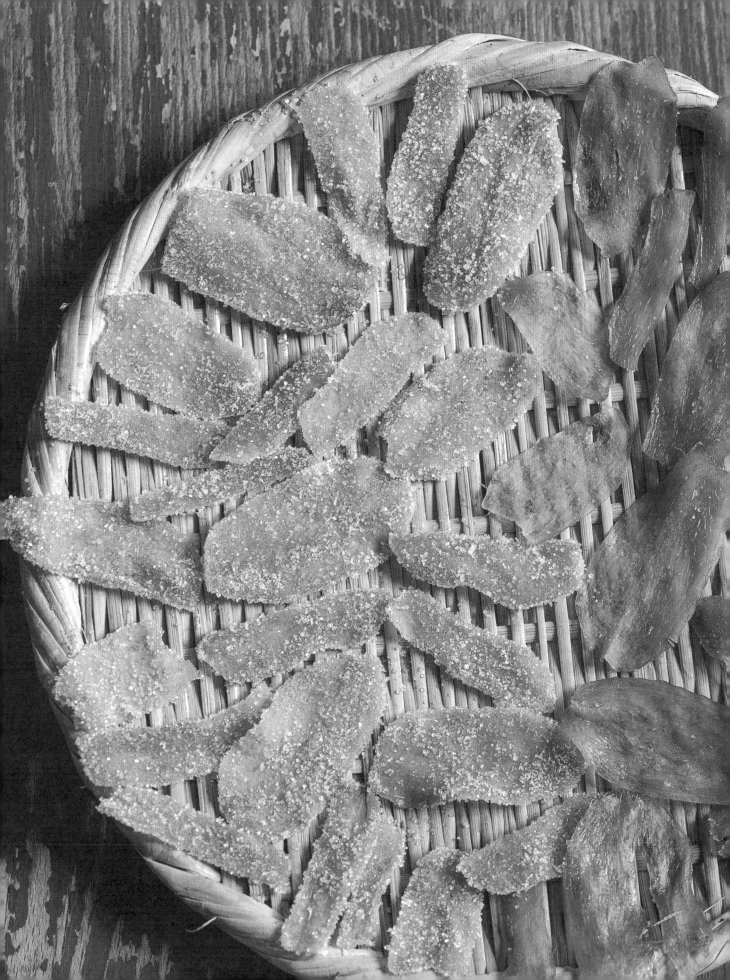

Kuzukiri

(KUZU PASTE WITH BLACK SUGAR SYRUP)

 VEGAN

Serves 4
Preparation: 30 minutes
Cooking: 10 minutes

Kuromitsu (black sugar sauce)
120 g (4¼ oz) muscovado sugar or Amami black sugar
80 g (2¾ oz) raw sugar
100 ml (3½ fl oz) water
½ teaspoon soy sauce

Kuzukiri
40 g (1½ oz) kuzu (starch thickener) or arrowroot powder
130 ml (4½ fl oz) water

Garnish (optional)
Matcha powder
Candied ginger (p. 238)

Utensil
1 baking tray, 20 × 15 cm (8 × 6 inches)

To prepare the kuromitsu, dissolve the sugars in the water in a small saucepan over low heat, stirring constantly. Skim off the foam. Add the soy sauce, mix, and remove from the heat. Leave to cool completely.

To prepare the kuzukiri, in a frying pan or saucepan large enough to completely immerse the baking tray, bring 130 ml (4½ fl oz) of water to a boil. Mix the starch and water in a bowl. Strain the mixture and pour half of it onto the baking tray. Turn the heat down to low and carefully place the tray on the boiling water using a pair of tongs. Let the tray float for 1 to 2 minutes, until the surface hardens and the mixture becomes a little translucent. Tilt the tray slightly to check that it does not move, then completely immerse the tray in the water. Once the mixture is completely transparent, after 2 to 3 minutes, remove the tray from the water and immerse it in a large container filled with chilled water. After the kuzukiri has cooled, slide a spatula around the edges of the tray to gently unstick. Repeat the process with the remaining kuzu mixture.

Place the kuzukiri sheets on a work surface and cut them into 1.5 × 20-cm (⅝ × 8-inch) strips. Divide the strips into four individual bowls and pour in the kuromitsu. Serve sprinkled with matcha powder and candied ginger, if desired.

TEA AND SWEETS

Lemon agar jelly

 VEGAN

レモンゼリー

Serves 4
Preparation: 15 minutes
Resting: 1 hour
Cooking: 4 minutes

2 lemons
30 g (4 teaspoons) honey
500 ml (2 cups) water
50 g (1¾ oz) sugar
3 g (1/10 oz) agar powder (agar-agar)

Cut the lemons in half and juice one lemon, taking care to keep the lemon skin and rind whole. Scoop out the flesh of both lemons, leaving the rind and outer skin to use as ramekins, trimming the bases slightly so that each half sits flat.

Mix the honey with the juice of 1 lemon in a bowl. Put the water, sugar, and agar in a saucepan. Mix well and heat over medium heat. When it boils, reduce the heat to medium-low and cook for 2 minutes, stirring constantly. Remove from the heat and gradually add the lemon juice and honey, stirring well. Pour the mixture into the empty lemon skins. Set aside for at least 1 hour in the refrigerator.

VARIATIONS

Replace the lemon with other citrus fruits (orange, clementine, grapefruit, etc.)

Yokan

(RED BEAN BARS WITH DRIED FRUIT)

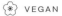 VEGAN

ドライフルーツ蒸し羊羹

Makes 2 bars
Preparation: 30 minutes
Resting: 15 minutes
Cooking: 20 minutes

25 g (1 oz) all-purpose flour

6 g (2 teaspoons) potato starch or corn flour

300 g (10½ oz) anko (red bean paste, p. 224)

2 tablespoons water

20 g (¾ oz) golden raisins

8 g (¼ oz) roughly chopped walnuts

2 figs, cut in half

6 chestnuts, preboiled

Utensils

4 bamboo leaves (find in major Asian grocery stores) or 4 sheets of 30 × 20-cm (12 × 8-inch) parchment paper + kitchen twine

If using bamboo leaves, soak the bamboo leaves in water for 15 minutes to soften. Tear a 1-cm (½-inch) strip off the edge of each leaf and gently separate. These strips will be used as twine to secure the bars.

Sift the flour and starch into a small bowl, then add the anko. Mix well using a spatula. Pour in the water and mix well. Stir in the raisins and nuts. Divide the mixture in half.

Shaping in bamboo leaves: Lay a bamboo leaf in front of you, long side parallel to the edge of your work surface. In the middle of the sheet, leaving a 1-cm (½-inch) border at the top and bottom, spread out two-thirds of the first half of the mixture to 1.5 cm (⅝ inch) thick. Arrange 2 fig halves and 3 chestnuts on top and cover with the remaining first half of the mixture.

Place a second leaf on top and press the edges at the top and bottom to ensure the mixture is well centered and to prevent it overflowing on the sides during cooking. Fold the two long sides together toward the middle, then the short sides, and secure using the bamboo strips.

Shaping in parchment paper: Place a sheet in front of you with the long side parallel to the edge of your work surface. In the middle of the paper, at the bottom, leaving a 2-cm (¾-inch) border in front of you, spread out two-thirds of the first half of the mixture to 1.5 cm (⅝ inch) thick, making a 14 × 5-cm (5½ × 2-inch) rectangle (there should be 8 cm/3¼ inches of paper left on each side of the mixture). Arrange 2 fig halves and 3 chestnuts on top and cover with the remaining first half of the mixture. Place a second sheet on top, fold the 2-cm (¾-inch) border upward, then roll the two sheets and the mixture together up to the top. Fold the sides over each other toward the middle and secure using kitchen twine.

Repeat the process with the second half of the mixture. Place the rolled leaves in a steamer basket and cook for 20 minutes over medium-high heat. Leave to cool completely before serving. The bars will keep for 3 to 4 days in the refrigerator.

お茶のお供

Kohakutou

(JAPANESE CANDY)

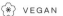 VEGAN

琥珀糖

Makes 500 g (1 lb 2oz) candy
Preparation: 30 minutes
Resting: 3 days
Cooking: 10 minutes

5 g agar powder (agar-agar)
200 ml (7 fl oz) water
300 g (10½ oz) granulated sugar
Natural food coloring in different colors (liquid, or powder dissolved in a teaspoon of water) or 1–2 teaspoons fruit juice or syrup

Fully dissolve the agar in the water in a small saucepan. Heat over medium heat and bring to a boil. Cook for another 2 minutes, stirring with a spatula. Add the sugar, stirring constantly. After about 5 minutes, the texture will thicken and a drop will fall gently when the spatula is lifted. Pour the mixture into a flat container, around 15 × 20 cm (6 × 8 inches).

Drop a few drops of natural food coloring onto the surface and mix well. (In the picture, I used 2 teaspoons of blueberry juice.) You can have fun putting several colors side by side and mixing them with a toothpick to get a marbled pattern; infuse tea in the water to make tea sweets; or decorate sweets with cherry blossoms (p. 116—soak flowers in water for 2 minutes to remove salt and pat dry gently). Set aside for 1 hour in the refrigerator.

Turn out the kohakutou onto a work surface covered with parchment paper by running a knife blade around the edges of the container. This is the second fun step. Cut the sweets into any desired shape (squares, triangles, gems, or even torn into pieces with your fingers). Leave to dry for 2 to 3 days at room temperature. Initially, the surface is completely transparent. After a day, it begins to crystallize. Then the outside becomes crunchy but the inside retains its jelly-like texture.

This is a very simple recipe that is a bit of fun to prepare, and the result is beautiful and tasty!

お茶のお供

TEA AND SWEETS

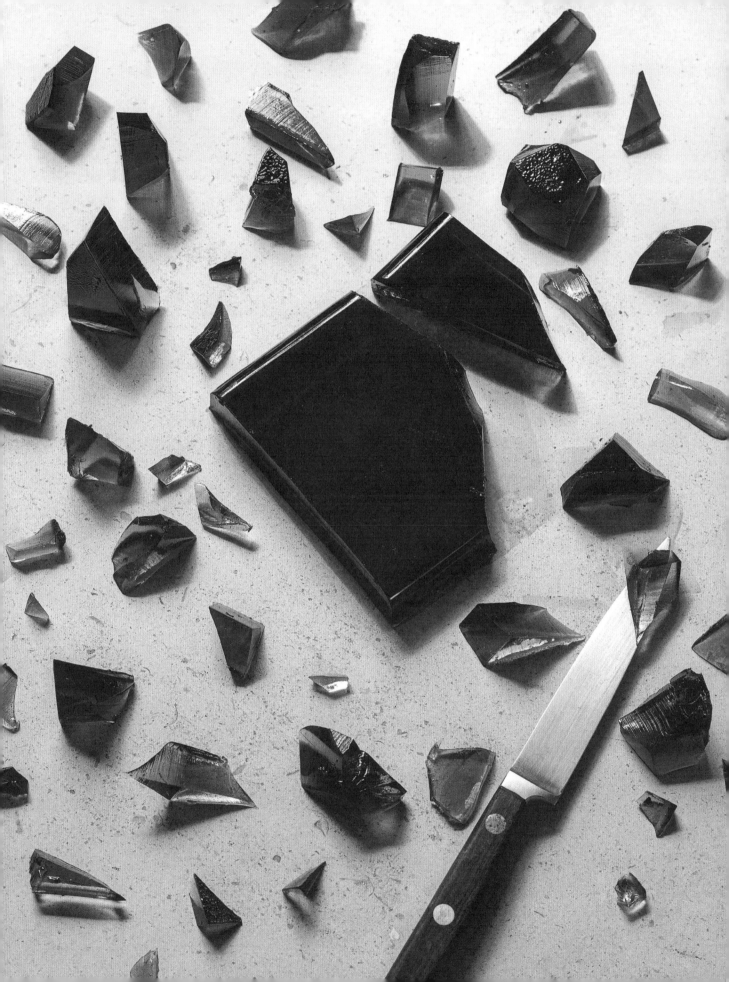

Steamed nut cake

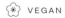 VEGAN

黒糖蒸しパン

Serves 4
Preparation: 10 minutes
Cooking: 25 minutes

120 g (4¼ oz) all-purpose flour
5 g (1 teaspon) baking powder
60 g (2 oz) muscovado sugar
100 ml (3½ fl oz) soy milk
2 tablespoons neutral vegetable oil
20 ml (4 teaspoons) rice vinegar
20 g (¾ oz) coarsely chopped walnuts, hazelnuts, and white and black sesame seeds

Bring water to a boil for steaming. Line a bamboo steamer basket—15 cm (6 inches) in diameter—with parchment paper. Or line a round cake pan of the same diameter with parchment and have a steamer basket nearby that it fits into.

Mix the flour, baking powder, and sugar. Add the soy milk and mix, then add the oil and mix. Add the vinegar and mix. Pour the dough into the steamer basket or into the cake pan. Sprinkle with the walnut, hazelnut, and sesame seed mixture. Steam 20 to 25 minutes. Check the cooking with a skewer. If it comes out clean, the cake is cooked, otherwise continue cooking in 2-minute increments and check again.

お茶のお供

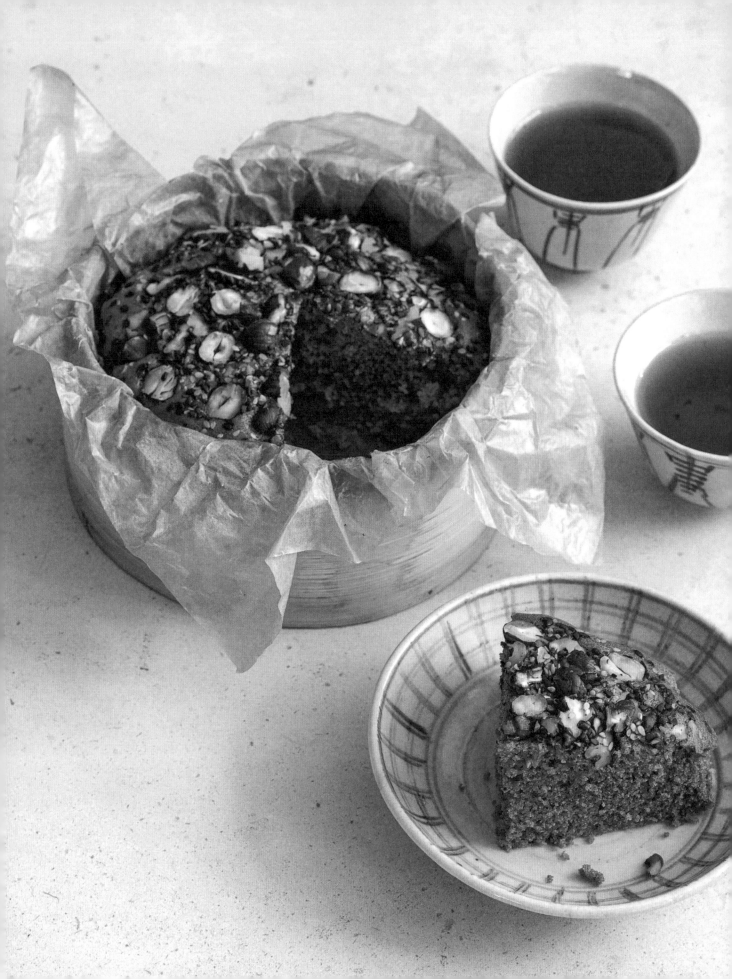

Castella

(JAPANESE SPONGE CAKE)

カステラ

Serves 6
Preparation: 40 minutes
Resting: 2 days
Cooking: 1 hour

2 tablespoons demerara sugar with large crystals
4 eggs
95 g (3¼ oz) granulated sugar
2 tablespoons honey
2 tablespoons mirin
110 g (4 oz) bread flour
4 tablespoons matcha powder

Preheat the oven to 170°C (340°F). Line a 16 × 16 cm (6 × 6 inches) square cake pan with parchment paper and sprinkle the base with the demerara sugar.

Mix the eggs and granulated sugar in a large bowl. Place the bowl in a container of hot (60°C/140°F) water and beat with a mixer at low speed. When the mixture is warm (40–42°C/ 104–108°F), remove the bowl from the hot water. Whip at high speed until the mixture becomes pale yellow and thick. When you remove the whisk, the peaks should hold and then fall back like ribbons.

In a bowl sitting in warm water, dissolve the honey and mirin completely. Pour into the egg-sugar mixture and beat for 1 minute at high speed. Sift the flour and the matcha into the batter, then beat for 1 minute at low speed.

Pour the batter into the cake pan and tap it several times on the work surface to remove the air bubbles. Smooth the batter with a spatula to remove the air. Bake for 15 minutes, then lower the temperature to 140°C (285°F) and cook for a further 40 to 45 minutes, until a toothpick inserted into the cake comes out clean. When you remove the cake from the oven, tap the pan several times on the work surface to prevent the castella from sinking in the middle.

Place plastic wrap over the cake, then a plate or tray on top. Turn over to turn out the cake and immediately wrap the cake in the plastic wrap. Leave to rest for 1 day at room temperature and then 1 day in the refrigerator to give the castella its moist and spongy texture.

To serve, cut the castella in half, then into 3-cm (1¼-inch) slices.

お茶のお供

付録

RESOURCES

Ingredients

食材

Anko
Sweet red adzuki bean paste. There are two types: subu-an (whole beans) and koshi-an (strained and smoothed paste). If you like Japanese desserts, this is the most commonly used ingredient.

Chuka-men
These noodles were imported from China to make Chinese-Japanese dishes, such as ramen. They are more yellow than other Japanese noodles and contain sodium carbonate or potassium carbonate. If you cannot find them, use Italian spaghetti and add 1 tablespoon of baking soda per liter (4 cups) of cooking water.

Ginger
This is a very popular plant in Japan. It has antiseptic properties and is often eaten in its pickled form (gari) with sushi. Nowadays, it is easily found in most supermarkets. In Japan, ginger is sweet and has light-colored flesh. Ginger with a darker yellow flesh has a more intense taste, so keep an eye on the quantity you use!

Toasted sesame oil
Try to find Japanese or Korean oil, as Chinese oil is often too strong for Japanese cuisine. Otherwise, dilute the Chinese oil with a neutral vegetable oil (50-50).

Katsuobushi
Dried and fermented bonito flakes. Like kombu, this ingredient is essential for preparing dashi broth, a staple in Japanese cuisine.

Dried kombu
An essential ingredient in Japanese cuisine. You can find it in Japanese grocery stores. When making dashi, kombu produces an umami taste.

Kuzu
This starch is a prized ingredient in Japan. In desserts, in dishes, or as a binder, it creates a pleasantly smooth texture. Kuzu is considered to have medicinal properties that warm and nourish the body. You can replace it with arrowroot, but kuzu is tastier.

Mirin
Mirin is a sweet rice alcohol. It brings sweetness and umami to a dish. Choose hon-mirin, the real mirin, which is made with kōji, shochu, and glutinous rice (about 14% alcohol). Avoid products called "mirin seasoning" or those made from glucose syrup and alcohol (10–11%). If you need to use a substitution for the mirin, mix up a ratio of 1 tablespoon sake to 1 teaspoon raw sugar. Mix them well till they are completely dissolved.

Mustard and wasabi powder
I prefer powder to products sold in tubes. Dilute it with a very small amount of water to obtain a paste.

Japanese curry powder
You can replace it with traditional curry powder, but if you find a Japanese one, you'll get a more authentic taste.

Daikon (white radish)
This is a mild radish that contains a lot of water. It is often used grated as a garnish because it helps digestion (and it also tastes good).

Sake
There is sake for drinking and sake for cooking. Choose to buy sake for drinking because it is cheaper than the one for cooking, which is often imported from Japan and may contain sugar, salt, glutamate... all useless additives! If you don't have any sake, use dry sherry or a very dry white wine.

Oyster sauce
This is a Chinese ingredient, but it is commonly used in Japan to make Chinese-Japanese dishes.

Soy sauce
Try to find a brand that is organic, made following the proper fermentation steps, but is not too expensive. If you can, avoid the big, very cheap brands.

RESOURCES

Fresh shiitake mushrooms

This is the most popular and most enjoyed mushroom in Japan. It has a delicate and delicious taste. It is now becoming much easier to find fresh shiitake mushrooms outside Japan. If you can't find any, replace them with baby bella, cremini, or oyster mushrooms.

Dried shiitake mushrooms

Dried shiitake mushrooms are used to add umami ("essence of deliciousness" in Japanese) flavor to a dish. They cannot be replaced by fresh shiitake mushrooms. Dried shiitake mushrooms contain thirty times more vitamin D, are richer in folic acid and fiber, and add ten times more umami flavor.

Somen noodles

These are very fine wheat noodles.

Umeboshi

Umeboshi is a Japanese salted plum. Unfortunately and surprisingly, it is rare to find real umeboshi, without additives or flavor enhancers, in Japanese grocery stores.

Rice vinegar

You can find rice vinegar in supermarkets or in Asian stores. You may see organic Thai rice vinegar, but note that its taste is much more intense than Japanese rice vinegar. You can replace it with grain vinegar (from a Japanese grocery store).

Fresh salted wakame and dried wakame

To use it, the salt must be removed or it must be soaked in water as indicated on the packet. In general, after soaking, the weight of fresh salted wakame is doubled or tripled and that of dried wakame increases tenfold. Be careful—do not use wakame flakes in Japanese cuisine, as they are not suitable.

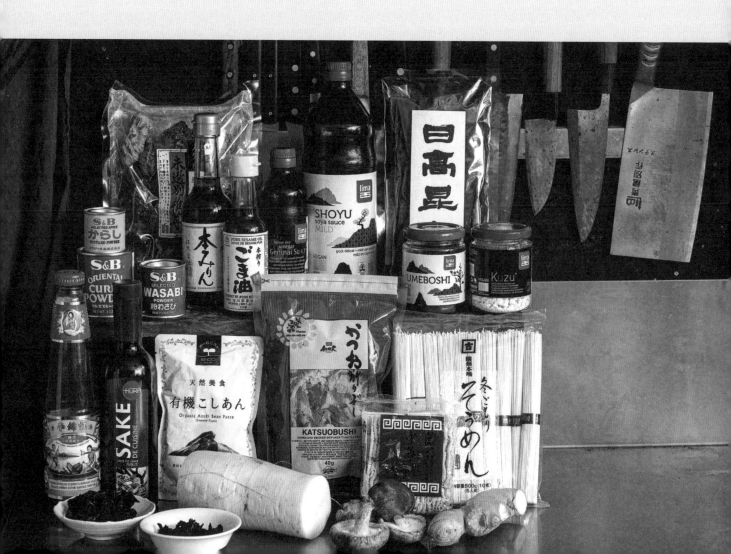

Utensils

調理道具

These are the utensils I brought from Japan. I have been using most of them for ten years or more. They are not essential for Japanese cooking, but they will help you a lot if you have them. You can find quality utensils in shops or online.

Zaru

This is a flat bamboo strainer, which is really handy for drying ingredients (such as dried fish, p. 170), draining noodles and vegetables (such as shiozuke, p. 94), or serving ingredients on the table (such as somen noodles, p. 34).

Large Japanese grater

I would recommend it. It is very easy to handle and makes it possible to quickly grate various vegetables, such as potato.

Small Japanese grater

This is essential for grating ginger, garlic, or wasabi.

Fine-mesh strainer

The fine mesh allows ingredients to drain well. It is essential—and much more suitable than a traditional colander—for rinsing noodles and rice.

Bamboo steamer basket

This is essential for steam cooking. It is used in many recipes and you can easily find them in Asian grocery stores. I don't have a microwave at home, and I've never thought about buying one because I heat everything up in the steamer basket. The taste is much better, and it is perfect for heating up rice.

Surikogi and Suribachi

This is the Japanese mortar and pestle. I wouldn't say it is the first utensil to buy, but it is very handy for crushing and grinding sesame seeds, nuts, tofu, and even potatoes, and it is such a beautiful utensil!

Makisu

This is the bamboo mat used for making maki. Without this mat, it is difficult! They are available online and in Asian grocery stores.

Menbou

This is a thin rolling stick used to roll out noodle dough. It is worth buying one if you want to make homemade udon noodles. You can replace it with a normal rolling pin, but the menbou is much easier to handle and produces better results.

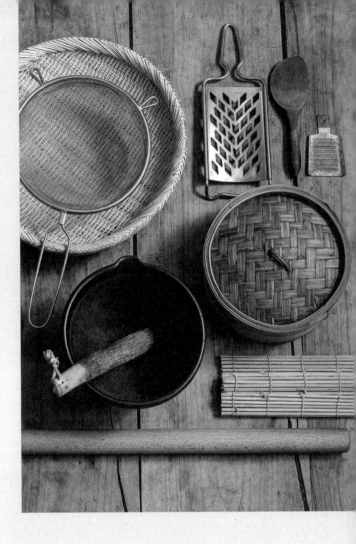

RESOURCES

Yukihira-nabe

This is a saucepan with a handle and a small spout. I use this pan, which is 20 cm (8 inches) in diameter and 8 cm (3¼ inches) deep, to simmer or fry mixtures. In the Japanese kitchen, there are many dishes cooked with liquid. This pan allows you to easily control the amount of liquid you pour into the plate. Its handle also allows for very stable pouring.

Petty (utility) knife

This was a birthday gift from my father, with my name engraved on it. This smallish knife (15-cm/6-inch blade) is lightweight and very easy to handle, especially if you have small hands. It can be used to cut vegetables into thin matchsticks and to fillet small fish with precision. When I travel, I always take it with me.

Board

It is good to have a cutting board that's not too big. Of course, a large board is necessary to cut up a lot of vegetables and/or to cut up large pieces of meat or fish. But most dishes can be prepared using a 25 cm (10 inch) board. Its small size makes it easy to get out, clean and put away.

Deep cast-iron frying pan

I don't like nonstick frying pans much. After a few years of use, the surface starts to come off and the pan has to be thrown out. A cast-iron frying pan requires some attention and maintenance at first but it has a long life and is easy to use. I use it to grill, sauté, fry, or simmer.

Oil strainer

To ensure your fried foods are crispy, it is important to place fried food on a rack or tray to aerate and drain the oil well.

Skimmer

This is very useful to remove foam or small pieces from frying oil or for dissolving miso paste into soup.

Long chopsticks

I can cook without a spatula, without a fork, without a spoon, but not without chopsticks! I do everything with chopsticks—hold ingredients, mix, turn over, poke to check the cooking. To cook, we often use special long and thin-tipped chopsticks because they distance you from the heat source and allow you to make precise movements. But normal bamboo or untreated wooden chopsticks will do the job. If you are comfortable eating with chopsticks, try cooking with them, too. You'll see how convenient it is!

RECIPE INDEX

12	Homemade udon 手打ちうどん	
14	Mentsuyu (Noodle sauce) めんつゆ	
16	Udon with duck broth 鴨南蛮つけうどん	
18	Spinach udon ほうれん草の幅広麺	
20	Ramen 手打ち中華麺	
22	Shoyu ramen (Tokyo-style ramen) 醤油ラーメン	
24	Meat broth ラーメンスープ	
26	Vegan ramen with three mushrooms and infused oil 精進ラーメン	
28	Vegetable broth 精進ラーメンスープ	
30	Hiyashi tantan-men (Chilled noodles with soy milk soup) 豆乳冷やし坦々麺	
32	Cold soba with bottarga カラスミ蕎麦	
34	Somen noodles 茄子素麺	
36	Soba salad with peanut butter and cilantro 蕎麦サラダ	
38	Gyoza dough 手作り餃子の皮	
40	Gyoza fillings 餃子のタネ	
44	Okonomiyaki (Japanese pancake) お好み焼き	
46	Oyaki (Grilled vegetable dumplings) おやき	
48	Nikuman and yasaiman (Pork buns and vegetable buns) 肉まん/野菜まん	
50	Bun fillings 肉まん/野菜まん	
56	Cooking rice 米の炊き方	
58	Sushi rice お米の炊き方	
60	Temari-zushi 手まり寿司	
64	Chirashi-zushi ちらし寿司	
66	Futomaki 太巻き (鯛/精進)	
68	Futomaki fillings 太巻き (鯛/精進)	
70	Tegone-zushi (Marinated tuna and herb sushi) てごね寿司	
72	Onigiri おにぎりの握り方	
74	Mixed onigiri おにぎり	
76	Chestnut and ginger rice 栗ご飯	
78	Rice with peas 豆ご飯	
80	Chimaki (Steamed sticky rice) 中華ちまき	
82	Donburi kakiage with prawns and broad beans 海老のかき揚げ丼	
84	Donburi with marinated fish and raw egg yolk 漬け丼	
86	Miso zosui (Japanese risotto with miso) 味噌雑炊	
90	Fermenting and preserving 発酵/保存食	
92	Nukazuke (Rice bran pickles) 糠漬け	
94	Chinese cabbage shiozuke (Japanese salting) 白菜の塩漬け	
96	Sokuseki-zuke (Quick pickles) 即席漬け	
98	Shiokōji (Fermented condiment) 塩麹	
100	Natto (Fermented soybeans) 手作り納豆	
102	Miso 味噌	
104	Various miso soups 味噌汁	
108	Miso (step-by-step) 手作り味噌	
110	Mackerel simmered in miso 鯖の味噌煮	
112	Dengaku (Vegetable skewers with miso sauce) 田楽	
114	Spaghetti with eggplant, peppers, and miso sauce 茄子味噌スパゲッティー	
116	Salted cherry blossoms 桜の塩漬け	
122	Dashi shojin (Vegan dashi) 精進だし	
124	Gomadofu (Sesame tofu) 胡麻豆腐	
126	Kinpira (Japanese-style stir-fried vegetables) 金平	
128	Agebitashi (Fried and marinated vegetables) 揚げびたし	
130	Korokke (Potato fritters) コロッケ	
132	Charred eggplant 焼きなす	
134	Oven-baked sweet potato サツマイモのオーブン焼き	
136	Potato salad ポテトサラダ	
138	My favorite homemade condiments 自家製調味料	

140	Homemade tofu ✿ 自家製豆腐	
144	Tofu salad with nuts and herbs ✿ 木の実とハーブの豆腐サラダ	
146	Ganmodoki (Fried tofu dumplings) ✿ がんもどき	
148	Rice paper rolls with fried tofu and pear ✿ 揚げ豆腐の生春巻き	
150	Mabo-doufu (Tofu with spicy sauce) ✿ 麻婆豆腐	
152	Unohana (Okara simmered with dashi and vegetables) ✿ 卯の花	
154	Aemono (Japanese salad with three seaweeds) ✿ 三種の和え物	
156	Korean-style pancakes with seaweed and potato ✿ 韓国風海藻とジャガイモのお好み焼き海藻	
162	Sashimi salad 刺身サラダ	
164	Grilled horse mackerel 鯵の南蛮漬け	
166	Dashi (Katsuobushi and kombu) 鰹出汁	
168	Chawanmushi with clams (Savory egg custard) あさりの茶碗蒸し	
170	Himono (Dried fish) 魚の干物	
172	Ikameshi (Squid stuffed with glutinous rice) いか飯	
174	Fish bento 鮭海苔弁	
176	Panko-fried oysters カキフライ	
178	Filleting sardines 鰯の手開き	
180	Sardine sashimi roll 鰯のレタス巻き	
182	Fried sardine bones イワシの骨の唐揚げ	
184	Oden (Hot pot with sardine balls) おでん	
186	Salmon and mushroom parcels 鮭のホイル焼き	
188	Fish tempura 白身魚の天ぷら	
192	Roasted lemongrass chicken stuffed with rice and mushrooms 鶏の丸焼き	
194	Kara-age (Fried chicken with sweet-chile sauce) 鶏の唐揚げピリ辛ソース	
196	Meat bento 鶏の生姜蜂蜜唐揚げ弁当	
198	Simmered pork and soft-boiled egg 豚の角煮	
200	Duck and watercress hot pot 鴨とクレソンの鍋	
202	Subuta with prunes (Sweet-and-sour black vinegar pork) 酢豚	
204	Japanese-style stuffed cabbage ロールキャベツ	
206	Tonkatsu (Breaded pork cutlet) 豚カツ	
208	Homemade hot dog and spicy ketchup ホットドッグ	
210	Hamburg steak (Japanese-style beef patty) ハンバーグステーキ	
212	Japanese curry ルーから作るカレー	
214	Japanese drinks 日本のアルコール	
216	Easy cocktails カクテル	
220	Tea 茶	
222	Tea-based drinks お茶のドリンク	
224	Anko (Sweet red bean paste) ✿ あんこ	
226	Dorayaki (Red bean pancakes) どら焼き	
228	Strawberry daifuku (Strawberry and anko mochi) ✿ 苺大福	
230	Shiratama dango (Glutinous rice balls) ✿ 白玉団子	
232	Soba manjyu (Sweet buckwheat buns) ✿ 蕎麦饅頭	
234	Sesame okara doughnuts ✿ 胡麻とおからのドーナッツ	
236	Karintou with black sugar and peanuts (Japanese cookies) ✿ ピーナッツかりんとう	
238	Candied ginger 生姜の砂糖漬け	
240	Kuzukiri (Kuzu paste with black sugar syrup) ✿ 葛きり	
242	Lemon agar jelly ✿ レモンゼリー	
244	Yokan (Red bean bars with dried fruit) ✿ ドライフルーツ蒸し羊羹	
246	Kohakutou (Japanese candy) ✿ 琥珀糖	
248	Steamed nut cake ✿ 黒糖蒸しパン	
250	Castella (Japanese sponge cake) カステラ	

✿ Vegan recipe

INDEX

A
aburaage (fried tofu), 86, 185
adzuki, 224, 230
aemono (Japanese salad with three seaweeds), 154–155
agar, 242, 246
agebitashi (fried and marinated vegetables), 128
alcoholic fermentation, 91
anko (sweet red bean paste), 224, 228, 230, 232, 244, 254

B
bamboo mat, 257
bamboo steamer basket, 256
bamboo strainer, 256
barley shochu, 214
beer, 214
bento, 174–175, 196–97
black sesame shiratama, 230
bottarga (kawasumi), 32
board, 257
breaded pork cutlet, 206
broth
 dashi (katsuobushi and kombu), 166–167
 dashi shojin (vegan dashi), 122
 duck, 16
 meat, 25
 vegetable, 28
buns
 nikuman (pork buns), 48–49, 50
 soba manjyu (sweet buckwheat buns), 232
 yasaiman (vegetable buns), 48–49, 50

C
cabbage, 40, 44, 50, 86, 94–95, 131, 204
candied ginger, 238
castella (Japanese sponge cake), 250
charred eggplant, 132
chawanmushi with clams (savory egg custard), 168
cherry blossoms, salted cherry blossoms, 116
chestnut and ginger rice, 76
chilled noodles with soy milk soup, 31
chimaki (steamed sticky rice), 80–81
Chinese cabbage shiozuke (Japanese salting), 94–95
chirashi-zushi, 64–65
chopsticks, long, 257
chuka-men, 254
citrus sauce (seasonal), 139
cocktails. See drinks
cold soba with bottarga, 32
condiments, 138–139
 ponzu (seasonal citrus sauce), 139
 ra-yu (ginger and spice infused oil), 139
 soy mayonnaise, 139
 spicy ketchup, 208
curry, 212–213
curry powder, 254
cutting board, 257

D
daginjo-shu sake, 214
daikinjo sake, 214
daikon (white radish), 32, 86, 112, 185, 254
dashi (katsuobushi and kombu), 166–167
dashi shojin (vegan dashi), 122
deep cast-iron frying pan, 257
dengaku (vegetable skewers with miso sauce), 112
donburi (with marinated fish and raw egg yolk), 84
donburi kakiage (with prawns and broad beans), 82
dorayaki (red bean pancakes), 226
dough. See flour
dried fish, 170–171
dried kombu, 254
drinks, 214–216
 beer, 214
 ginger beer, 216
 hot sake with cherry blossom, 216
 pilsner, 214
 sake, 214
 shochu, 214
 umeboshi shochu, 216
 umeshu, 214
duck broth, 16
duck and watercress hot pot, 200
dumplings
 ganmodoki (fried tofu dumplings), 146
 gyoza, 38–39, 40
 oyaki (grilled vegetable dumplings), 46–47

E
eggplant, 35, 47, 154, 128, 132, 212–213
eggs. See also tamago
 chawanmushi with clams (savory egg custard), 168
 donburi (with marinated fish and raw egg yolk), 84
 simmered pork (and soft-boiled egg), 198
enoki mushrooms, 26, 86, 186

F
fermenting and preserving, 88–117
 Chinese cabbage shiozuke (Japanese salting), 94–95
 dengaku (vegetable skewers with miso sauce), 112
 koji, 91, 102, 108–109
 lactic and alcoholic fermentation, 91
 mackerel (simmered in miso), 110
 by microorganisms, 91
 miso, 102
 miso soups (various), 104–105
 natto (fermented soybeans), 100–101
 nukazuke (rice bran pickles), 92–93
 by other bacteria, 91
 preservation by salting, 91
 salted cherry blossoms, 116–117
 Sanga (miso), 107, 108–109
 shiokōji (fermented condiment), 98
 sokuseki-zuke (quick pickles), 96
 spaghetti (with eggplant, pepper, and miso sauce), 114
filleting sardines, 178–179
fine-mesh strainer, 256
fish, 160–189
 chawanmushi with clams (savory egg custard), 168
 dashi (katsuobushi and kombu), 166–167
 donburi (with marinated fish and raw egg yolk), 84
 filleting sardines, 178–179
 fish bento, 174–175
 fish tempura, 188
 fried sardine bones, 182
 grilled horse mackerel, 164
 himono (dried fish), 170–171
 ikameshi (squid stuffed with glutinous rice), 172
 mackerel (simmered in miso), 110
 oden (hot pot with sardine balls), 184–185
 panko-fried oysters, 176
 salmon and mushroom (parcels), 186
 sardine sashimi roll, 180
 sashimi salad, 162
 tegone-zushi (marinated tuna and herb sushi), 70–71
fish bento, 174–175
fish tempura, 188
flour, 10–51
 cold soba with bottarga, 32
 gyoza, 38–39, 40
 hiyashi tantan-men (chilled noodles with soy milk soup), 31

mentsuyu (noodle sauce), 14
nikuman and yasaiman (pork buns and vegetable buns), 48–49, 50
okonomiyaki (Japanese pancake), 44
oyaki (grilled vegetable dumplings), 46–47
ramen, 20–21
shoyu ramen (Tokyo-style ramen), 22
soba salad (with peanut butter and cilantro), 36
somen noodles, 35
spaghetti with eggplant, pepper, and miso sauce, 154–155
spinach udon (with mint), 18
udon, 12–13
udon with duck broth, 16
vegan ramen (with mushrooms and infused oil), 26
fried chicken with sweet-chile sauce, 194
fried and marinated vegetables, 128
fried sardine bones, 182
fried tofu dumplings, 146
furikake, 167
futomaki, 66–67, 68

G

ganmodoki (fried tofu dumplings), 146
genmaicha, 220
ginger, 254
ginger beer, 216
ginger and spice infused oil, 139
ginjyo-shu sake, 214
glutinous rice balls, 230
gochujang, 134, 180
gomadofu (sesame tofu), 124
grater
 Japanese (large), 256
 Japanese (small), 256
grilled horse mackerel, 164
grilled vegetable dumplings, 46–47
gyoza, 38–39, 40

H

hamburg steak (Japanese-style beef patty), 210
himono (dried fish), 170–171
hijiki, 146, 156
hiyashi tantan-men (chilled noodles with soy milk soup), 31
homemade hot dog (and spicy ketchup), 208
homemade tofu, 140–141
honjozo-shu sake, 214
hon-mirin, 254

horse mackerel, grilled, 164–165, 171
hot pot
 duck and watercress hot pot, 200–201
 hot pot with sardine balls, 184–185
hot sake with cherry blossom, 216
houjicha, 220
houjicha with soy milk, 222

I

ikameshi (squid stuffed with glutinous rice), 172
ikura onigiri, 74
ingredients, 254–255

J

Japanese candy, 246
Japanese cookies, 236
Japanese curry, 212–213
Japanese curry powder, 254
Japanese pancake, 44
Japanese risotto with miso, 86
Japanese salad with three seaweeds, 154–155
Japanese sponge cake, 250
Japanese-style beef patty, 210
Japanese-style stir-fried vegetables, 126–127
Japanese-style stuffed cabbage, 204
junmai-ginjyo sake, 214
junmai-shu sake, 214, 216

K

kama-asa, 52–53
kara-age (fried chicken with sweet-chile sauce), 194
karintou with black sugar and peanuts (Japanese cookies), 236
katsuobushi, 166–167, 175, 254
katsuo-kombu onigiri, 74
kinpira (Japanese-style stir-fried vegetables), 126–127
kohakutou (Japanese candy), 246
koji, 91, 98
Korean-style pancakes (with seaweed and potato), 156
korokke (potato fritters), 130–131
kombu, 74, 96, 127, 159, 166–167, 254, 164
kuromitsu, 240
kuzu, 254
kuzukiri (kuzu paste with black sugar syrup), 240–241
kuzu paste with black sugar syrup, 240–241

L

lactic fermentation, 91
lemon agar jelly, 242
lemongrass, 192–193
long chopsticks, 257

M

mabo-doufu (tofu with spicy sauce), 150
mackerel (simmered in miso), 110–111
makisu (bamboo mat), 256
marinated tuna and herb sushi, 70
mat, bamboo, 256
matcha, 221
meat, 190–213
 duck and watercress hot pot, 200
 Hamburg steak (Japanese-style beef patty), 210
 homemade hot dog (and spicy ketchup), 208
 Japanese curry, 212–213
 Japanese-style stuffed cabbage, 204
 kara-age (fried chicken with sweet-chile sauce), 194
 meat bento, 196–197
 meat broth, 25
 nikuman (pork buns), 48–49, 50
 roasted lemongrass chicken (stuffed with rice and mushrooms), 192–193
 simmered pork (and soft-boiled egg), 198
 subuta with prunes (sweet-and-sour black vinegar pork), 202
 tonkatsu (breaded pork cutlet), 206
menbou (rolling stick), 256
mentsuyu (noodle sauce), 14
mirin, 254
miso, 102
miso soups (various), 104–105
miso zosui (Japanese risotto with miso), 86
mixed onigiri, 74
mochi, 228, 185
mortar and pestle (Japanese), 256
mugicha, 221
mushrooms
 burdock and shiitake mushroom kinpira, 127
 dashi shojin (vegan dashi), 122–123
 fish tempura, 188
 roasted lemongrass chicken (stuffed with rice and mushrooms), 192–193
 salmon and mushroom (parcels), 186–187
 shiitake, 255
 temari-zushi, 60–61

vegan ramen (with mushrooms and infused oil), 26
mustard and wasabi powder, 254

N
nameshi onigiri, 74
natto (fermented soybeans), 100–101, 105, 154
negiabura, 26
nigari, 140–141
nikuman and yasaiman (pork buns and vegetable buns), 48–49, 50
noodles. See flour
noodle sauce, 14
nori, 70, 175, 155, 175
 futomaki, 66–67
 onigiri, 72–73
nukadoko, 92–93
nukazuke (rice bran pickles), 90–91, 92–93

O
oden (hot pot with sardine balls), 184–185
oil
 ginger and spice infused oil, 139
 vegan ramen (with mushrooms and infused oil), 26
oil strainer, 257
okara, 141, 152, 234
okonomiyaki (Japanese pancake), 44
onigiri, 72–73, 74–75, 197. See also rice
oven-baked sweet potato, 134
oyaki (grilled vegetable dumplings), 46–47
oyster, 44, 156, 168, 176
oyster mushroom, 26, 168, 186
oyster sauce, 254

P
panko, 131, 176, 204, 206, 210
panko-fried oysters, 176–177
petty (utility) knife, 257
pilsner, 214
ponzu (seasonal citrus sauce), 139
pork buns, 48–49
potato fritters, 130–131
potato salad, 136
prawns, donburi kakiage (with prawns and broad beans), 82
preserving. See fermenting and preserving

R
ramen, 20–21
 shoyu ramen (Tokyo-style ramen), 22

vegan ramen (with mushrooms and infused oil), 26
ra-yu (ginger and spice infused oil), 139
red beans. See flour
red bean bars with dried fruit, 244
red bean pancakes, 226
rice, 54–87
 chestnut and ginger rice, 76
 chimaki (steamed sticky rice), 80–81
 chirashi-zushi, 64–65
 cooking rice, 56–57
 donburi (with marinated fish and raw egg yolk), 84
 donburi kakiage (with prawns and broad beans), 82
 futomaki, 66–67, 68
 glutinous rice balls, 230
 ikameshi (squid stuffed with glutinous rice), 172
 miso zosui (Japanese risotto with miso), 86
 mixed onigiri, 74
 onigiri, 72–73
 rice with peas, 78
 roasted lemongrass chicken (stuffed with rice and mushrooms), 192–193
 shiratama dango (glutinous rice balls), 230
 sushi rice, 58–59
 tegone-zushi (marinated tuna and herb sushi), 70
 temari-zushi, 60–61
rice paper rolls (with fried tofu and pear), 148
rice with peas, 78
rice vinegar, 255
roasted lemongrass chicken (stuffed with rice and mushrooms), 192–193
rolling stick, 256

S
sake, 214, 253
salmon and mushroom (parcels), 186
salmon marinated in shiokoji, 176
salted cherry blossoms, 116–117
salting, preservation by, 91
Sanga (miso), 107, 108–109
sardines, 60, 162, 171, 178–179, 181, 182, 185
sardine bones, fried, 182–183
sardine sashimi roll, 180–181
sashimi
 chirashi-zushi, 64–65
 donburi, 84
 sardine sashimi roll, 180

sashimi salad, 162
tegone-zushi, 70–71
saucepan, 257
savory egg custard, 168
sea bream, 61, 65, 68, 162, 188
seaweed, 146, 154–155, 156–157, 158–159
sencha, 220
seame oil, toasted, 254
sesame okara doughnuts, 234
sesame tofu, 124
shiitake mushrooms, 255. See also mushrooms
shiokōji (fermented condiment), 98
shiozuke, 91, 94–95
shiratama dango (glutinous rice balls), 230
 black sesame shiratama, 230
 shiratama with adzuki soup, 230
shiso leaves, 35, 70, 74, 105, 132, 180,
shochu, 214
shoyu ramen (Tokyo-style ramen), 22
simmered pork (and soft-boiled egg), 198
skimmer, 257
soba. See flour
sobacha, 221
soba manjyu (sweet buckwheat buns), 232
soba salad (with peanut butter and cilantro), 36
sokuseki-zuke (quick pickles), 96
somen noodles, 35, 255
soups
 hiyashi tantan-men (chilled noodles with soy milk soup), 29–30
 miso soups (various), 104–105
soy mayonnaise, 139
soy sauce, 254
spaghetti (with eggplant, pepper, and miso sauce), 114
sparkling matcha tea, 222
spinach udon (with mint), 18
squid stuffed with glutinous rice, 172
steamed nut cake, 248
steamed sticky rice, 80–81
steamer basket, bamboo, 256
strainer
 bamboo, 256
 fine-mesh, 256
strawberry daifuku (strawberry and anko mochi), 228
subuta with prunes (sweet-and-sour black vinegar pork), 202
surikogi and suribachi (mortar and pestle), 256
sushi rice, 58–59. See also rice

sutezuke, 92
sweet buckwheat buns, 232
sweet red bean paste, 224
sweets. *See* tea and sweets
sweet-and-sour black vinegar pork, 202

T
tea and sweets, 218–250
 anko (sweet red bean paste), 224, 254
 candied ginger, 238
 castella (Japanese sponge cake), 250
 dorayaki (red bean pancakes), 226
 genmaicha, 220
 houjicha, 220
 houjicha with soy milk, 222
 karintou with black sugar and peanuts (Japanese cookies), 236
 kohakutou (Japanese candy), 246
 kuzukiri (kuzu paste with black sugar syrup), 240
 lemon agar jelly, 242
 matcha, 221
 mugicha, 221
 sencha, 220
 sesame okara doughnuts, 234
 shiratama dango (glutinous rice balls), 230
 sobacha, 221
 soba manjyu (sweet buckwheat buns), 232
 sparkling matcha tea, 222
 steamed nut cake, 248
 strawberry daifuku (strawberry and anko mochi), 228
 umesho-bancha, 222
 yokan (red bean bars with dried fruit), 244
tegone-zushi (marinated tuna and herb sushi), 70
temari-zushi, 60–61
tempura, fish, 188
toasted sesame oil, 254
tofu, 143
 ganmodoki (fried tofu dumplings), 146
 homemade tofu, 140–141
 mabo-doufu (tofu with spicy sauce), 150
 rice paper rolls (with fried tofu and pear), 148
 sesame, 125
 tofu salad (with nuts and herbs), 144
tokutei-meishoshu sake, 214
Tokyo-style ramen (shoyu ramen), 22
tonkatsu (breaded pork cutlet), 206
tuna-mayo onigiri, 74
tzukemono, 91

U
udon, 12–13. *See also* flour
udon with duck broth, 16
umé onigiri, 74
umeboshi, 60, 61, 74, 175, 216, 222, 255
umeboshi shochu, 216
umesho-bancha, 222
umeshu, 214
unohana (okara simmered with dashi and vegetables), 152
utensils, 256–257
 bamboo steamer basket, 256
 board, 257
 deep cast-iron frying pan, 257
 fine-mesh strainer, 256
 large Japanese grater, 256
 long chopsticks, 257
 makisu (bamboo mat), 256
 menbou (rolling stick), 256
 oil strainer, 257
 petty (utility) knife, 257
 skimmer, 257
 small Japanese grater, 256
 surikogi and suribachi (mortar and pestle), 256
 yukihira-nabe (saucepan), 257
 zaru (bamboo strainer), 256
utility knife, 257

V
vegan dashi, 122
vegan ramen (with mushrooms and infused oil), 26
vegetable broth, 28
vegetable buns, 48–49
vegetables, 118–159
 aemono (Japanese salad with three seaweeds), 154–155
 agebitashi (fried and matinated vegetables), 128
 charred eggplant, 132
 condiments, 138–139
 dashi shojin (vegan dashi), 122
 ganmodoki (fried tofu dumplings), 146
 gomadofu (sesame tofu), 124
 homemade tofu, 140–141
 Japanese-style stuffed cabbage, 204
 kinpira (Japanese-style stir-fried vegetables), 126–127
 Korean-style pancakes (with seaweed and potato), 156
 korokke (potato fritters), 130–131
 mabo-doufu (tofu with spicy sauce), 150
 oven-baked sweet potato, 134
 oyaki (grilled vegetable dumplings), 46–47
 ponzu (seasonal citrus sauce), 139
 potato salad, 136
 ra-yu (ginger and spice infused oil), 139
 rice paper rolls (with fried tofu and pear), 148
 rice with peas, 78
 seaweed, 159
 soy mayonnaise, 139
 spaghetti (with eggplant, pepper, and miso sauce), 114
 spinach udon, 18
 tofu, 143
 tofu salad (with nuts and herbs), 144
 unohana (okara simmered with dashi and vegetables), 152
 vegetable broth, 28
 yasaiman (vegetable buns), 48–49, 50
vinegar, rice, 255

W
wakame, 105, 155, 159, 255
wasabi powder, 254
watercress, 185, 200
white radish, 254

Y
Yasai, 121
yokan (red bean bars with dried fruit), 244
yukihira-nabe (saucepan), 257

Z
zaru (bamboo strainer), 256

ACKNOWLEDGMENTS

Thank you to my mother and grandmother, who passed on the pleasure of cooking for others. It is thanks to you (and also to my father, who cooks a lot for his family, which is quite surprising for a Japanese man of his generation!), that I learned to cook with passion and love.

Thank you, Audrey and Christine, for giving me the wonderful opportunity to create this book with you. Thank you for always listening to my ideas and for being so patient and respectful.

Thank you, Akiko, for once again being the photographer for my book. Your company and talent inspire me immensely and bring me so much joy. What a pleasure and relief every time you tell me that my recipes are good! And thank you very much to Miyako, your daughter, for agreeing to feature in this book after her appearance in the previous one.

Thank you, Élise, for your help in writing the text. Without you and your efficiency and precision (and your kindness), I would never have finished writing my recipes in French!

Thank you, Sidonie and Line from Hic and Nunc Studio, for always being willing to listen and for the elegant design of this book.

Thank you to everyone who was kind enough to meet with me for the insights: Anna-san for meeting me in the Yasai fields and Jyuri-chan for accompanying me; Julie from Hep Ken organic seaweed for giving me a behind-the-scenes tour of the world of Breton seaweed; Laetitia, Timothée, and the whole Algolesko team, for showing us your seaweed production facility and sharing your passion; Arnaud, from the restaurant AC Le Levier, for allowing us to taste your unforgettable seaweed-based culinary creations; Mrs. Ogawa, Takako-san, and Ophélie from Suzu Tofu for meeting us and showing us the secret of your delicious tofu; Mrs. Hiruta and Mr. Miyatake for sharing your in-depth knowledge and passion for quality Japanese cooking utensils.

Thank you, Yu, for your beautiful cherry blossoms.

Thank you, Fumi-chan and Ami-chan, for forever being my passionate fermentation senseis.

Thank you to my family in France. Pascale for your help and encouragement. To Hugo for being there for me, for your help and patience. Thanks to you and for you, I never forget that cooking is a joy that brings me great happiness.

To Mae, my daughter, thank you for being there with your dad and eating my dishes every day.

First published in French under the title *Cuisine Japonaise maison* in 2021 by Marabout, an imprint of Hachette Livre.

Published under the title *Japanese Home Cooking* in 2022 in the United Kingdom by Murdoch Books, an imprint of Allen & Unwin.

SIMPLY JAPANESE

Copyright © 2021 by Hachette Livre (Marabout)

English Translation Copyright © 2022 by Murdoch Books.

All rights reserved. No part of this book may be used or reproduced in any manner whatsoever without written permission except in the case of brief quotations embodied in critical articles and reviews For information address Harper Design, 195 Broadway, New York, NY 10007.

HarperCollins books may be purchased for educational, business, or sales promotional use. For information please email the Special Markets Department at SPsales@harpercollins.com.

Published in 2022 by
Harper Design
An Imprint of HarperCollins*Publishers*
195 Broadway
New York, NY 10007
Tel: (212) 207-7000
Fax: (855) 746-6023
harperdesign@harpercollins.com
www.hc.com

Distributed throughout the world by
HarperCollins*Publishers*
195 Broadway
New York, NY 10007

ISBN 978-0-06-325974-4

Library of Congress Control Number: 2022937054

Book design by Hic et Nunc Studio
Photographs by Akiko Ida
Photographs on pp. 106 and 109 by Pierre Javelle

Printed in Spain

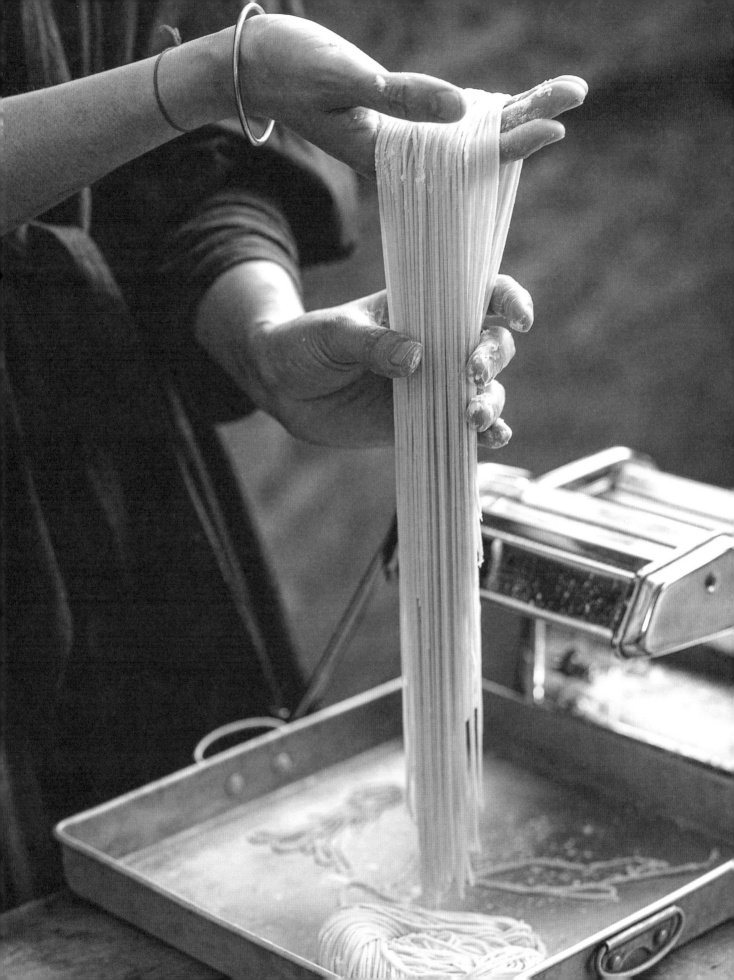